25 Women

25 Women

Essays on Their Art

Dave Hickey

THE UNIVERSITY
OF CHICAGO PRESS
Chicago and London

DAVE HICKEY is former executive editor of *Art in America* and the author of *The Invisible Dragon: Essays on Beauty* and *Air Guitar*. He has served as a contributing editor for the *Village Voice* and as the arts editor of the *Fort Worth Star-Telegram*.

The University of Chicago Press, Chicago 60637
The University of Chicago Press, Ltd., London
© 2016 by Dave Hickey
All rights reserved. Published 2016.
Printed in China

25 24 23 22 21 20 19 18 17 16 1 2 3 4 5

ISBN-13: 978-0-226-33315-1 (cloth)
ISBN-13: 978-0-226-24914-8 (e-book)
DOI: 10.7208/chicago/9780226249148.001.0001

Library of Congress Cataloging-in-Publication Data

Hickey, Dave, 1940– author.
25 women : essays on their art / Dave Hickey.
 pages cm
 ISBN 978-0-226-33315-1 (cloth : alkaline paper) — ISBN 978-0-226-24914-8 (ebook)
1. Women artists. 2. Art criticism. I. Title. II. Title: Twenty-five women.
 N8354.H53 2015
704'.042—dc23

 2015009740

♾ This paper meets the requirements of ANSI/NISO Z39.48-1992 (Permanence of Paper).

Key to the cover photographs.

This book is offered up in memory of

MARCIA TUCKER (1940–2013),

JOAN MITCHELL (1925–1992),

ELIZABETH MURRAY (1940–2013),

SARAH CHARLESWORTH (1947–2013),

HELEN VIRGINIA HICKEY (1914–1983),

And all the free spirits who died too young.

Contents

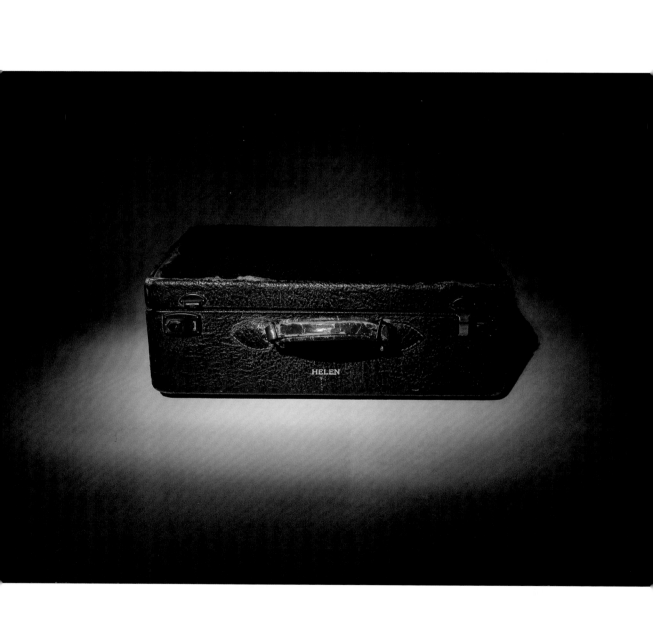

A Ladies' Man

Introduction

I assembled this book of essays on the work of women artists because I wanted to do something to honor my late friend Marcia Tucker, who was my first rabbi in the art world. When Marcia was curator at the Whitney, I cold-called her office to set up a lunch date. She said, "How will I recognize you?" I told her I would be the black guy in the cowboy hat. She was disappointed when I showed up white and hatless, but she laughed and told me that people are not usually so spunky with museum curators. I acknowledged this as a fault, and over the next few months Marcia recruited me to serve as the Sherpa on her art treks. She called me "Cowboy," and I called her the "Queen of Poland," out of respect for her status. We began in the late morning, slogging through the snow and slush of the Manhattan winter, past haunted buildings. We climbed stairwells that ascended into the mist. We visited artists' studios all day, because this was back when artists had a lot of art in their studios.

Afterward, we would have cocktails in a dark hotel bar on Madison Avenue where they played "Angel Eyes" and "Lush Life" on the sound system. We talked about what we had seen and who we were. I was obviously being mentored, and it was great. It was so New York, so noir, and, actually, so sweet that we almost had to drift away from our pleasant conspiracy to deal with the frazzled business of our lives. In the process, though, I learned everything I needed to know about the art world of the early seventies. I met nearly everyone I needed to meet as a consequence of knowing her. My debt to Marcia is incalculable. She was brave, energetic, and nonjudgmental to the point of having no taste at all. This was OK because I had enough taste for us both. Marcia thought art was

Nic Nicosia, *Helen's Suitcase*, 2013. Courtesy of the photographer.

Cover from *A Short Life of Trouble: Forty Years in the New York Art World*, by Marcia Tucker (University of California Press, 2008). Photo by Michael Tucker.

about holding back the night. I am from the West. I thought art was about holding back the professors, but no matter. Marcia would go on to invent The New Museum and reinvent herself as a politically correct museum director. I would become a very bad boy for writing an arrogant book about beauty. We ended up on opposite sides of the river, but I always loved her. She was a warrior, a woman of the world, and she liked Harleys. So what's not to love? I miss the Queen of Poland and I miss her being here.

In her honor, I scrolled my hard drive and came up with thirty essays on the work of women artists. I trimmed the juvenilia and ended up with twenty-five women, counting Marcia and my mom. I checked the Internet for competition, and I was amazed to discover that there is a lot of journalistic writing about women artists, but not much at all by way of critical prose. So here's a little brick for the wall, although this is far from a synoptic book. It is not a fair book either, but to its credit, it does not set out to colonize "women's art." The women in this book asked me to write about their work and found me enthusiastic about the prospect—mostly because I am an adept of difficulty. I love art that is evanescent and very far away. I love the mystery of gazing across the craquelure of gender gaps that still deploy themselves like canyons across our provisional utopia. American men still treat women with casual cruelty, even the women they love, but there is no agenda here.

There is a lot about art in this book. That is what I do. There is a lot of euphony, death, vogue, fanciful narrative, and fugitive nuance. There is some interesting grammar and more digression than I usually tolerate because a lot of art is best talked about by talking about something else, lest writing shatter the art like a fragile leaf in clumsy hands. What is not here is art politics, which I find abhorrent, and there is not much about feminism. I have never not been a feminist, and it really seems corny to say "Dern it! Everybody should be a feminist!" Also, I retain a vestigial temerity from the days of identity politics, when men could best demonstrate their feminism by staying away from women so the women could talk—by not writing about women's art so women could write about it. This "shock and awe" feminism without men was not much of a consolation for me. I remember confessing to one adamant Valkyrie that,

damn it, I *liked* women. She replied that if I liked women, my feminism didn't count.

Even so, I have always lived like a slightly bewildered Hagrid in a palace of talented women. I know firsthand how much they pay for their freedom. My grandmother was a businesswoman. My mother was a very successful businesswomen and a professor. My sister is a businesswoman. My wife is a professor, and all my favorite editors are women; all my favorite art dealers are women; and most of my favorite people are women. Meanwhile, the men in my family have always been charismatic wastrels—myself among them—so I have seen the hammer of sexism come down up close, and, if I need to be reminded, I look right over there at this tiny, battered, Montgomery Ward, fake-leather suitcase with my mother's name engraved in gold leaf under the handle. *Helen*, it says.

My mother bought that little suitcase to venture forth as the first member of her family to go to college since the Civil War. It is the bravest object I own, that dumb little suitcase. When she was promoted to full professor in economics, she gave it to me, not as a gift, but to punish me for wasting my life on rock-and-roll and art, and writing for magazines like *Playboy*, *Penthouse*, and intellectual journals one step up from mimeograph. She was always aggrieved that she couldn't show my writing to her friends. I'm sure she was equally aggrieved at whatever of my writing she might have read. At least, in the half century we shared, she never mentioned liking anything or reading anything I'd written.

So I must admit here that my mother was a brilliant woman and as terrible a mother as I was a son. We were awful at the parent-child thing, and I realize now that we were much alike, driven, offended, and unforgiving. And there is no denying that I started the whole thing by bouncing around in her womb for the last two months of my gestation, much to Mom's discomfort. I could never get myself positioned properly for exeunt, so I fell out on my ass with a cord around my neck. Snip, slap, scream and I was there, while my mom was being rushed off to ICU for the next two weeks, an event that arose fairly regularly in her concatenation of grief. Even so, I may be said to have been born a feminist, and, ultimately, in the very last days of Dave and Helen, when my mom was dying and furious about it, when she was still wishing (after all the things she'd done) that she had never given up painting, I came and

stayed at her house (which one *never* did), and we became good friends, if not quite family. If I were to say that I am writing about women artists now to better understand my mother, she would fucking love it, but she would be wrong. I understood my mother. Even so, during those months, it gradually became clear to me that whoever I am came out of that little suitcase.

Alexis Smith

My Pal Alex

I will make the true poem of riches,
To earn for the body and the mind whatever adheres and
 goes forward and is not dropt by death;
And I will show that there is no imperfection in the present,
 And can be none in the future,
And I will show that whatever happens to anybody it may
 be turn'd to beautiful results,
And I will show that nothing can happen more beautiful
 than death,
And I will thread a thread through my poems that time and
events are compact,
And that all the things of the universe are perfect miracles,
each as profound as any.

—*SHORT FORM OF WHITMAN'S LEAVES OF GRASS, ALEXIS SMITH* (1977)

If my mom were still alive, she would write me a fancy note in her executive écriture on her seventy-pound satin-finish stationary. *"Dear Reader,"* it would say, *"Please excuse Dave for writing an essay about an artist who is one of his best friends, and with whom he shares a great many idiosyncrasies. I realize this is not much done, nor altogether proper by my standards, but Dave was a friend of Alexis Smith and her husband Scott Grieger for years before he became an official art critic. When they met, Dave was a chemically enhanced art dealer. They would hang out at the Orange Julius stand in Pasadena and sometimes Peter Plagens or Bruce Nauman would drop by. Dave's affection for Alexis's work and her manner dates from that time, and has never flagged. So I hope he may be forgiven on this occasion for yet another of his enthusiastic indiscretions. Yours, Helen Virginia Hickey"*

Alexis Smith, *The Ape Man*, 1985. Mixed media collage, 29 1/8 ✛ 21 1/4 in. Courtesy of the artist.

This would do for juried publications, I think, but the real problem with writing about the art of one's friends is that you know too much, and you know too little. When you're together, the attributes you share dissolve into a general ambience of comfort. More to the point, most artists are quite unlike the art they make, so there is always the chance that the better you know an artist, the more imperfectly you know their art. Since Alexis's works, in their arctic modesty, are unlike any artist's I know, and since I only understand about a third of Alex's pieces, this is no problem. So here is what I know about Alexis Smith. She is a California girl who is married to my friend Scott. She and Scott live in a little house in Venice and tend their garden of succulents. She likes to make collages and scavenges yard sales, which I consider to be the dark side of her profession.

Temperamentally, Alex is a woman of the West—a blonde in the dust—chic when necessary. On the East Coast of the United States, men are presumed to be thoughtful, measured, and sane. Women in these climes are expected to be neurasthenics. In the West, however, men are habitually delusional dreamers or veterans with that thousand-yard stare. The men roll cigarettes, pan for gold, shoot buffalo, start ostrich ranches, militias, or carob plantations, or head out into the wake of some pissant dream. Women do the accounting, keep the septic working, and shoot critters around the property. They try to live like human beings. They are never too excited about the fantasies dazzling in the eyes of their menfolk. If you're sick, they will nurse you. If you die, they will bury you and then do their other chores.

If you had had the pleasure that I had of watching Alexis negotiate the budget for a large public artwork with a county commission, you would know what I mean. Pioneer women are meticulous and sane, and, given the low entrance requirements in today's art world, Ms. Smith is overqualified for her job, or—as we say in Las Vegas—too hip for the room. If you don't understand her art, you can be fairly certain that she does, but you will hear no scorn from Alexis. She will assure you in her Whitmanesque dialect that "ninety percent of the behavior we attribute to malice, may be attributed to plain stupidity." Having grown up on the grounds of a mental institution with no mother and a psychiatrist father, who, as we used to say, "had a hard war," Smith knows what crazy is. She's seen too many people whose worlds are flying apart, so she is always putting the shreds of our civilization back together, realigning the jewels and the junk.

In practice, she is more like the set designer of her art than an artistic personality, more beguiled by the tumbled flow of history than emotion, or, more precisely, beguiled by the emotional residue that can be squeezed out of its yard-sale tatters. Even so, no set designer is smarter, more meticulous, more impersonal, better educated, or more flagrantly opaque. No one cares less about the cosmetic appeal of her art, unless the cosmetics are part of the joke. No one is more unfazed by criticism. Ms. Smith has contemporary theory for breakfast, and she is happiest amusing herself in the studio, occupying her niches. When she started doing collages, she decided it was better to work naked, and she did. Only a sorry California winter put paid to this practice.

She is a collagist (a tiny subcategory among modern artists), and she is the only woman of standing in that genre. She has shown in all the places you should show, and this is sufficient for her, although her work is much more than collage. Like Rauschenberg and Lichtenstein she has roots in Harnett and Peto, in their modest multilayered cultural synthesis. From high to low and top to bottom, everything in Smith's work comes from somewhere else. Ms. Smith's own persona is a faint aroma that lingers around its hard-edged androgyny. She puts it together and gets out of the way, so, if the Great Library at Alexandria had been blown up rather than burned away, Alexis would be the one to put it back together better than it was before.

Ms. Smith does the philosophy and the darkness along with the goofiness. She doesn't do whimsy or make mistakes, and this can be off-putting. The absence of visible insecurity, faux-naïf gestures, when added to the quotidian opacity of her art, marks her as the elitist she is. She doesn't care what you think, but she does have her skeins of vanity. She was born Patty Ann Smith, and she always hated being Patty Ann Smith. She felt it lacked panache, so, when she entered the art world, her *nom du plume*, Alexis Smith, was a collage itself, stolen from a fifties movie actress, and, far from being mysteriously opaque, her works are intelligently opaque. Her tightly wound collages gradually unfold like slow-motion roses. This, perhaps, is because her work, in its adolescence, began with her editorial penchant to cut and compress.

Ms. Smith grew up as a voracious reader, like her fellow cutter and compressor John Chamberlain. At Black Mountain College, Chamberlain would read anything he could get between covers then stack the books he'd read

in the window to keep out the cold. As he read, Chamberlain would keep a notebook, writing down words or phrases that appealed to him and putting them together into poems. Eventually, he began collecting archipelagos of old car parts and putting them together into poetic sculptures that, as you walk around them, have their own poetic euphony and cadence. Alexis Smith's literary method is analogous. As a beginning artist, Smith kept a notebook in which she pared things down, copying out words and phrases critical to the atmosphere and pace of the "big data" manuscript. She did a ten-page version of *Oliver Twist* that was all Dickens. She compressed the two thousand pages of *Leaves of Grass* into a three-page version, all Whitman.

My own suspicion is that the pioneer woman in Alexis regarded this penchant as housecleaning and proper frugality, and also as a Calamity Jane way of getting right to the bull's-eye. Just on my own, flipping through her images, I have come across fragments of John Milton, Walt Whitman, Mark Twain, George Gershwin, Dorothy Parker, Isadora Duncan, Diana Vreeland, Tennessee Williams, Scheherazade, John Dos Passos, Jack Kerouac, Jorge Luis Borges, John Barrymore, and Raymond Chandler. I am sure there are many more. Her foundation in the history of Western Letters explains why Smith walks into a yard sale as Indiana Jones might walk into a Hindu cave. She knows what she is looking for and builds her melodies around the obbligato of Western culture in her head.

In this sense, Smith is less interested in "art" than in the fragile armature of American civilization in all its folly and glory. She builds series of works around fugitive images, hyper-edited texts, and popular patois. They touch the sky and scrape the ground. She prefers Westerners. There is a series of collages she calls Chandlerisms, arranged around quotes from Raymond Chandler. There is also a series of collages and assemblages in homage to Jack Kerouac. My favorite for its drollery is her starter kit for American culture based on variations of the "Dick and Jane" books, whose hero and heroine were the Scott and Zelda of grammar school readers when I was a kid. There are a lot of Janes out there (Calamity Jane, Lady Jane, Jane Fonda, Jane Greer, Jane Eyre, Jane Austen, etc.) and lots of Dicks (Deadwood, etc.). My favorite image in this series is *Wild Life* (1985)—the mock up of a *Life* magazine cover with a picture of Jane Greer looking gorgeous. It bears this small caption: "Jane lives in Bel-Air California with her poodle, two goats and an actor."

It's all so simple: There is "Life." There is "Jane." There is the wild ocean, the breeze in Jane's hair, Jane's sweater scattered with spades, clubs, diamonds, and hearts, which, if you love the movies, reminds you of Greer's career as a femme fatale and her role as Robert Mitchum's lethal crush in Jacque Tourneur's great film noir *Out of the Past*, with its suave Frenchy sound track. It's all accumulated and surgically compressed without cutting corners, so to look at *Wild Life* is to unfold America in the fifties when there was something called Life and there were Film Stars.

If you were there, it brings it all back. If you weren't, you get the idea. If you don't, don't worry, Alexis Smith is not a public utility. Alexis makes palimpsests for art lovers, like the wax tablets used by antique scribes to take notes then wipe them out and write more notes on top, so multiple levels of text are visible under good light. Her *Twentieth Century* collages are literally palimpsests. The series is named for a 1934 Howard Hawks movie with John Barrymore and Carole Lombard. Its poster bears a quote from the script that is very Barrymore. *"I don't live I act. I've died so often, made love so much—I've lost track of what's real."*

For this project, Alexis acquired about fifty film posters from old films. She made the same number of silk-screen images of the *Twentieth Century* poster with the dialogue quote and a falling or rising girl, depending on her configuration in the final version after she cut, inverted, rearranged, and deconstructed the poster screens. She silk-screened these tweaked *Twentieth Century* posters over the old posters she had acquired and voila: The Twentieth Century, itself, as if through a glass-bottomed boat. Each text changes the ambience of the image below, and since Ms. Smith is only pleasing herself, decoding these images can be a project for the beholder, like gardening, since Smith's collages mimic the waves in the cool majesty of their not caring.

The smaller works that Smith makes to please herself can require patient living with. Her public works, the ones she makes for us, invite applause, and not many artists can swing both ways. George Gershwin (who is one of Smith's heroes) could do this. He could move between pop, opera, and classical music without a pause or a hint of snobbery—from *Fascinating Rhythm*, to *Porgy and Bess*, and to *An American in Paris* without a blink. Alexis can do the same thing, transforming herself from a private artist to a public artist, from a poet to a songwriter in a blink. She addresses her

own eccentric, poetic sensibility in the studio. She writes songs in public that arise from the knowledge and desires she shares with everyone.

As Alexis will tell you, and Gershwin probably would too, "It's harder to do public art than to do regular art. For public art to be good, it has to solve problems but be natural enough that no one notices. It has to be meaningful enough to be beyond question, to work on a subliminal level. That's the trick." When I asked her, "Why bother then?" Ms. Smith's answer was evasive. I finally figured out that Alexis thinks like one of those gifted athletes whose talent allows them to play a game that they love—whose public works function as a way of "giving something back" for their exotic gifts. In their presence, Smith's public art is no more dumbed down than a Gershwin song. It's just witty, clear, and public.

She laid a fifty-thousand-foot terrazzo map of the world in the south lobby of the Los Angeles Convention Center, and you don't have to be a rocket scientist to realize that you are striding across the world like Gulliver across Lilliput. In the north lobby, there is a view that looks over the curve of the earth as an astronaut might gaze at the constellations and the Milky Way. Smith designed another terrazzo floor surrounding the sports arena at Ohio State University, for which she won some kind of national terrazzo award from the Italians who usually do this work. At Ohio State, the floor is scattered with images of famous Ohio athletes at more than twice life-size—so the effect of the convention center maps is reversed. At the convention center, you are a giant. At the arena, you are part of a tiny congregation in a hall of giant heroes. No science required, just a fifty-degree grayscale of terrazzo in matrixes with zinc dividers.

My favorite of all her public art is her snake path that leads through a Smith-curated forest to the steps of the library at the University of California, San Diego. Smith was given a large meadow in front of the library to work with. She created berms and seeded it, so it would grow into the arboreal landscape that it is today. A nine-foot-wide snake path twines through this forest. It is made of snake-colored, octagonal tiles in shades of ocher and gray. The path twines and curls for about five hundred feet. At this point the snake's body loops itself around an apple tree. The head of the snake lays at the foot of the steps into the library. About two-fifths of the way down the path stands a twelve-foot statue of a copy of *Paradise Lost* from the library itself with the title and Dewey decimal number on the spine.

The front of the book bears Milton's version of the snake's argument to Adam and Eve about the virtues of biting the apple and acquiring forbidden knowledge of good and evil:

Then wilt thou not be loth
To leave this Paradise, but shall possess
A Paradise within thee, happier far.

The book is an advertisement for the library. It stands as an invitation to follow the snake through an arboreal earthly Paradise to the library. The argument is at once subversive and academically undeniable. This is pure, knowledgeable Alexis Smith in her public mode. Every time I see the path I find myself trying to enumerate the accumulated sequence of world-class formal and iconic decisions that went into creating this elegant argument for undeniably heretical knowledge. I find myself thinking of Gershwin's "It Ain't Necessarily So" from *Porgy and Bess*.

To infer just what kind of creature Alexis Smith might be, however, I must turn back to the artist. In 1989, Ms. Smith and the poet Amy Gerstler collaborated on a book called *Past Lives* (Santa Monica Museum, 1989). It was accompanied by an installation that contained rooms full of children's chairs, little historical objects that Ms. Smith had accumulated from yard sales over the years. On the walls, there were photographs, blackboards, and schoolroom life-narratives. The accompanying book contained paralleled information. Birth announcements juxtaposed with obituaries and short narratives of the artists' lives. Here is the biography Amy and Alexis made up for Ms. Smith.

Alexis Smith

A FICTIONAL BIOGRAPHY, *or* "THE STORY OF THE CENTURY"

CHAPTER 1

"Is it to be the Chaste Madonna, or the Messalina, or the Magdalen, or the Blue Stocking? Where can I find the woman of all these adventures?"
—Isadora Duncan, *My Life*

Social historian with a pastepot. Irony-edged archivist of the vernacular. Nurse Smith, aka cultural temperature-taker. Magician who can coax objects to throw their quavering, half-throttled, or overbold voices across great distances, i.e., the expanse of the fruited plain. Distiller of disillusionment, long-potent but sippable visual moonshine, with a marked emo-tional undertow. Ele-gant pack rat. Sharp-eyed scavenger. Someone who finds herself facing herself, seated on both ends of the romantic/anti-romantic seesaw. Ms. Smith, concert synthesist, tickler of the ivories of the unexamined American conscience. Slang-slinger. Chandler-ologist. Reliable girl-reporter taking down heartfelt eyewit-ness accounts in a unique mixture of long- and shorthand. Al Smith, Inc.: road signs collected, curios resurrected, & clichés dissected While-U-Wait. Her oeuvre is the rearview mirror in which the USA, en route to who knows where, frequently checks her freckling complexion.

[Just who is this Alexis Smith? Here are some of the by now old-hat responses to this much-asked question.]

Alexis Smith, *A Fictional Biography, or "The Story of the Century": Chapter 1*. From *Alexis Smith*, by Richard Armstrong (Whitney Museum of American Art, 1991).

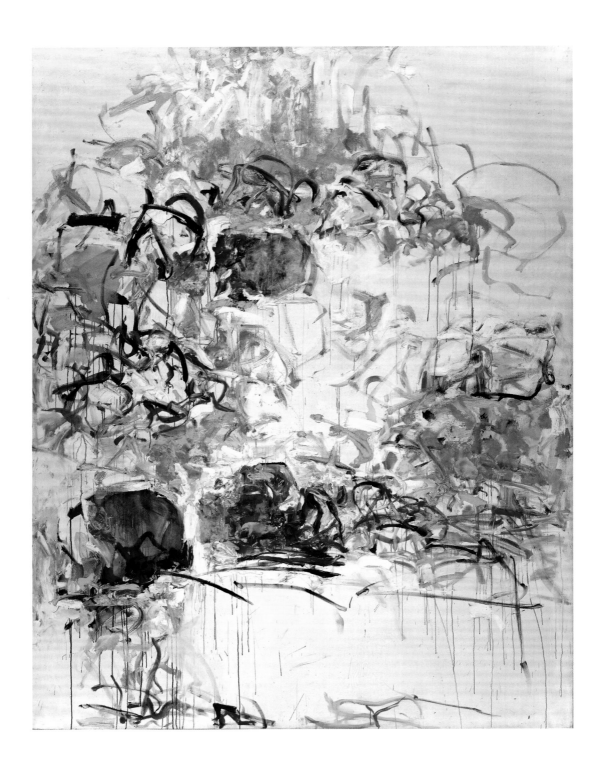

Joan Mitchell

Epigrammata

I hate and love. Perhaps you're asking why I do that?
I don't know but I feel it happening and I am racked.
—CATULLUS

This is my position: In the last ten years, nothing has gotten better but mobile phones and Joan Mitchell's paintings. In Mitchell's case, I am not alone in this belief. I have admired Mitchell's paintings for as long as I have admired paintings. They are better now, greater even, and infinitely more powerful. I suspect that they are the best paintings of her generation. Her late-blooming vogue is undeniable and all the more amazing in a period during which abstract painting may be said to have lost its raison d'être. So why have Mitchell's paintings not lost theirs? Fresh eyes and new diversity in the marketplace is an obvious surmise. The blessing of not having to deal with Joan would be another. The decline of gender victim criticism could also be a contributor, along with the tedium of our overexposure to the rest of her crowd. For me, however, it is far more likely that Joan Mitchell was never *one* of that crowd at all, and the changing times have torn away the veil of our outdated expectations.

Looking at Mitchell's paintings today, it's almost impossible to reconstruct what we once thought that we *should feel* when we looked at paintings by Mitchell's generation of painters. Even so, it is easy enough to recognize that you are feeling something more and something other than you were taught. So, today, Mitchell's paintings feel newer and more available. They manifest a detailed emotional intricacy that, in years past, I suspect, manifested itself as a kind of visual static that one associates with Tiepolo's

Joan Mitchell (1925–1992), *Sans Pierre*, 1969. Oil on canvas, 102 1/2 ✛ 78 1/2 in. (260.4 ✛ 199.4 cm). © Estate of Joan Mitchell. Courtesy Cheim & Read, New York.

drawings, so they failed to comply with our grandiose expectations. Today, although they tell no stories, Mitchell's paintings seem to arise from specific emotional occasions: from a terrible argument in a beautiful kitchen, ecstasy in a dark city, disappointment on a warm afternoon. Primarily, they forsake expressionism for industrial strength anxiety.

This is not to say that the things we once saw in Mitchell's paintings are not there, they are. I only want to suggest that there is more—that if we look at Mitchell's paintings plain, without attributing redeeming virtues to them, they evoke an array of feelings that fall well short of the sublime. So, if we only seek sublimity, as many have, the idiosyncratic, angry virtue of Mitchell's paintings is transformed into a vice. For years we pretended not to notice that, along with the joy, the grace, and the ebullience, there is pettiness, panic, recrimination, jealousy and contempt, and naked self-hatred. The effect of feeling these small, sharp, human emotions while you're looking at an abstract painting takes some getting used to, but they do seem to be there in Mitchell's paintings and this friction distinguishes them from the paintings of her peers and inheritors.

Consider this: Mitchell's sunflowers bloom for us in their glory, singly and in floral banks. They reward us in the fullness of their moment, which is not much longer than the painter takes to reimagine them, but they die dead. Mitchell insists that they do. They decay into weeds and sticks. They don't swoon or wilt in elegiac tristesse, like Victorian maidens, or submit themselves willingly to "The Great Cycle of Life." They turn ugly and forbidding, rot and burn away. This would be the irony: that the longevity of Joan Mitchell's paintings might be attributed to the fact that she believed in death—and life, too, perhaps, but nothing else, nothing with a capital letter: not Painting, Art, Genius, Heroism, History, America, Patriotism, True Love, Doubt, or even Nature as it is romantically conceived. I do not offer this suggestion lightly. After thirty years of looking at Mitchell's paintings, the attribute that defines their bitter glory best for me is their uninflected atheism, which is not the atheism of one who has forsaken God but of one who never thought to imagine that we were anything more than lonely creatures on a big planet.

My insistence on Mitchell's naked atheism, however, is not intended to add another layer of interpretive obfuscation, but to strip away a few layers of exegesis and obfuscation. The only way I can think of to describe the

clear zone of nothingness that surrounds Mitchell's handmade objects is their fierce resistance to anything like an aura. Their plainspoken unbelief aligns Mitchell in my lexicon with no moderns save Albert Camus, Henry Miller, Samuel Beckett, and Nathalie Sarraute, whose *Tropismes* might be written notes on Mitchell's paintings. I had only to step over to my shelf of Latin verse, however, to find a compatible and equally turbulent comrade-in-arms for Mitchell in the poet Catullus, the Latin master of the bitter, personal, meticulous epigram. Catullus writes in bundles, in tight interactive overlays of metrics and euphony, focused down on real people and singular events. Joan Mitchell, I suspect, shares this penchant, along with Catullus's crisp mix of tenderness and invective, his longing for fame before eternity. As a poet of words, Catullus doesn't sing and snap in English as he does in Latin, but here is Catullus in love:

> Do you believe I could have cursed my life
> Who is more dear to me than both my eyes?
> I could not. If I could, I would not love so desperately.
> But you and Tappo engage in every monstrous act.

Here is Catullus in anger:

> What riles me is that your disgusting spittle
> Has piddled on a pure girl's purest kisses.
> You'll pay for that. Every century shall know you,
> And my fame in old age will tell the world what sort you are.

Here is an epigram of Mitchell's from the dinner table:

> Twenty five years in France, because he loved it,
> Because that was what women were supposed to do,
> Then he ran away with the dog-sitter.

I met Mitchell once, shared a dinner table with her two or three times, and that was enough for me. She was not one of them. She portrayed herself as a woman among men, she was more of a lioness among wildebeests. She told a good bawdy joke, argued like a highwayman, and I recognized my own mom in Mitchell's towering rage and energy, and I knew that these attributes are best admired from a distance. Even so, Mitchell wore the immense charm of her undeclared privileges like a crown of thorns:

the privilege of money, education, talent, courage, and athletic grace—all of which would have served her better if she were a CEO, or a congress-woman, or competing in the Olympics. As an artist, there is not much to be done with privilege but to abuse it: to push one's talent out to the point where it betrays you—to challenge one's physical well-being until it lets you down—to berate those drawn to your charisma for their childlike in-comprehension until they finally turn away.

That said, the most impressive thing for me about Mitchell as a person and a painter has always been her physical poise. She exuded the perpetual awareness of gravity that dancers and athletes share, the bodily knowledge of our mortality. She stood on the ground, firmly—a living creature in the physical world—born ready, fierce, and up for a fight. You knew that a lot of things were easy for Joan Mitchell. You also knew that this facility probably drove her crazy. In her time, Mitchell was a gestural painter too skilled to be ignored but too singular to be "original." Her manner is at once too varied and too specified ever to be "a style." She could make any mark but she never fell in love with one, just with the speed of it. Moreover, her marks are painters' marks, not écriture; she never writes; she makes the marks that block out writing. Beyond her affection for the "tangle," an epigrammatic form, she never falls in love with any shape or any default configuration in the rectangle.

The truest measure of her gift, however, and of Mitchell's confidence in it, is that she never does the boring parts. She never deigns to "fix it up," to engage in the tedium of color balancing, formal counterweights, or fill-ing-in spaces. She approaches the blank canvas as Rubens might approach a history painting that has been brought up to form by the painters in his atelier, hitting it here and there with the white, the rose, the lapis lazuli, adding the magic bend or flow. Mitchell dispenses with the atelier. She only makes the master's marks. She only does the magic, and, by any measure of courage and talent, Mitchell is better at painting than any of her contemporaries. She was willing to abandon her facility, of course, but she was also willing to prove it.

Anyone conversant with the pride and petulance of improvisers—of painters, jazz musicians, and bel canto singers—will recognize, in Mitchell's late fifties paintings, her sly suggestion that de Kooning is painting with the wrong hand. In the early sixties, she would out-Guston Guston al-

EPIGRAMMATA

most as an afterthought, and overwhelm Bradley Walker Tomlin in a flurry of loose, perfect floral gestures. She would wait until Hans Hoffman was dead to embark upon her deconstruction of his practice, and wasted valuable time arresting the push and the pull. Admittedly, she never touched Pollock and Kline. Once, at a dinner party, Mitchell claimed to find Pollock's paintings tedious and overplanned, but Mitchell said many things at dinner parties. As for Kline, she liked him, found him a big teddy bear, and probably didn't take him seriously at all as a competitor.

About her own paintings, Mitchell preferred them before the "blah, blah, blah" was poured all over them, and a lot of "blah, blah, blah" was poured—some of it by Mitchell herself. Fortunately, critics believe their eyes. Having seen Mitchell's paintings and Mitchell herself, I think we have to admit that when she was calm, sober, insecure, and stranded in the light, glancing away from the camera, with nothing but a cigarette for moral support, she lied about her paintings. She said all the things that a female artist of her generation was expected to say, because she never really expected that anyone would understand except in the act of looking.

Mitchell talked a lot in interviews about "big Joan" who lived in the world and "little Joan," who lived in the studio, whom "big Joan" protected. To which I say, "Oh please!" The idea of this spiritual, natural-loving Tinker Bell lurking behind Joan Mitchell's power and presence is ludicrous. So, trust me, "big Joan," rowdy and fearless, made the greatest of her paintings, while "little Joan" stood by insisting that she make them beautiful—an important contribution on its own. Big Joan got into the same car that everyone else did and drove it in the opposite direction, back toward the hard, Godless specifics of living; and as a result, the aspirational, romantic blah-blah-blah that drowned her contemporaries' paintings drained off Mitchell's like water off a duck's back. She was not one of them. Fashions in spirituality and romance come and go, but the facts of living and dying do not.

So it helps me to think of Joan Mitchell's paintings as classical epigrams that intertwine the light and dark, the petulance and grandeur—that arise from the daily fret of living and breathing: from the aroma of fresh bread and the annoying habits of the dog-sitter (that preening bitch!), made one in a flurry of marks. Only an intense belief in death after life, it seems to me, could have elevated Mitchell's gargantuan annoyance

and depression into such a substantial body of work. As John Ashbery remarked, when asked about his own prolific output: "Oh, it's just like TV. There's always something on." There is always something on, as well, in Mitchell's seamless flow of domestic circumstances as it moves toward closure. Those who work at art like a day job, or wait for grander sources of inspiration, have no access to this realm. They never make so many lovely drawings while taking a break between paintings, or so many lovely epigrams while taking a break between cantos. Nor will these artists' deaths invest their paintings with so much hard-won liveliness.

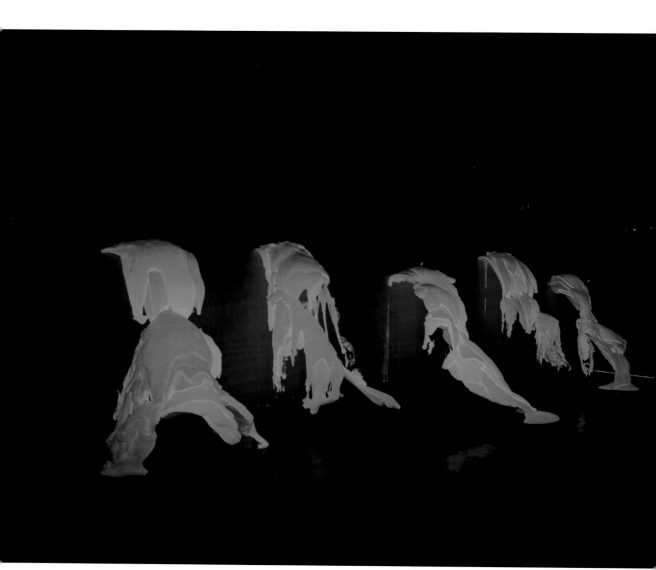

Lynda Benglis

Fire on the Water

Lynda Benglis's early work, from about 1966 to 1974, is divided into four rough groupings. She made lozenge-shaped, vertical wax landscapes by applying one layer of wax over another and changing colors at every level. Each layer of wax exacerbated the irregularities in the previous layer. The accrued levels gradually rose into to a geological landscape. Benglis's process, as Kenneth Price remarked, was like making surfboards exactly wrong, and it was. Benglis also made flat geographic pours that covered floor space with geological maps in nongeological colors. The inference was that these pours were color-field paintings "made right" by remaining horizontal in the position such paintings were painted, thus her *Odalisque (Hey Hey Frankenthaler)* in 1969. Lynda thought of the pours as mementos of her home in Louisiana and the multihued oil slicks on the bayous. Benglis also created urethane lava flows gushing from walls like ballast gushing from an oil platform. They were poured then allowed to rise and harden like biscuits, sometimes guided by armatures, sometimes not. Finally, Benglis made racy photographs, "advertisements for herself" that insisted on the erotic subtext of all her work. Today, looking back, Lynda seems to be standing naked with a dildo in the gathering dusk of the last moment that "the artist as kinky pinup" might seem like a fun, sexy thing to do.

I was part of the downtown scene when Benglis created this work and often at the loft she shared with Klaus Kertess and a wonderful Agnes Martin, so what follows is less art history or criticism than a critical memoir designed to argue that the vein of practice Benglis opened up was richer and more logical than the route followed by artists of that time who were responding to seismic shifts occasioned by ideology, journalism, educa-

tion, patronage, and real estate. At this time, the "civilizing" influence of university lifestyles and government largess was making inroads into the badass erotic cauldron of a downtown culture that was old school but still too young. Artists who had been to "graduate art school" were arriving in SoHo in droves, bringing with them the shopping habits of the upper middle class. A superstructure of nonprofit foundations, elite universities, and governmental patronage was fitting itself around that world like an exoskeleton. The prices of property and issues of propriety were suddenly at stake. Continental theory and Marxist politics were reordering and refocusing the improvisational hedonism of underground America.

Painting was still the bête noire and minimalism was stumbling around like a mammoth with Alzheimer's, with no memory and no future. Lynda Benglis, however, understood that an artist in the Western tradition might slay one's parents with impunity. (Warhol and Judd, in this case.) This was one's obligation as a young artist. To slay one's *grandparents*, however, to slay de Kooning and Frankenthaler too, would obliterate a genealogy and it did during the ruthless aesthetic cleansing of that period. Be that as it may, the aesthetic obsessions of this period were "process" and "materials," but nobody talked about them. They were presumed to be proprietary, so everyone talked tactics. To convey a sense of that time, here's an evening in the early seventies—something like an elementary-school performance of the first Thanksgiving.

The critic Peter Plagens, myself, and a group of sculptors were wandering around the SoHo opening of a Barry Le Va scatter-piece. As we surveyed Le Va's receding plane of dispersed objects, Plagens said, "The floor is the new wall."

"How could the floor *not* be the new wall?" I said, "After thirty years of the biggest market for the biggest paintings in the history of the world. *There are no walls anymore*."

"There are corners, though," Plagens said. "And Judd does walls. Otherwise, you want a narrow Noland to fit over the couch, or a tall, skinny Olitski like Dave's that will fit between brownstone windows." I mentioned that Bob Smithson thought the idea of the floor as the new wall was hardcopy landscape painting, that it was sissy and too minimalist. "We should be saying that the earth is the new sky," Bob said one night at Max's.

"This is beginning to sound like the Hudson River school from a weather balloon," Plagens said.

"This is the natural consequence of treating the floor non-architecturally," someone else said.

We ran into Barry Le Va. He didn't say anything. As we moved on, a young woman whispered to me, "Can you really sell this stuff?" I reassured her that, in the New York art world, you could sell *anything*. The Australian dealer Max Hutchinson once insisted to me that anyone who couldn't sell a handful of air with an idea in it didn't deserve to call himself an art dealer.

This scrap of watercooler chatter demonstrates the complexity of issues befuddling artists at this time. The burgeoning logic of postminimalism led toward industrial materials newly adapted to the ends of art. The new art embraced a cult of fractal, chaotic, noncyclical nature. It led away from the sixties habit of using new materials in the formats that referenced the uses for which they had been intended and subverted them, like Warhol and Chamberlain. It led away from the "natural look" of Sierra Club nature, and in the midst of all this *mustn't do this* and *must do that,* one has to admire the subversive grace of Benglis's solutions. Her artificial materials, artificial colors, and natural forms evoked the sixties melted into lava, like the scat from cartoon animals in Jellystone Park. Add to this the corners she seductively articulated, the faux-naïf candor of her color-field paintings left on the floor, and the New York School drips gushing out of the wall—as if Benglis had built a room inside her body and the walls were giving way to the physical pressure. All these organic intrusions were frozen in their gravitational fall, and in the 1980s Robert Gober would pick up on Lynda's device of using the wall as a cultural guillotine to celebrate another nature over another culture.

All of these maneuvers constitute major innovations that were at once too simple and too complex for theory and pedagogy. One lesson to be learned from this work was that Lynda could do it and you couldn't—Twombly did it and you couldn't, or Rauschenberg did it and you couldn't, or, more recently, Robert Gober does it and you don't dare. In their own defense, Benglis, Rauschenberg, and Twombly sited the visual roots of their works in the riotous swamps and tangled profusion of the American South—in the puddles, vines, goo, cypress roots, and mushroom balconies. This should have helped professors understand, but it didn't. All

these artists broke rules that professors were loath to admit *were* rules. In an age when revolutionary professors were seeking art with the utility and longevity of a crowbar, it was hard to justify art that aspired to the longevity and mystery of the Everglades.

As a result, to this day, Benglis's work from this period has not been allowed to mean what it meant. Benglis took the regimen of "procedures and materials" from the generation of artists who invented it, and, using their own rules, turned it against them with a flirtatious smirk. Benglis took their ideology, added steroids, and let it bubble up. Postminimalists imposed a reign of chastity; Benglis countered with profligacy and promiscuity; she opened up a hundred roads that were never taken and should have been. Even so, taking these transgressions into account, Benglis work was undeniably dominant American art in this period—the articulate consequence of a narrative that runs from Burchfield to Pollock to Frankenthaler to Warhol—a powerful demonstration of *logos* in the service of *eros*—of nature without romance and sex without sentiment. The rest of this essay could easily be a catalog of the mistakes she didn't make, and lessons we didn't learn.

As a friend of mine remarked at the time, foreshadowing the dildo photograph, "If she'd only been a guy, it would have been less intimidating."

But she wasn't a guy, and I should note here that, contrary to urban myth, male artists have always been welcoming to female artists—except for artists like Lynda Benglis, Hannah Wilke, Bridget Riley, and Joan Mitchell whose effortless talent and erotic charisma scared the hell out of everybody, women included. In these cases, the gender insults were never about gender. They were always about sex and talent, in combination, as an unfair advantage. I remember one of Benglis's detractors sending her back to the kitchen like a maid: "She isn't *making* art, she's *cooking* art!" Such cries of indignation at the culinary (read painterly) privileges Benglis granted herself prefigure those of Puritan feminists a generation later. The controversy over Benglis's dildo photograph prefigured the controversy over Mapplethorpe's "X Portfolio" a generation later, by which time the damage had already been done.

Thus, not surprisingly, the first major moment in Benglis's career was submarined. She was chosen to participate in a 1969 exhibition at the Whitney Museum from which she felt compelled to withdraw her work at

the last moment. Marcia Tucker and James Monte curated the exhibition, *Anti-Illusion: Procedures and Materials*. It included Robert Ryman, Barry Le Va, Robert Morris, Richard Serra, and other artists of that ilk, along with Benglis, who was the youngest artist in the show. The idea of the exhibition, in Carter Ratcliff's phrase, was to celebrate "the meltdown of the minimalist object." On the street, it marked the advent of what we called "stuff art"—the era of the general noun, like "dirt" or "snow" or "lint." Unfortunately, the curators of *Anti-Illusion* and many of the artists in the exhibition felt that the minimalist object should not melt down quite as gorgeously as Benglis proposed.

This problem arose when Benglis, in the process of completing her pour piece, responded to the Whitney's black floor by adding hot green and Day-Glo pink to the palette of her piece. This added an element of color to an exhibition otherwise devoted to white, black, and shades of industrial gray. This was, of course, an outrage! Wrists were slapped to foreheads. Muttering and wall kicking ensued. So much so that finally, in a classic demonstration of the "mission creep," the meaning of "Anti-Illusion" was expanded to mean "Anti-Color," because except for its colors, Benglis's piece conformed perfectly to Tucker and Monte's agenda.

Negotiations ensured. Finally the curators suggested that Benglis's piece be moved downstairs and installed on a ramp. This destroyed the rhetoric and reading of Benglis's Frankenthaler/oil slick. So Benglis withdrew her piece. She probably shouldn't have, but she was young and a haughty southern bitch. Today, this all sounds crazy and mean, and it was, so you'll have to trust me that it really took place. And why? Well, you see, colorlessness, at this moment, was hilariously presumed to be the color of thought and intellect—black and white being the palette of écriture. This delusional premise meant nothing, of course; it was only a beard for the real reason. The simple truth I heard from a booth at Max's was that this girl, this young upstart, this cutie-pie, had outfoxed them all. She had executed a perfect Warholian maneuver. She did it exactly right and got it exactly wrong, and, the times being what they were, Benglis's impudence was not allowed to stand.

Today, I like to imagine the consequence of Benglis's piece actually appearing in this exhibition. She would have been its star by default, having stirred controversy before the fact. As a consequence, the ambience

of gravitas and Puritan asceticism would have been lightened to the point of being giggle-worthy. The new school would have become old school. The underground mandate of absolute permission would have been confirmed and celebrated. The underground adage of "Hey, why not?" would have mitigated the power of ideological exclusion. But this *didn't* happen, and to this day I suspect that if Benglis's early works had been recognized as the simple and self-evident alternatives they were—had Eva Hesse and Bob Smithson not died—had Hannah Wilke possessed a somewhat firmer grasp on reality—the American underground might have survived, and we would be looking at a different and more variegated world. We could have rid ourselves of the nineties in the seventies.

All of Benglis's work from this period points away from the chaste academic mainstream toward which Augustan minimalism and postminimalism aspired and might have mitigated the attention minimalism commanded for thirty years—about twenty-five years more attention than any art movement deserves. With a brighter, looser, sexier, and more profligate idiom at play in the discourse, the underground would have been better insulated against academia. This didn't happen but it could have. Bob Smithson and Eva Hesse share as much with Benglis and Wilke as they do with Nauman and Serra. But Smithson and Hesse died, and the eight years about which I am writing became a long, slow escalator ride up into the realm of mainstream Ivy League values. The underground died as consciousnesses were raised. Those of us who chose to defend the underground could look over at a long line of aspiring young "art professionals" moving upward into jobs with medical and benefits.

This was a major sea change. Since the end of World War II, the American underground had been a dumpster load of indiscriminate trash and a powerful force in American culture. It provided a clear conduit from the crazy bottom to Holly Solomon, Sam Wagstaff, and Baby Jane Holzer at its libertine top. The entrance requirement for this underground was some stigmata, any stigmata: a motorcycle, schizophrenia, homosexuality, exhibitionism, manic-depression, drug addiction, anorexia, promiscuity, crossdressing, poor impulse control, leather clothing, a European title, or, like punk rock, some fantasy of grandiosity borne across the bridges from the boroughs. Even so, by the end of the seventies, the underground was dead. Outsider solidarity had been balkanized. Bikers, schizophrenics, homosex-

uals, exhibitionists, manic-depressives, junkies, anorexics, cross-dressers, and sex maniacs had been sorted out into their own identity groups striving upward toward public recognition of their "normalcy"—as if normal had ever helped anything. By this time, a substantial segment of America's best artists had joined a diaspora into the wilderness: Don Judd moved to Marfa; Bruce Nauman to moved Galisteo; Ed Ruscha stayed in LA; Rauschenberg, Chamberlain, and Rosenquist moved to Florida; Ellsworth Kelly to Spencertown; Agnes Martin, Ken Price, and Larry Bell to Taos; Benglis, Sherry Levine, and Judy Chicago ended up in Santa Fe. I went to Nashville and played guitar just like Mick Ronson.

By then, we had what we have now, an art world without heroes or mentors and a surfeit of hall monitors. The plague of AIDS, herpes, and heroin in the early eighties thinned the population of art citizens predisposed to take risks even further, although safe never bought anything but social security, and sadly, in retrospect, Lynda Benglis's dildo photograph now stands as a good-bye to all that. At the time, on the street, the photograph was a great, serious joke, a confirmation of Benglis's bodily agenda, a slap at the male egos with whom Benglis contended, and an acknowledgment of the androgyny toward which the art world had been tending since the Trial of Oscar Wilde. It was also a show-off, a "look at this and just die" glimpse of Benglis's body. If her bravura seemed invulnerable to criticism, it wasn't. It teased a new order of authoritarian Puritans out of the closet, writing for *October* magazine. It sent the remnants of the underground into the wilderness, but this doesn't mean that Benglis wasn't *right*. She was right from jump street.

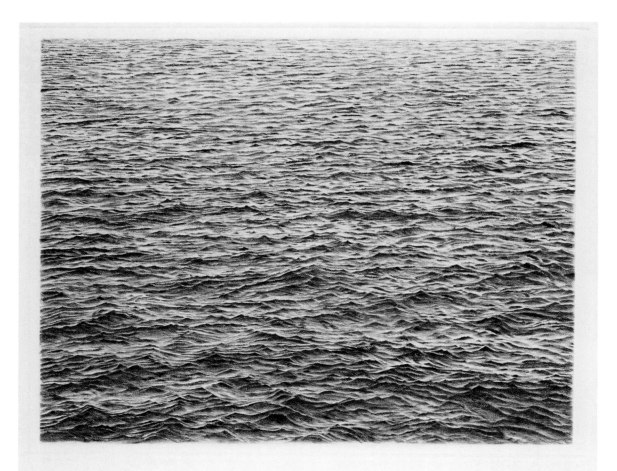

A.P 3/12 V. Celminš

Vija Celmins

The Path Itself

History is always written from a sedentary point of view, even when the topic is nomads. What is lacking is a Nomadology, the opposite of a history.
—GILLES DELEUZE AND FELIX GUATTARI, *A THOUSAND PLATEAUS*

You cannot travel on the path before you have become the Path itself.
—GAUTAMA BUDDHA

According to Bruce Chatwin, there are two hotels in Djang, Cameroon. There is the estimable Hotel Windsor and, across the street, the Hotel Anti-Windsor. Chatwin simply inserts this notebook entry into the text of *The Songlines* and doesn't explicitly relate it to the discussion of nomadic cultures in the midst of which it appears, but his implication could not be clearer: If the names of these venerable hostelries mean *anything*, then the residents of the Hotel Windsor would certainly be tourists, refugees, or colonials—taking shelter under the signifier of their lost or absent homeland—while, across the street, in the Hotel Anti-Windsor, the residents would certainly be nomads, in the broadest philosophical sense—profoundly at home under the banner of negated centrality.

Chatwin's observation provides the armature for further elaboration—a little narration of Vija Celmins's early days, rendered here in the mythic manner of Jacques Tourneur. So I offer this little film noir treatment of Celmins's early progress: Music precedes the images, a European folk melody, faintly liturgical and in a minor mode: then, in gorgeous black-and-white, we catch idyllic glimpses of a Latvian childhood behind the credits—a little girl and her mother sit by the Bay of Riga. They wig-

Vija Celmins, *Drypoint–Ocean Surface*, 1983. Drypoint on paper, 186 + 239 mm. Collection Tate / National Galleries of Scotland. Courtesy of the artist and McKee Gallery.

gle their bare toes in the water, watching the mild wavelets disappear into the mist; then, suddenly, a sequence of quick cuts to the oncoming Red Army—explosions, low-angle tanks. Cut back to the idyll. Then back to the Red Army and dissolve into Brechtian procession of the refugees in smoky silhouette. A door is flung open. They have arrived in Esslingen under the blanket of the Allied bombardment; first the Russians, then the Americans, more explosions, the roar of bombers, newsreel footage of buildings disintegrating followed by crane shots of the cold, quiet, ruined city. A schoolgirl, with books under her arm, picks her way through the fallen masonry on the sidewalk. She and her friends play soldier in the rubble. She sits, self-absorbed, in a ruined choir and sketches.

Then, as the credits conclude, we cut to a broad, tropical boulevard awash in morning light. We see her arriving, alone, on the riptide of history. She hauls the baggage of her past up the steps of the Hotel Faraway through its whitewashed portal. From our position in the bright street we can just make her out in the lobby. She is standing at the desk, checking in. Then we are inside a large, somber room with stucco walls; it is full of deep shadow and light slashing through venetian blinds; we hear a key turn in the lock and, as the camera pans toward the sound, the door swings inward and we catch a glimpse of Vija Celmins standing in the door frame, half in shadow, her luggage on the floor beside her.

There follows a time-montage of the years she spends making paintings in this somber room in the Hotel Faraway. She begins angrily, in the expressionist style of the day. She gets good at it and quits in disgust; she looks around her then, and paints what she sees—the lamp, the hot plate, the television set—ominous gray paintings that resonate with dis-ease and anomie. As an antidote to these apparitions of the haunted present, she re-creates talismanic objects from her lost childhood with astonishing verisimilitude, most larger than life, realer than real: her comb, her pencil, her erasers. She places them around the room, leans the comb against the wall.

Then she is sitting on a chair, elbows on knees, silhouetted against the bright window. She is apparently surveying the work she has done to date—and without much satisfaction. Through the open blinds we catch a glimpse of the receding Pacific, as gray as her paintings. Then we hear a door slam and catch a glimpse of her head as she disappears down the

stairs. We see her striding across the lobby, tossing her key to the desk clerk without stopping; he catches it with a wink and a conspiratorial grin. Then we are out in the sunlight, off to the left, watching her as she hurries away from us, across the busy boulevard and up another set of broad, white steps. Finally, we see her in full-length profile, leaning against the rail as she autographs the register. She is checking into the hotel Anti-Faraway, without luggage.

At this point, the story begins—with this walk across the street into the negation of absence and loss. However we choose to characterize it, if we are to understand anything about Celmins's career, I think we must understand this odd transmutation. It is an ideological inversion, really, a change in the intellectual weather. It mysteriously distinguishes Celmins's early evocations of stranded objects from her later more intimate performances of skies and deserts and oceans. I have chosen to characterize this shift as one of status—from "refugee" to "nomad"—because of the available narrative, but just as importantly because of Celmins's persistent, nomadic alignment of "thinking" and "drawing" and "traveling"—a conflation of activities that aligns *her* with the two great celebrants of the peripatetic heart and the Gothic line: John Ruskin and Gilles Deleuze. "I see drawing as thinking," Celmins says, echoing them both, "as evidence of thinking, as evidence of going from one place to another."

Before drawing any finer distinctions, however, it helps to remember that Celmins's art, early and late, refugee and nomad, has always made a virtue of displacement and has never found a comfortable niche within the art world's sedentary fiefdoms of style and territory. In Los Angeles, Celmins's rigorous *grisaille* looks "New York"; in New York, its *haut malaise* looks "European"; in Europe, its blank capaciousness looks "L.A." It always seems to have just arrived from someplace else. "Odd" is a word you used to hear a lot, but I prefer to think of the work as having a kind of stateless foreign accent. The provenance of its proclivities is irrevocably American, however. In its reductive penchant for replicating the photographic image, its deadpan exploitation of the "artless" all-over, its nonjudgmental affection for the cosmic banal, Celmins's work appropriates some aspect of every large strategy in American art from Jackson Pollock to Cindy Sherman. Yet it never seems to be quite *there*, you know, in its pigeonhole.

Even Celmins's professed affinities seem to lose (or gain) something

in translation. She admits, for instance, to an early affection for the reductive, repetitive strategies propagated in the writings of Ad Reinhardt: "No texture, no brushwork or calligraphy, no sketching or drawing," and so on. And yet, as you try to isolate these privative and iterative qualities in the work, they always seem to cleave more closely to the grainy, hard-boiled minimalism of Samuel Beckett than to the manic spirituality of Reinhardt. Beckett says, in *How It Is*: "Always the same song pause SAME SONG." *That* sounds like Vija Celmins. Furthermore, if one wished to characterize the atmospheric shift from Celmins's early object-paintings to her later photo scapes, one could do worse than to evoke the sea change that takes place in the French novel between the malignant banality of Sartre's *La Nausée* and the cool *école de regard* of Robbe-Grillet's *Le Voyeur*, which is, perhaps, the Parisian equivalent of the transmutation I have been talking about—from the refugee heart to the nomadic eye.

Celmins the refugee is a pure creation of the historical moment, a pebble shot from under its wheel, the anointed victim of political geography and its fluid pulse. She is the epitome of displacement and loss. She is never at home except in memory. And she can never recoup her loss, because at that point, that home from which she has been expelled is lost forever. It is a receding blip in the time-space vortex of geopolitics, spinning into the past. So the refugee is not really a traveler at all but a sedentary from whom the past rushes away. She has been thrown to the edge and declared it the center, although, as she will tell you, she carries her homeland in her head, and given the opportunity to make art, she will celebrate that interiority by infecting the world about her with nameless dread and infinite longing, by building monuments of mourning to what is forever lost, or by cooking up some borscht.

Celmins the nomad, on the other hand, given the opportunity to make art, will celebrate her exteriority by *intensifying* what is always there. It is a trick that travelers learn. One begins in a state of bemusement at the oddity and eccentricity of each new location and ends in the knowledge that, when time and space move together mindfully across the plain or the page, there is no location. Location is Euclid's creature, the point of the compass, a fantasy of imperial history and geography that presumes one's displacement amidst the hierarchies of time and space—the slippage between where you are and where you feel you ought to be—like Ovid exiled

to a fishing village on the Adriatic. In the absence of these displacements, the sky, the plain, and the waters vary only in surface incident. A square foot of earth in the Arctic is indistinguishable from a square of earth in the Mojave or in Tierra del Fuego, and Celmins has the drawings to prove it.

So the refugee looks at Vija Celmins's dislocated, de-historicized performances of the heavens and the earth and the waters rushing away and says, "This is an alienating memento of *nowhere*, an icon of irretrievable loss!" The nomad, on the other hand, says, "This is a portable recapitulation of everywhere—a living document—the plane of existence intensified and made smooth by having been mindfully traversed, again and again, by having been lived in *real time*." It is a measure of spatial duration, of the number of breaths one takes to get, thoughtfully, not from *here to there*, but from *this here* to *that here*, with a pencil or on horseback, on foot or in a Thunderbird, by the extension of consciousness or by traverse of the eye.

In this sense, Gilles Deleuze characterizes nomad thought and art and travel by their tendency to generate "fields of intensity." As Brian Massumi remarks, in an essay on Deleuze, nomad thought "does not lodge itself in an edifice of an ordered interiority; it moves freely in an element of exteriority . . . it does not respect the artificial division between the three domains of the representation: subject, concept and being . . . Rather than reflecting the world, its elements are immersed in a changing state of things." Thus, nomad art, as described by Deleuze and Felix Guattari, exploits "close-range" vision (as opposed to the remote gaze) and generates "tactile" or "haptic" spaces—"smooth," complex expanses that deploy themselves laterally in fractional dimensions that glimmer between plane and volume—as opposed to the rigorous, full-dimensional volumes of "stated-thought" and purely optical space. The primary aspect of this closely scrutinized, fractal space is not unlike that of the differential equation: "its orientations, landmarks and linkages are in continuous variation; it operates step by step—desert, steppe, ice and sea—in local spaces of pure connection."

Obviously, for anyone who has puzzled over Vija Celmins's later work, these speculations about "local spaces of pure connection" and "fields of intensity" provide a context in which we might consider its more baffling aspects. Deleuze and Guattari suggest a nomadic rational for Celmins's

translation of the remote gaze into close-range vision via the modality of the photograph. Photographs supply an intellectual mise-en-scène for Celmins's meticulous articulation of coextensive but conceptually distinct haptic spaces in which the image of nature, the objecthood of the work, and the activity of the artist reflexively signify one another—thus disrespecting "the artificial division between the three domains of representation."

Most importantly, however, Deleuze and Guattari's speculations allow us to view the achievements of Celmins's later work as indicative of something more intellectually rigorous than a mere change of heart or technique. In this context, I think, the transmutation that takes place in Celmins's work can be characterized as a turning outward—as a moral recalibration of interiority and exteriority—a shift of dimension out of "history" and into its opposite. Deleuze calls this "nomadic flux." Celmins calls it "real time"—an awakening, as Joyce would have it, out of the "nightmare of history" and the dreamscape of its political geography.

But, of course, as Westerners, we are no more likely to awaken *permanently* out of the nightmare of history than we are to awaken *permanently* out of sleep. (We fight holding actions, at best, against the night—conduct rescue operations—snatch images and moments from the great teleological flow—remind ourselves that we live amidst the atmosphere, not in the world.) Further, no work of Western art is ever likely to induce anything so apolitical as a pure obliteration of history—nor would we wish it to. To presume to have banished history from an object as culturally saturated as a work of art would be like insisting that one has never thought about an elephant—and, in fact, "not thinking about the elephant" is about the best we can aspire to: that positive negation. The felicity of the trope of the "Hotel Anti-Windsor" is a signifier in which the august, historical absence of the House of Windsor is colossally present.

What I am suggesting, then, is that looking at Vija Celmins's paintings is a little more complicated than flinging oneself into the whoosh of nomadic flux. It is, in fact, more akin to gingerly disrobing for a quick, cold dip in a mountain spring. We come to the work of art fully clothed in layers of cultural expectations. I can remember, for instance, walking into an airy, white room lined with Vija Celmins's graphite deserts and oceans and immediately thinking, "Mmmm. Cézanne meets Shelley," calling to mind a quatrain from "Julian and Maddalo":

This ride was my delight. I love all waste
And solitary places; where we taste
The pleasure of believing what we see
Is boundless, as we wish our souls to be.

A few minutes later these lines seemed inappropriate, yet I was hardly
wrong to think of Shelley in this context. The aura of longing and displace-
ment is never quite affirmed, but never completely absent. Celmins's work
for all its coolness is always haunted by an atmosphere of loss, again, as
in Shelley:

See the mountains kiss high heaven
And the waves clasp one another;
No sister flower would be forgiven
 If it disdained its brother;
And the sunlight clasps the earth,
And the moonbeams kiss the sea;
And what is all this kissing worth,
 If thou kiss not me?

So I think I was *right* to think of Shelley and just as right to reconsider
his relevance, because the manner in which Celmins's drawings first evoke
sublime romantic melancholy and then negate it constitutes part of their
meaning (as does the manner of their evocation and subsequent negation
of auteurist notions of cubist space). The works exist in real time, after
all. Their arousal and subsequent frustration of romantic and modernist
expectations parallels our growing cognizance of the intervening photo-
graphs—of the frail cultural membrane these photographs seem to impose
between the plane of natural imagery and the field of the artist's marks.

Gradually, once we have "remembered" that membrane, the memory
of the photograph begins to function in our awareness as a kind of two-
sided scrim, preempting any *identification* between the natural world and
Celmins's marks, while elegantly externalizing the analogical nature of
their fractal mechanics. This burgeoning awareness, I think, leads to the
inescapable conclusion that it is the *photograph* (and not the object or the
image or its reference) that constitutes the critical *content* of Celmins's
work—and, further, that it is the memory of the photograph that facilitates

Celmins's seamless conflation of romantic iconography and modernist studio practice into a distinctly postmodern celebration of the exteriority of the image.

In a sense, Celmins brings us closer to the world by moving us further away. Her faithful replication of the photographic images of nature attenuates any comfortable modernist presumptions we might make about her work; just as certainly, our gradual realization that the focus of Celmins's activities *is* the photograph and *not* the image of nature attenuates our access to the domains of sublime romantic melancholy: however much the work seems to honor, on first glance, the romantic grail of seeing nature plain, on second glance, its subtle evocation of the photographic surface quietly but resolutely deflects any projection of ourselves through it and any tendency to subjectively "identify" with it.

Conversely, even though the cropped and focused, black-and-white photographs that Celmins uses as sources do, indeed, endow her work with the ominous grisaille, the horror vacui and the aura of romantic melancholia are deflected as well. Celmins's deadpan rendition of the photograph denies us any clue, or image or mark that might humanize the "character" of this melancholia and allow our theatrical participation in it. Consequently, whatever soliloquies the paintings might portend remain, at best, only exquisitely immanent.

Furthermore, Celmins's almost suboptical adjustment of the photographic image to the smooth plane of her work has the effect of *freezing* it, of denaturing its surface at a single level of articulation that emphasizes the blunt, single-point focus of its photographic provenance. The image seems to invite it, but we do not feel free to move outward or upward or inward into those complex fields of incident that from Turner to Pollock have signified the ominous, boundless, proliferating "otherness" of Edmund Burke's "Terrible Sublime." Standing before Celmins's drawings and paintings of the heavens, for instance, we find ourselves imaginatively immobilized by the "frozen" image and denied that cosmic expansion cited so often by Pascal as one of the proofs of the existence of God:

> Let man then contemplate the whole of nature in her lofty and abundant majesty . . . Let him behold that blazing light, set like an eternal lamp to illumine the universe; let him see the earth as a mere point in

comparison with the vast orbit described by the sun; let him wonder at the fact that that vast orbit is itself but a faint speck compared with that described by the stars in their journey through the firmament. But if our view is to stop short there, let the imagination pass beyond; it will sooner cease to function than will nature to supply him material . . . try as we may to enlarge our notions beyond all imaginable space, we will yet be conceiving mere atoms in comparison with reality.

Conversely, before the ocean and desert images, we are denied that vertiginous swoon into the microcosmic mysteries of the image that Ruskin evokes in his classic exposition of the "picturesque sublime":

What we call seeing a thing clearly, is only seeing enough of it to make out what it is; this point of intelligibility varying in distance for different magnitudes and kinds of things, while the appointed quality of mystery remains nearly the same for all. Thus: throwing an open book and an embroidered handkerchief on a lawn, at a distance of a half a mile, we cannot tell which is which: that is the point of mystery for the whole of those things. They are merely white spots of indistinct shape. We approach them, and perceive that one is a book, the other a handkerchief, but cannot read the one or trace the embroidery of the other. The mystery has ceased to be in the whole things, and has gone into their details. We go nearer, and can now read the text and trace the embroidery, but cannot see the fibers of the paper or the tread. The mystery has gone into a fourth place, where it must stay until we take a microscope, which will send it into a fifty, sixth, hundredth or thousandth place.

In the case of Ruskin's model, however, although we *are* denied that vertiginous swoon into the *image*, our peripatetic relationship to Celmins's actual works in the gallery *is* closely analogous to Ruskin's description of our approach to the open book on the lawn—that progression from distant perception of the book as a single object, then up to and *through* the image of the text to the physical components of the watermarked page; like the text of Ruskin's book, Celmins's verisimilar surfaces ultimately function as transitional signals as we move toward the image then effect a phase-shift that takes place as we are turned away from the plane of the object and into the flat field, or, in Latvian, the *pļava* of the artist's activity.

So when we consider Celmins's source photographs as *content*, it helps to remember that all the promises that Vija Celmins's work make, and consequently break, the photographs *keep*. Where else does one go but to photography for subjective iconography? Emotive imagery? Nostalgic atmosphere? Sublime Nature? Formal transcendence? Icons of personality? Atmospheric melancholy? Catalogs of loss? Communion with the dead? Certainly the artist went nowhere else in 1965 when, in a miasma of homesickness, she scoured the junk shops, secondhand stores, and yard sales of Los Angeles for evidence of her war-ravaged past—buying up "war books and tearing out little clippings of airplanes and bombed out cities— nostalgic images."

And certainly nothing other than an awareness of this pathology could have given Celmins the heart and mind, in 1965 and 1966, to forge four amazing little paintings out of that bundle of clippings—paintings that, taken together, constitute, at least for me, the real narrative of that metaphorical "walk across the street" described earlier in this essay. Each modest canvas (16 × 26 in. or thereabout) portrays a warplane in sensuous grisaille—viewed from slightly above and exquisitely situated in the rectangle. Three are American bombers, flying high and to the left—one bomber is relatively intact, one is on fire, and another is breaking up in the air—the fourth is a German plane, posed on the airstrip, facing the right edge of the canvas. (The direction of the airplanes indicates, I think, that Celmins is looking at them from the north, from Latvia. American images are viewed from the south; so Allied planes in the European theater are portrayed flying from left to right.)

At any rate, all of the airplanes seem to be simultaneously tight upon the picture plane and alive in pictorial space—immobile, dry, and inaccessible to us yet still frighteningly present in that antique moment. Thus, for the first time in Celmins's work, history stops (without disappearing) and real time takes over; and these modest paintings remain, in my estimation, four of the earliest and most courageous embodiments of an incipient postcolonial ethic—insisting as they do that however "healthy" it may be to seal off nature and the past from the neurosis of subjective appropriation, it is both damnably foolish and hysterically pretentious to distort or abolish or deny its visual traces.

Here is the distinction, simply: What makes a Cézanne Cézanne's is the

difference between the natural, historical configuration of Mont Sainte-Victoire and his painting of it. What, on the other hand, makes a Vija Celmins Vija's is the difference between the *photograph* of the ocean and her drawing of it. The prospect of the ocean at the moment that the shutter clicked remains available to us, but exterior. And it is exactly this thoughtful decorum with regard to the visual aspect of nature and *temps perdu* that distinguishes Celmins's covenant from the denial and subjective revisionism that characterize the "separate peace" with history that was negotiated by such high modernists as Matisse and Hemingway.

Finally—if a brief divagation into "Sighcology" can be forgiven—we might theorize that the photograph itself, cherished and scrutinized by the artist, objectifies her loss and subsequent desire, and that the painting made out of it *objectifies the subjectivity of the photograph,* investing it with an undeniable exteriority. In that attenuation of desire, the painting transmutes the empty loss of the refugee into the full absence of the nomad—diverting the angst of history into the intensity of real time.

In this view, the four little paintings from 1965–66 mark nothing so millennial as a personal conversation but, rather, the beginning of the artist's ongoing, mindful, physical commitment to perpetually redeeming the present. We will never awaken permanently from the nightmare of history—and we may, if we dream at all, awaken one morning reconstituted as refugees, but day after day, over and over, as Celmins succinctly puts it, "I just go into that little gray world and draw my way out." In this manner, she patiently deflects the dark rush of history as it pours out of the deep, gray mouth of the photograph—of all photographs—and resists the vertiginous gravity of the past that simultaneously sucks us back in. She turns time sideways—redirects the rush of the past into the present and our free-fall back into it—deploying a fragile veil of lateral gestures in real time across the portal through which it ebbs and flows—transforming that black hole of history into a surface—a nomadic *plain* of a thousand thoughtful traverses—a proliferating, human analogue of the slow dance of geological time.

Pia Fries

The Remains of Today

A friend of mine said this: "The earth doesn't care if it's ruined or toxic or depopulated. When it all comes down, when everything comes loose, quakes up, melts away and burns out, when the atmosphere turns to methane, it will still be the earth and it will go around the sun." With this in mind, I was looking at a painting by Pia Fries. I found myself thinking that, if alien aesthetes arrive someday on this ruined and depopulated earth and decide to wander around, like tourists at Machu Picchu, and, if they are free of memory and expectations, they will probably find the wreckage of this world and what we did to it utterly enchanting—full of terrible beauty and brutal grandeur, and if, amid the rubble, they should come across a painting by Pia Fries, they will almost certainly take it home as an unsentimental memento of the ruined planet. This is one of my ways of explaining, at least partially, a feeling I have always had about Fries's paintings, that they are the most European "American-style" paintings I have ever seen. Of all the continental exemplars of American abstraction, Fries's I think are the most knowing and cosmopolitan, the most forgiving of nature and culture catastrophically jumbled, the most tolerant of the past and present fatally blurred.

Certainly, Fries's paintings are the least innocent, the least personal, and the least pure paintings in this tradition. Their exuberance promises the comforts of expression and delivers the randomized, chemical residue of industrial culture. Their eventfulness promises narrative and delivers the end of narrative. Their fractal physicality promises the rhetoric of landscape and delivers the worldly pictorial dynamics of premodern European painting. The title of the painting *Schwarze Blumen* (in four parts) promises a pastoral and delivers an ominous serial frieze in the compositional

manner of Tiepolo with hard overtones of Goya and Baudelaire's verbal sneer. Thus, despite their physical analogies to New York School paintings, the American art that Fries's paintings call immediately to mind (to me at least) are Robert Ryman's early, brown-linen abstractions, Rauschenberg's roughest combines, and Robert Smithson's bulldozer interventions, because of their stupid courage, their physical bravura.

This boldness, I think, explains why Fries's paintings always seem intimidating to other painters, whether they like them or not. I will stand with a painter before one of Fries's works and the painter will stare enviously at a pricy, crusty, archaeological slab of multicolored paint that is part gesture, part puddle, and willfully applied in exactly the wrong place. The plain impudence of the act is so daunting that these painters shake their heads and start talking about Gerhard Richter, with whom they know Fries studied, and with whom they are more comfortable. This is a cross that Fries must bear, the early influence of a great painter, and it is not all bad, since Richter is certainly a more user-friendly artist than Fries. Even so, the two share, at best, the contiguity of ships passing in the night. They share a penchant for beginning with primary designs and painting them out, but their agendas could hardly be more different. Richter begins with what one might call "aesthetic" under-painting, a design, which he eventually scrapes down like an asphalt parking lot. Fries, in the traditional manner of European painting, begins with orderly under-painting and seduces it into chaos and madness.

Fries's debt to her maestro, then, is more contrary than informing. A generational divide separates the two artists, as it separates Fries from Sigmar Polke to whom she also owes a debt. As a German-Swiss artist she could hardly not absorb these influences, and the simplest way to explain the abyss that divides them is to suggest that Richter and Polke grew up in "crazy Europe"—in a civilization so misshapen and haunted by madness and ideology as to be almost incapacitating to an artist of any stripe. Pia Fries, on the other hand, grew up in the midst of its contra-coup—in "sane Europe"—in a culture so bureaucratically ordered, sanitized, forgiving, and well meaning as to be similarly incapacitating. So Fries's paintings come at us from a new angle, from a new place. Their manner of address is not so much messy and intense as rough and arrogant, rather in the mode of early Warhol—an artist whose early reputa-

tion, like Fries's, suffered somewhat from Andy being perceived to be a pleasant young lady.

So, the ships pass in the night between "crazy Europe" and "sane Europe." Richter will risk banality in his struggle for sanity; Fries will risk chaos in her search of some informing madness. Yet, even so, Richter's paintings remain a little disturbing and crazy, while Fries's paintings are equally disturbing in their high sanity. They are rather like Rauschenberg's paintings in this way, and the fact that we are more ruffled by sanity than madness makes Fries the more specialized taste. She asks for no forgiveness. She requires no preliminary accommodation for any presumed cultural or psychological deficit. Her paintings come at us straight and there is no way for any of us, in the act of beholding them, to achieve a moral advantage over her extravagant equanimity, especially when we come upon it in the act of breaking its own heart.

The second cross that Fries must bear is that her work is not properly "modern" or "postmodern" according to the current critical patois. To come to her painting, for instance, with some expectation of reflexive criticality is to be horribly disappointed. The search for irony or any evidence of Richter's "postmodern doubt" is equally unsatisfying. In their place, Fries proposes an aggressive condition of absolute disbelief, something closer to Enlightenment rage or, if one can forgive the oxymoron, Swiss promiscuity. From this position, Fries may appropriate the rich, mixed styles and intervening collage from her elders and effectively strip that idiom of narrative and atmospheric reference. Thus, when we come upon silk-screened flora in her paintings, when we take note of collaged fabric, we do not, as we might with Sigmar Polke, wonder immediately what they might mean. We do what we often do with Picasso: we wonder whether these additions mean anything at all, or if, perhaps, they are only formally efficacious scraps that fell to hand, or if, perhaps, Fries is teasing us with her subversive pictorial intentions.

Having said all this, it should be clear that Fries's work, which is too confident and authoritative to qualify as "postmodern," is simply too sophisticated, too tertiary and "chemical," to bear the attribution of neomodernism. Fine distinctions like this hardly matter anymore, of course. Terms like "modernism" and "postmodernism" have devolved into academic knife-rests, designed to keep the sticky off the linen, but the dis-

tinction does point to a lost attribute of modern art that Fries's paintings manifest. They have about them what Bob Hughes calls the "shock of the new"—a sense that they could not have been made at any other time or in any other place. Since narrative history is presumed to have withered away around 1968, we hardly use this phrase, "shock of the new," anymore (or its formal equivalent, "temporal defamiliarization") but we should.

The concept remains relevant because history may have stopped but time has not, and to deny "the shock of the new" is to deny that things get boring. To ignore the toxic consequences of ennui is to deny the seed from which art grows. It is true enough that, in the present, the new does not preempt the old as it once did (there are too many "sustaining" institutions for that), but it does open a door and make a little space for the kids. In a space like this, Pia Fries may dispense with Utopia and The Fall. She may provide a hedge against fantasies of "global meaning," and a dose of bravura knowingness as an antidote to being "in the know."

Most importantly, Fries's paintings deliver that quiver of cold, potential emptiness that accompanies the advent of anything new in the realm of art. We confront a work of art. We know some of the words, but we don't know the language at all, and we haven't the instrumentalities to understand what we instantly appreciate. Thus, we are assured of having something to look at tomorrow. So, for the moment, I am thinking of Fries's style as primal rococo. It is related, in my mind at least, to the great stucco church interiors that populate her geographical neighborhood, and wedded to their premodern compositional strategies. It is blended with the improvisational daring of late Picasso and enabled by the craggy, cultural archaeology of kinesthetic postminimalism. To be honest, I never could have imagined anything like that, and this, I suppose, is the whole idea.

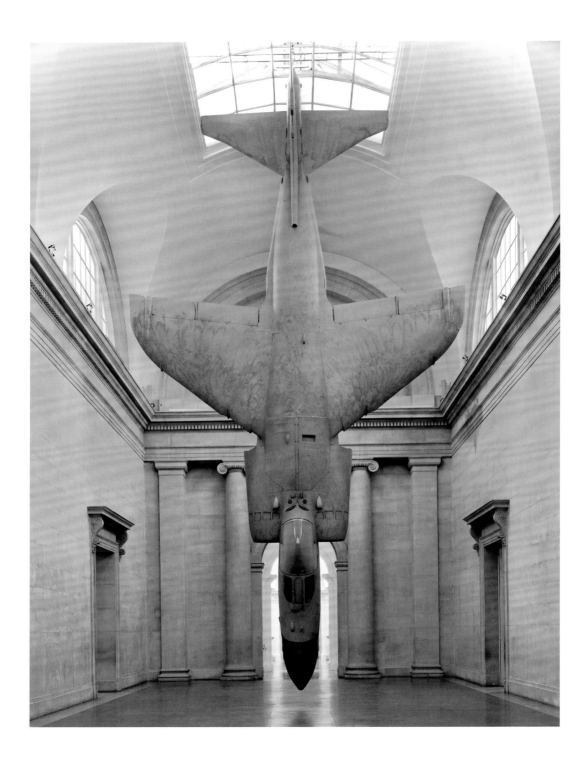

Fiona Banner

The Beauty of Our Weapons

For Fiona Banner, it's simple. It begins with predator and prey, tooth and claw—we call this hunting, unless we're being hunted; then we're dinner. Next it's predators fighting predators over prey or territory—we call this war. Then there's predators fighting predators but nobody gets killed—we call this sport, and, since everybody usually survives in sport, predators get better at predation. They come to admire its skills and its instruments. At the level of sport, refinement and craft become valued attributes, since those who don't participate, watch. We celebrate this refinement and craft with ornament. Then, finally, we celebrate the refinement and ornament of our weapons above their instrumentality. We call this art, and in this democratic sport, the winner is elected as the most desirable fruit of the poison tree.

First death, then a simple hierarchy of sublimation in which, theoretically, fewer and fewer people die in the process of daily life. The people who survive get better and better at what they do. The people who watch get better and better at understanding what's being done. So, the design adorns the dagger and the design becomes a painting. The shuffle becomes a march; the march becomes a dance; the fort becomes a castle, the castle a decorative ruin. (The Tate Modern is in fact a decorative ruin.) Renaissance

Fiona Banner, *Harrier*, 2010. BAe Sea Harrier aircraft, paint, 7.6 ✛ 14.2 ✛ 3.71 m. Courtesy of the artist. Photo © Tate, London 2014.

men develop the trigonometry of aiming cannon fire. This manipulation is inverted and deployed as single-point perspective in verisimilar painted images, and then nuanced out of it by Veronese.

Fiona Banner has taken unto herself that task of reminding us of the roots of art in war and the roots of loveliness in pornography. In Banner's work, war and pornography never disappear nor does the fraught residue of loveliness. We all feel the tug both ways. Today, we have become so safe that we try not to think about beauty anymore, lest we think of death. Conversely, we have become so fraught and anxious that we can no longer see the relevance of ornament and decoration, lest we think of death. The physical world can disappear under the threat of both eternity and oblivion. Fortunately, we do die, and everything teeters on the edge of predatory advantage. Ornamental layers are nested like Russian dolls, with death at the center. Without Tate Britain, and the fine manners of Georgian architecture, there would be no new predators like the fighter planes Banner has installed within it, the Jaguars and the Harriers, and no connection between Georgian architecture, the predatory aircraft and the natural predators whose designs they have appropriated.

So I started wondering what would have happened if these airplanes were installed in Tate Modern rather than Tate Britain? I realized immediately that the thought would never have presented itself. The building and the aircraft are not rhyming artifacts. In the Tate Modern's stripped out, sexless, denaturalized environment, they would fit but they would not speak; they would risk becoming yet another progressive-minded repudiation of the roots of industry in conflict. Tate Britain, on the other hand, invests the aircraft with the vocabulary of its design, and the aircraft invest Tate Britain with the aura of worldly power that it once possessed. Place the aircraft in Tate Modern and nothing would happen. The building would be overpowered; it would be a hanger, an accessory, and a pragmatic umbrella to keep the rain off the machines. There would be no conflict, no confrontation, and no power struggle.

The function of the planes and the museum is interesting: the fighter planes have the rather pointed attribute of being able to fly and blow the shit out of everything. The Harrier, the Jaguar, and Tate Britain celebrate national life. They are fully evolved and refined artifacts in aid of blowing the shit out of everything. They each have a past and a future. They

each hold a position in the narrative of evolving modernity, curvilinear and streamlined to emphasize the motion of historical time. In fact, if you gave Palladio, with his skills as a stone mason, a large chunk of granite, a chisel, a hammer, and some heavy timber-rebar, he could knock out a very sleek and persuasive Jaguar in a couple of weeks, since the plane's shape accommodates itself to his vernacular. The plane wouldn't fly, of course, but neither do Palladio's angels. The dream of flying would still be there.

The most crucial aspect of Banner's installation, then, is the "fit" of the objects together. Tate Britain and the fighter aircraft nestle symmetrically into and around one another because the aircraft and the building are both based on the scale of human beings. They have undergone manipulations to perform their separate functions, but they are human at their core. Like the Sforza galleries displaying armory in Milan, the rooms and the weapons seem to recreate the ghosts of warriors. The fighter planes are as small and streamlined as they can be to carry their armaments and their pilot; their shapes are extensions of the pilot. The Duveen Gallery is in the Palladian tradition. It is as large as a space can be without diminishing the scale of its occupants, which would be churchy, collectivist, and impolite. In this sense, both the building and the planes use the human body as a building block. As a consequence, human bodies fit rationally into the space and around the objects.

At Tate Britain, the bond between weapon and ornament remains unbroken. History, form, gesture, and direction are all an essential part of their armature. So the instruments of grandeur and death rather ominously cuddle up to one another. They rhyme like lines in some imperial epic, and this is unnerving. By letting them cohabit, of course, we acknowledge that it's all about death. If we were all immortal, of course, we might make some very beautiful things, but why would we?

As it exists, Banner's installation is an intimidating work of art and a sleek cultural aperçu.

Sarah Charlesworth

Embracing the Beast

There is a framed photograph made by Sarah Charlesworth on the north wall of the corner room where I am writing this essay. I installed it a few years ago because it seemed an appropriately anxious and seductive image for a room in which writing takes place. It is all the more appropriate today, of course, because I am writing about Sarah Charlesworth's art. The photograph is entitled simply *Text* (1994), although it might just as easily have been entitled *The Pleasure of the Text*—after Roland Barthes's text to which the image alludes—or *The Mysteries of the Text* or even *The Anguish of the Text*, because all of these elements are in it and the image insists on all the fluttering anomalies of writing and reading and seeing—all the questions that cannot be answered when one writes about the world of not-writing.

Questions like: What am I actually *doing* as I move my fingers over these computer keys from which, over the years, the letters have been worn away? And where, exactly, am I doing it? Is all of this transpiring in my head? In my fingers? On the screen of my little laptop? Or in *your* eyes as you read these words? Or in my eyes as I read what I have written? And what of this so-called subject? Does it somehow inhere in the detritus scattered across my desk: the silver discs, the yellow legal pad lined with notes in black ink, the Xerox offprints bloody with red Magic Marker, the old *Arts* magazine open to an essay on the artist? And how do all these disparate occasions conspire toward an outcome? Or is there any outcome at all, beyond the accretion of an additional level of encoding?

Charlesworth's *Text* is a black-and-white photograph (as a text is black and white). At first glance, it seems to portray a cropped and horizonless landscape of glossy white satin, viewed from a high angle, with the cloth

Sarah Charlesworth, *Text*, 1992-1993. Gelatin silver print, 26 + 31 in. Courtesy of the Sarah Charlesworth Estate and Maccarone.

gathered here and there into mountains, valleys, and ridgelines. On second glance, we see that the landscape features of the satin arise from the presence of a book that lies open beneath the surface of the cloth, and we notice that the cloth is not only reflective but apparently translucent, as well. Lines of text are just visible on the surface of the fabric covering the exposed pages; it is unclear, however, whether these lines are printed on the pages of the book, on the reflective cloth, or, even, on the photograph itself.

There is no way of knowing this, so we are left with this question: If reading a book, as the image implies, is to snatch the word-soaked satin off the page and carry it away, just what does one carry? The "text" or the reflective, semitransparent satin? The question applies, as well, to our looking at the photograph. Having looked at the photograph (as I just did) and turned my attention back to the screen, what have I borne away in memory? This is the ultimate, cautionary question for any writer who addresses the visible world, and one that Sarah Charlesworth never lets us forget. All of her work references the ineffable recursiveness of seeing and reading the world around us; *Text* addresses the elusive complexities of seeing and reading itself, explicitly and inescapably.

Thus, when we look at *Text*, it is immediately apparent that the relationship of the open book to the satin that covers it—which simultaneously distorts and portrays it—is analogous to the relationship of the satin to the photographic image that simultaneously distorts and portrays *it*, which is analogous to the relationship of the photographic image to the framed object that distorts and portrays it, which is analogous to the relationship of the framed object to our imperfect seeing of it—which, in my own case, is analogous to the relationship of my remembering my own imperfect portrayal of that memory in writing, etc. It is a process of hierarchical diffusion and decay, an expanding sequence of nested portrayals, each inscribed upon the other, with each portrayal simultaneously revealing and disguising that which it portrays.

The instability of this experience is further complicated by the fact that our encounter with *Text* is not just a quotidian activity; it is an "art experience" that entails its own categories of expectation. So, even as we respond to the photographic object and the object it portrays, we are also responding to a work of art by Sarah Charlesworth, to the title she has assigned it,

and to the "kind" of portrayal it is—each of which brings with it a particular atmosphere of meaning—each of which exponentially complicates the presumed mechanical innocence of simply looking at a photograph (with the inference that we never really do "simply" look). When we look at *Text*, for instance, we immediately recognize the "picture" before our eyes as a *landscape* with a cropped horizon. This cue elicits the proprietary, scanning gaze that the landscape genre entails in our culture; it activates, as well, all the pleasures and references of our "landscape experience." Specifically, it calls up for reference our experience of American, modernist, black-and-white landscape photography.

The title of the piece, however, refers us *away* from the genre of landscape and landscape photography to Roland Barthes's heterogeneous theories of reading. By insisting, specifically, upon "the text," it implies that the locus of meaning in the image we see resides in that which we see least clearly, that which is most occluded—in the text that we assume to be printed on the pages of the hidden book. In this way, the pleasures of that text, which we cannot read, are displaced onto the pleasures of the view—the pleasures of what we "see" while we are trying to "read." Thus, if there is any general "moral" to be derived from this complex perceptual experience, it would seem to be that "seeing" and "reading" are totally distinct yet inextricable activities that cannot be conducted in isolation from each other.

This inclusive, double invitation to see the "object" and read the "text" is the pervading ideological feature of Sarah Charlesworth's practice. Invariably, when we confront Charlesworth's work, we find ourselves looking, first, at a handsome and authoritative object, then at a "compromised photograph." The photograph of a "kind of picture": a landscape (in *Text*), a still life (in the *Doubleworld* images), a magazine advertisement (in the *Objects of Desire* images), a censored newspaper front page (in *Modern History*), a censored narrative painting (in *Renaissance Paintings and Drawings*); a modernist abstraction (in *Tartan Sets*), or a photograph of photographic pictures (in *In-Photography*). More specifically, the titles of these sets of works call our attention to their artifice. They remind us that our learned responses to photographs, picture-genres, and images have been activated and insist on the intricate diffusion of their interdependent meanings.

So we are usually "looking at" a glossy photographic object, then

"looking through" that glossy photographic surface so we may "look at" a genre picture in the Western tradition, then "looking through" the genre picture to "look at" portrayed objects that themselves insist upon being "looked through"—as we "look through" the satin in *Text* to "look at" the occluded book, which itself insists upon being "looked through," upon being read although we cannot do so, because at this point the infinite regress of "looking at" and "looking through"—of seeing something then reading it—has dissolved into an entropic blur. (One thinks of Michelangelo Antonioni's *Blow-Up* here.)

In this way, the process of viewing Charlesworth's work is made articulate for us: First we see, then we read what we have seen, then we see what we have read and read that, then, again, we see what we have read, and we read that, and so forth. In this way, the "texts" we see and read recede into the imaginary and whatever "conceptual" knowledge we purportedly derive from this ritual of infinite regress dissolves into neural mystery; it cannot be localized as anything more than the atmosphere of reference that surrounds the process of knowing, the dance of seeing and reading, of looking at and looking through. It is important to note, however, that Charlesworth's works are not *about* this recursive ritual of seeing and knowing. Each image addresses its subject with the way we see and know specific images and portrayed objects. The recursiveness of the image merely defines the intellectual territory within which knowing takes place. It dissolves the presumption that this iterative process of seeing and reading constitutes anything like disembodied "knowledge."

Even in Charlesworth's earliest work we find this thoughtful insistence that the unrequited "pleasure of the text" cannot be extricated from the bodily "pleasure of the view"—along with a further insistence that both of these are, in fact, and do remain, pleasurable. Consider the most "empirical" work in this exhibition: *April 21, 1978* (1978) from *Modern History*, a series of photographs of newspaper front pages from which the narrative text has been suppressed. Of all the works in *Sarah Charlesworth: A Retrospective*, this series is the most locally specific and historically self-conscious. It documents the dissemination of news subsequent to the kidnapping of Italian premier Aldo Moro and foregrounds the formal strategies through which we encode priorities of gender and status in our public presentation

of information. The position and size of Moro's image on each front page betrays the status of Moro's kidnapping to local editors and readers.

Even in these images, however, we find Charlesworth's characteristic emphasis on the way our knowledge of the historical world is tied to our "aesthetic" conventions of arranging it—on the recursive rituals of seeing and reading that dissolve, at one extreme, into the contingent mechanisms of memory and, at the other, in the entropic limits of the image. At one point, standing in the gallery with the prints from *April 21, 1978* (1978) on the wall, we will find ourselves looking at a single photograph of a newspaper page (*Tribune de Genève*) that bears a photograph of another newspaper page (*La Repubblica*) that bears a photograph of yet another newspaper page from an earlier edition of *La Repubblica* that bears another photograph that is cropped and illegible, without uniform order, entropic. Viewing this nested sequence, of course, calls our attention to the gallery itself as a framing device, as an "information delivery format" within which a group of photographic objects are arranged. Like the newspapers, the gallery delivers information in a deployable array of framed, floating rectangles—although what we "learn" from our experience of this nested array is, again, little more than the atmosphere of our learning.

In these images, the recursive and formal "pleasures" of our learning would seem to be mitigated by the gravity of the events inferred and portrayed. In fact, they are emphasized by the implicit analogy between the newspaper page and the gallery wall. This connection is made even more explicit by Charlesworth's suppression of the text on the "top" of the newspaper of her nested sequence. So the nested photographs-within-photographs do their social work: They express their specific content by theatricalizing the peculiar kind of strobed, stop-action serial-memory that photographs have introduced into our historical consciousness. At the same time, they emphasize the formal conventions that modern newspapers share with modernist painting: their common language of arranging and balancing weightless rectangles within weightless rectangles. By foregrounding the language that newspapers share with Mondrian, Charlesworth infers the analogous function of newspapers and art galleries. More generally, she demonstrates the "art component" of daily life—the formal and musical conventions of modern culture that underpin our very knowing of it—by emphasizing the extent to which "pleasures" of

knowing must first include those of *looking at* the text, with its embodied pleasures of arrangement, before we *look through* it to read its designative significance. Moreover, since the pleasures of arrangement and design precede our consciousness of their efficacy, they remain no less pleasurable for our knowledge of their operations.

In this aspect, Charlesworth's practice recalls Charles S. Peirce's first axiom of pragmaticism, which proposes that logic is a branch of ethics, and ethics a branch of aesthetics. In Charlesworth's work, the logic of representation is always informed by the ethics of critique and made public through the aesthetics of arrangement, which is always explicit and articulate. In fact, the defining characteristic of all of Charlesworth's images, in the context of their times, would seem to be their willingness to construe "representation," "critique," and "pleasure" as coextensive events that mitigate one another without negating their separate effects. Thus, as Charlesworth's work has moved away from the rigorous "high conceptualism" of the mid-1970s, it has become at every stage more "intellectual" than "theoretical"—more intelligent than ideological—more *interested* in pleasure than opposed to it, and more concerned with the *ethics* of representation than with its morality.

The invitation is always twofold. Thus, the photographs in Charlesworth's *Objects of Desire* series are themselves objects of desire. The photographs portray and critique "objects of desire" appropriated from popular magazines that unabashedly propose their own desirability. In doing so, they emphasize the "boutique" aspects of the gallery setting (its status as an architectural "glossy magazine") in much the same way that *Modern History* emphasizes the gallery's information-bearing aspects. Moreover, because it is the photographic objects and not the images that demand our attention, these seductive objects argue for the inextricable dynamic of knowing and longing. To do otherwise, to suppress the desirability of works of art, would be to deny the pleasures of knowing the world in general (or else set the experience of art apart from that quotidian experience as a special category of coded communication) and it is precisely this denial of art's embodied effects that, in the mid-1970s, made it possible for conceptual artists to propose works of art as transparent vehicles through which we glimpse the artificial, Platonic reality of "conceptual" knowledge. By proposing works of art as texts to be read but not seen, how-

ever, such works deny the pleasurable, recursive, and contingent activity of knowing the world, which is Charlesworth's great subject.

⌣

At this point, it seems appropriate to return to the question that opened this essay: Just what is going on here? Because anything written about works of art, as self-disclosing as Sarah Charlesworth's, should aspire, at least, to some self-disclosure of its own—it should acknowledge just what "kind" of writing it is, as Charlesworth's works admit their genres. So what kind of writing *is* a "retrospective catalog essay for a living artist" (who died in 2013). Well, my writing is "art writing" to be sure, but it is not strictly "criticism," or "commentary" because the author's commitment to the artist's work is assumed, as is the author's affection for it. As a consequence, at its worst, such writing proposes itself as "background music"—as a score for the exhibition, emphasizing the highlights and brightening up the quiet places. As such, it should embody the key, tempo, and genre of the artist's work—a tendency that is reinforced by the fact that, even though an essay like this, because it deals with primary sources and defers to their authority, is not strictly criticism or really scholarship either. Nor can it really aspire to historical authority, because "history," one presumes, begins at a somewhat earlier date, and the history of Sarah Charlesworth begins at a somewhat later date.

Such writing does, however, accept some obligation to interpret, to see the work in question "as a whole"—to offer some normative generalizations about the habitus of the artist's practice, as I have tried to do in the preceding passages. Most importantly, though, essays of this sort should *look back*; they should take a "retrospective" view, because most of the occasional writing about artists in the midst of their careers tends to *look forward*, to see the artist's most recent work in terms of "where it is going." This kind of writing tends to derive the significance of an artist's work from the zeitgeist out of which it first arose. This occludes the fact that most artists make art to *distinguish* their vision from the zeitgeist and the norms of its milieu.

In the case of Sarah Charlesworth's career, this teleological mindset has placed such a distorting emphasis on her early associations with the Art & Language movement and the once-trendy "critique of representa-

tion" that it is easy to overlook the fact that Charlesworth's work was, almost from its inception, *departing* from that reductive ideology. In truth, one finds more authoritative precursors for Charlesworth's concern with the poetics of knowing in the "incarnate" conceptualism of John Baldessari and Bruce Nauman than in the high Anglican "concept art" produced in New York in the 1970s.

The real question, however, is not "Where does Charlesworth's work come from?" but "What has she been doing and with whom?" The "with whom" is easy, because Charlesworth's work, from the outset of her career, has been closely associated with the work of her two friends, Cindy Sherman and Laurie Simmons—and rightly so, I think. The "what" is somewhat more problematic, but I would suggest that Charlesworth, Sherman, and Simmons have, over the years, been involved in the gradual reaccession and reinscription of Western pictoriality—in reconstituting its vast repository of representational strategies by rendering them visible and explicit. Rather than dispensing with these pictorial strategies on account of their seductive artifice, these artists have simply made that artifice articulate and proceeded with their own agendas on the reasonable premise that the artifice of seduction is less toxic when we are made aware of it, but no less pleasurable.

The trick, in my view, is to seduce without dissembling, and this strategy is most demonstrable in the most anomalous series of works that Charlesworth has produced: *Natural Magic* from the early 1990s. Unlike the bulk of her pictures, these works are *sui generis*, and ironically so. They purport to portray "magic tricks" in progress, so we see photographs of floating cards, bent spoons, levitating cups, and flaming fingers. The joke, of course, is that the "magic" of these magic tricks is completely neutralized by the frozen "magic" of photography. In the weightless, timeless, painless metaphysical world of the photograph, magic is unnecessary because photography does the things that magic tricks purport to do—so a levitating card is nothing very special in a photograph, although no less alluring.

Looking back at Charlesworth's production through the lens of *Natural Magic*, then, we see the work of an artist as much beguiled as appalled by photographic magic. From the floating rectangles of *Modern History*, to the frozen falling bodies in *Stills*, through the levitating *Objects of Desire*, to the groundless images from *Renaissance Painting and Drawing*, Charlesworth's

affection for the timeless, weightless metaphysical realm of photography is simultaneously demonstrated and critiqued. Her affection is most articulate in *Natural Magic*, which, as a series, constitutes an especially cosmopolitan form of critique, in that it demonstrates the "falsity" and "unreality" of photographic space by articulating the temporal falsity of magic and its seductive attractions. Much like Bruce Nauman, Charlesworth embraces the beast rather than attempting to slay it, domesticates it and uses its magic by giving away the trick—in much the same way that Cindy Sherman embraces the beast of narrative cinema or Laurie Simmons embraces the beast of "toy reality." In each case, "the beast" resides in an idiom of embodied expression, a traditional language of arrangement, and some simulacrum of beauty.

There is always the question of how artists deal with the past in their historical moment: Do they detoxify its past history, enhance it, or simply amputate it? I would suggest that, left to their own devices and given enough power and permission, most artists opt for amputation, for no better reason than to clear the stage for their own production. In fact, nothing reveals the perverse, dialectical nature of art practice in Western culture better than its paradoxical, historical responses to freedom and repression. How is it that the periods of surveillance, oppression, and regulation that existed in the Middle Ages, in the Elizabethan Age, the baroque period, and the French Empire have given birth to practices that revel in complexity and profusion? And why have ages of liberty and absolute permission like the later eighteenth century and the late twentieth century engendered periods of almost hysterical artistic self-regulation that have given birth to a proliferation of practices grounded in self-imposed, reductive rules and ideologies?

I have no answer for this question beyond the obvious surmise that, granted enough power and permission, artists in our Protestant tradition tend to behave like everybody else: They become obsessed with self-mastery as a mode of controlling other people's behavior, exercising their power of self-control to restrict other people's permission. The fact that such self-regulation is a function of privilege, however, may explain why the great inclusive, permissive gestures of late twentieth-century art have issued from the work of artists who do not feel free and empowered—and are thus less inclined to self-regulation. From this perspective, we may

view the progress of artistic production in the late twentieth century as a kind of silent-film comedy during which work-gangs of empowered white males strive to purify their art and bring it into line by subjecting it to one regimen after another—by insisting on the "purely retinal," the "purely physical," or the "purely conceptual"—while various disenfranchised women, queers, and provincials strive to disrupt that reductive linearity.

Think of it this way: Up in the front of the boat the guys in power are tossing bales of "inessentials" overboard—content, rhetoric, image, narrative, genre, contingency, complexity, and desire all go over the side—while, back in the stern, as the boat chugs along, a bunch of women and queers are frantically hauling those bales out of the water and back into the boat. Pollock, de Kooning, and Rothko dispense with everything but the authentic object and autonomous self; Don Judd reduces that to the authentic object; Richard Serra reduces that to the actual *stuff*; at the same time, Warhol, Rauschenberg, and Johns are hauling the bales back in and recreating a redeemed image of the protean self in a fluid culture—as an image of the image of the image.

In the seventies, Lawrence Weiner, Joseph Kosuth, and Douglas Huebler sought purity in the other direction by dispensing with everything but the pure idea and the descriptive text; Charlesworth, Sherman, and Simmons hauled the bales back in, reconstituting the idea and the text into another brand of redeemed image—a critical representation of the self-evident photograph through which we may know our pleasure in its darker and brighter aspects, even as we experience it. In both of these permissive scenarios, the "essential" object of the idea—the embodiment of the artist's intentions—is deemed inessential and replaced by an infinitely recursive imaginary configuration that occurs at the intersection of the artist and the culture. In its restrictive mode, late twentieth-century art purifies Art. In its acquisitive configuration, art redeems culture.

At its heart, then, Sarah Charlesworth's endeavor seems grounded in a permissive Darwinian proposition that knowing the world is pleasurable in itself, because we must know the world in order to survive in it—just as sex is pleasurable because, presumably, we must propagate. The corollary is the seventeenth-century proposition that if any form of knowing the world is *not* pleasurable, then it is not "knowing" in its ordinary glory. It degrades knowing, flows from ink-stained wretches who insist on our sub-

mission to its rigor. Charlesworth's project allows us the privilege of knowing the world while knowing the pleasure of knowing it. It is grounded in the same premise: that there are no autonomous, disinterested positions from which we may know anything. The signifier of our knowing anything is our admission that we enjoy it, so we either admit our complicity in the pleasures of the text and the coextensive pleasures of the view, or we dwell in the realm of codified ignorance that we call knowledge.

Mary Heilmann

Surfing on Acid

I have two images of Mary Heilmann. The first comes courtesy of Norman Rockwell. He painted it for the cover of a *Saturday Evening Post*, and I know it's corny, but the timing is right and Rockwell's pitch is perfect. So I always think of Mary as that schoolgirl in pigtails sitting on a bench outside the principal's office with an enormous black eye and a smile of sly triumph on her lips. In my lexicon, that's Mary. She was that girl then and she is that woman now. The atmosphere of that sly smile brightens the offhand insouciance of her paintings; it enhances their tomboy dishabille, and inflects their self-possession with an impish kind of glee. The first thing I know, in fact, when I see one of Mary's paintings, is that, however daunted I might feel standing in front of it, Mary is happy with it. Whatever it cost, she considers it worth the price, and, whatever it means, it does mean something. It's not just a design or another "contribution to the discourse" but something more like graffiti tag on a stucco wall, a private mark whose very opacity bears with it a promise of the artist's perfect candor.

My second image of Mary is a real one, a story she tells of being a Catholic schoolgirl forced by the demands of hipster fashion to shop at an ecclesiastical clothing store for black nun's stockings that she and her friends so anxiously desired so they could masquerade as beatniks in the bars and coffeehouses of San Francisco and listen to poetry and jazz. This, of course, is a classic strategy of improvisational rebellion. When at a loss for defining what's new, one simply appropriates the local iconography of power to serve a subversive agenda—the way British Invasion rockers appropriated Victorian cavalry jackets, the way Black Panthers affected fatigues, and punk rockers sported business suits. It is also the way Mary Heilmann

Mary Heilmann, *Surfing on Acid*, 2005. Oil on canvas, 60 ✛ 48 in. © Mary Heilmann. Collection of the artist; courtesy of 303 Gallery and Hauser & Wirth. Photo credit: John Berens.

would ultimately appropriate the august historical discourse of geometric abstraction. She would deftly subordinate its spiritual and conceptual pretensions to the contingencies of the hand and the heart, and, in the same fiat, adapt the fluid elegance of Greenbergian color-field painting to a willfully inorganic, geometric idiom.

As Thomas Carlyle was fond of recommending, she maneuvered herself into the most unfashionable position imaginable to make it new and to make visible the chains of fashion in which we languish. To this end, she would subvert the minimalist agenda of her own friends and contemporaries by returning to painting at the absolute nadir of its vogue, and as a friend of mine said at the time, "Painting was *so* dead. That is *so* punk." But with a difference, always with a difference. In Heilmann's case, the canvas support upon which she paints somehow manages to remain, in the minimalist tradition, a literal object—a literal object, however, that has been impudently decorated with painted marks. So, in the presence of Heilmann's paintings one is always noticing the raw physicality of the stretched canvas support, the occasional scuff, flutter, or warp that leaves the inference that Mary might have found the canvas in the street and wasn't much bothered by the fact that she had. This blunt physicality invests her work with an atmosphere of professional unprofessionalism that has less to do with the history of painting than with the raggedy ambience of work by her contemporaries like Keith Sonnier, Eva Hess, and Bruce Nauman.

In apparent contradiction to this minimal toughness, Mary has always given her paintings fifties-type evocative titles of the sort favored by Laguna Beach abstractionists, titles like *Enchantment*, *Music of the Spheres*, *Waimea*, and *Save the Last Dance For Me*. The result is a low-tech, rat's nest of ambiguities: semiautonomous, semiautobiographical titles are appended to semiautonomous, semiliteral canvases to which semiautonomous, semigeometrical designs have been applied. Amazingly, though, Heilmann's hierarchal dissonances and cavalier informality invariably reads as absolutely *knowing*. The all-too-fashionable, deeply parental, assumption of innocence that allows bad craft to be read as a signifier of youthful sincerity is simply not an option with Heilmann's paintings. The titles, as dissonant as they are, contribute to the ambience of the paintings, and to their wily, surfer sophistication, by pointing out all-too-obvious figurative cues in the abstract image. The execution of the image, by virtue of

its chromatic and formal sophistication, evokes the ebullience of Matisse rather than the incompetence of youth.

As to the craft of painting itself, don't get me started. Heilmann readily admits to knowing nothing about it. She never studied it and never planned to do it. At Berkeley, she studied ceramics with Peter Voulkos who specialized in the earth, in its brutal, tatty grandeur, so, when she started painting, Heilmann began painting canvases as if they were ceramic objects—as if, more specifically, they were *pots,* informal domestic accouterments with no specific shape and no vertical edges. The trademark "look" of Hielmann's paintings derives from this casual, vaguely oriental aesthetic, from Heilmann's contempt for the rectangular enclosure of the support and her willful refusal to address those "problems of the edge" that have obsessed every painter since Manet. The confluence of these wildly eccentric appropriations from the past, guarantees her work's stylistic currency. She has never set up housekeeping in the past, and as a consequence Heilmann's work remains resolutely high-style American painting in that tradition. She has never appropriated an image, juxtaposed anything, or interrogated anything. She has never trafficked in the "new nostalgia" of current European painting or participated in its self-conscious longing for the "lost" attributes of expression, gesture, and figuration.

The canons of geometric abstraction, color-field painting, and minimalism are honored in spirit but not in the letter. In Heilmann's synthesis, they are straightforwardly looted as available precedents. So it is fair to say, I think, that Mary never looks back except for something to steal. One may rest assured that she only dons her nun's stockings in hopes of looking young and hot and trashy, and that the unladylike blemish of the black eye is, for her, a badge of honor. So, these are my images of Mary, and they will explain perhaps why the attribute of her paintings that I feel more urgently than most is the residue of their history. The inherited traces of the impudent schoolgirl, the beatnik Catholic, the surfer slut, and the hippie chick tending marijuana on the roof are all present in the paintings for me because Mary is my sister in time and space. We share a tiny arc, a traverse through the historical world. We rode the same waves on adjacent beaches in Southern California. Alive with terror, we launched ourselves off the same diving platforms. We listened to the same music and read the same books at the same time in our lives. We shared a circle of friends and

floated in the same centrifugal cultural currents—the ones that invariably lift you up onto the crest of the breaker.

First and foremost (and as quaint as this might sound), we thought of ourselves as Americans. We are members, in fact, of the last generation for whom being an American seemed an intriguing and exciting proposition—and we continue to share, in Mary's phrase, "the loyal yet yearning patriotism of the outsider." As outsiders, we were, in sequence, beach kids, hipsters, beatniks, hippies, rockers, druggies, drifters, burnouts, and late bloomers. Finally, blandly, boringly, and mostly by attrition, we became what we are now: transnational art personalities. Back in the day, we hung out at Max's Kansas City bouncing between Bob Smithson's table and Andy's. We took in the air and a lot of other things on the balcony of Norman Fisher's drug emporium and penthouse, chatting up the two Davids, Bowie and Johansen. We dabbled in the drug trade, behaved badly, worked feverishly, and detonated relationships out of sheer craziness. Then we felt it all die and fall apart. Then we watched it keep on going and wondered just what had died, along with our friends, that it should keep on going so effortlessly and relentlessly?

This is a question I feel qualified to answer by virtue of being Mary Heilmann's sibling in time and space. What died, I would suggest, was a culture with a very specific architecture of ambition. It had to do with "be there or be square"—with the allure of what philosophers call "limit-experience" and Mary calls "facing death." It also had to do with promiscuity, serious fun, and the exquisite joy of absolute permission. To this day, Mary remembers her delight at sitting in a room with Bruce Nauman watching his "bouncing in the corner" video, reveling in its delicious weirdness. I remember a night at the Factory when Ondine dissuaded Eric Emerson from jumping out the window with four words: "Not in those shoes!" I also remember a joke that went around Max's after Bob Smithson died in a small plane crash out near Amarillo. According to this joke, after Bob went down, the heavens opened and the booming voice of God announced, "Sorry about Buddy Holly!"

This was the Max's modality for facing death, after which everybody went back to work because once you were in the right place, surrounded by the right people, and informed by their generous permission, you had to believe that this was some serious shit, otherwise the anguish and ruthless

competition would have been silly. Otherwise one might become a silly celebrity and everybody at Andy's table knew what celebrities were, how they were made and how little one had to do to be what they were. So you made it serious. You embraced the imperative of passionate labor through which pleasure was redeemed and recreated with enough physical intensity to blanch the paper world of governments, museums, academies, and press celebrity into a sepia-toned backdrop. As Lou Reed once sang, echoing Andy in a parody of Springsteen, "Fools like us, baby, we were born to work."

So we worked at weird, promiscuous, permissive, facing-death kinds of work so we could be someone at Max's or Norman's and not care about anywhere else. Then it died and everyone kept working although all of us who had lived in the grip of that peculiar brand of American ambition could see that it was over as a cultural phenomenon, that all of its elements were inextricably intertwined and could not survive singly. So weird died of *really* weird, of being so weird that you would shoot poor little Andy. Promiscuity and casual intimacy died of AIDS and herpes. Facing death died of air bags, seatbelts, helmet laws, and total surveillance. Absolute permission died when the "art world" became the "art community" around 1975—when everybody had a "little wife" or a "little husband"—when we all started intervening, and nursing one another, with or without permission. Passionate work died when passion died—on the day someone actually believed in celebrity. For those of us who survived that moment, however, people like Mary and me and Richard Serra, Bruce Nauman, John Chamberlain, and Keith Sonnier, the effect of this death only reconfirmed the validity of our lost project. As a consequence, the remnants of a whole generation of American artists, in a country not famous for artists with second acts, embarked upon second acts in their careers, and of all these second acts Mary Heilmann's has to have been the bravest and the most subversive, the one that actually raises the bar. Unlike the products of contemporary practice, which strive at best to surpass the products and standards of popular culture, Heilmann is still competing with and working within the deep history of Western art. Life or death, win or lose, the bloodline of her practice dates back to Raphael while looking back to the beach.

So it makes perfect sense to me that Mary's most recent painting is the one that looks back the farthest. It's called *Surfing on Acid*—a title which,

in my book, offers a perfect definition of fluid, passionate, outsider work under extreme conditions of maximum risk, maximum attentiveness, and radical disorientation. For those who do not share Heilmann's arc in time and space, the title of the painting can easily be read as a painterly allusion to multicolored, psychedelic waves, but the reference is thicker than that. As T. S. Eliot wrote, in our end is our beginning, and anyone who grew up in the surf will tell you that it never goes away. It remains a primal metaphor and defines a whole canon of exquisite connoisseurship. All disasters feel like wiping out, gagging, bouncing off the bottom and breathing salt foam. Anxiety expresses itself in dreams of a careless glance that reveals a mountainous rogue wave rolling in, sucking up five stories over your head and too late to do anything about it. Anything that goes well feels like dropping perfectly into the wave—like giving yourself up at the exact instant. And triumph? Triumph is always a sweet ride up onto the sand. It happens or it doesn't. You can only romance the liquid, lean into it, and keep your head up. For me, the confidence, anxiety, and relaxed intensity in Mary Heilmann's work speaks this physical/intellectual language. It embodies the surfer's ethic of finding the moment to fall and never trying too hard to save your life since you're surfing dizzy. In this lexicon, life and art are a sequence of daring little rides—daring little events. The challenge is always there because of the never-ending sets of waves rolling in.

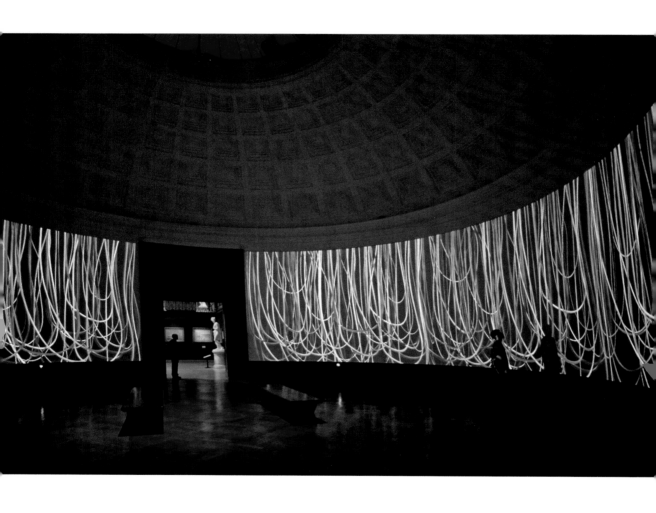

Jennifer Steinkamp

Breathing in the World

You can't fly if you don't have the hardware,
You just hang there like a heart on a wall.
—JIMMY DESTRI

In the chaotic narratives of art and culture, there are always jobs left undone and promises unkept. Every age presents its artists with possibilities that, for reasons of fashion or technology, cannot be realized when they present themselves. In any age, there is a logic of practice and stylistic continuation from which we may infer new resolutions that cannot be articulated with the materials at hand. Usually, when this happens, attention wavers, the runner stumbles, the torch falls, flickers, and goes out. The world moves on to more modest and achievable options. The possibility does not die, however. It remains, redolent with potential, in the historical objects and the practices that originally created it. It waits for the moment when it becomes doable—and for the moment that it needs to be done. Some tasks wait forever, but sometimes the original runner picks up the torch again, as Frank Gehry did when he produced the Guggenheim at Bilbao and gave form to a vision that was conceptually and aesthetically available in 1972, even though it was technologically impossible and wildly incongruous with those darkening times. Sometimes a younger runner, sensing the vacancy and the need, grabs the torch, relights it, and runs with it. Suddenly the promise and the conditions of the old vision are new and available again.

This is the case with the work of Jennifer Steinkamp. Early in her ca-

Jennifer Steinkamp, *Loop*, 2000. Six-channel video projection, 13.5 ft. high. Composer: Jimmy Johnson. Photo: Jennifer Steinkamp. Part of the Collection: The Corcoran Gallery of Art, Washington, DC. Courtesy of The Corcoran Gallery of Art, Washington, DC; ACME, Los Angeles; greengrassi, London; and Lehmann Maupin, New York and Hong Kong.

reer, she perceived, in the untethered ambition and slightly demented optimism of "1960s structuralist cinema," a job that needed to be done and that finally *could* be done, twenty years after what Gene Youngblood refers to as the *paleocybernetic moment*. Most critically, Steinkamp found a job she wanted to do and instinctively made an artistic choice to set off like Gauguin to her own technological Tahiti. To escape the tyranny of contemporary fashion and ideology and to see the world clearly, she relocated her practice to the most unfashionable position imaginable. From this vantage point, the chains of fashion and the intellectual mindset are all too visible and a new future is readily available. One proceeds from there.

So Jennifer Steinkamp decamped to her technological Tahiti. She set up shop in what was, in the 1980s, a lost world—a terrain so remote from the art politics of the time that it didn't even tick on the meter. And it was all hers: the detritus and fringe atmospheres of the late 1960s techno: the punch cards and Stone Age computer languages, the subculture of acid-dropping science geeks and techno-cosmic weirdos, the rigorous ephemera of Michael Snow, Robert Whitman, Jordan Belson, and Stan Brakhage, the secrets of the old Jewish dudes who animated *Fantasia* and the proto-hackers who designed Kubrick's *2001*, the strobe-lit Warholians at the *Exploding Plastic Inevitable*, and the stoner wizards at the Fillmore who concocted oceanic lava flows of light that spilled out, over, and around the Allman Brothers. Needless to say, setting off like this was a brave choice for a young artist in the 1980s, but it was a very, very good one. In an act equivalent to Mary Heilmann embracing painting at its nadir, Steinkamp embraced structuralist cinema at the apex of its obscurity. She removed herself quite literally to the primal site, flung herself into the turbulent soup out of which arose the lineaments of postindustrial digital culture—the world we live in.

As an additional bonus, Steinkamp found herself in a lost art world whose base presumption challenged the most cherished bits of art theology in the 1980s. At that time, for instance, it was widely presumed that, since "history" died in the late 1960s, innovation and the idea of the "new" had died with it. History, it was said, would soon be replaced with a "thick sociological discourse" of personal narratives—his-stories and her-stories—as if Foucault had never laid bare the mindless solipsism of sociology—as if Derrida had never named language a shared prosthetic. The adepts of structuralist cinema agreed that history was dying all around them, but they also

knew that time and complex causation were not dying. Nor was genetics. Time goes on, consequences proliferate, as does artistic practice. So innovation is always required. There is no way to do without the new. The alternative is ennui and entropy, and the world in the wake of history is, after all, a new world (and newer than any of them imagined). Moreover, this new world is grounded absolutely, if paradoxically, in the languages of abstraction—in statistics, cybernetics, dynamic systems, and genetics—so discussion in the structuralist conclaves within which I grew up and which Jennifer Steinkamp has happily revived, was never about abolishing abstraction. It was always about keeping it sexy. We worried, and Susan Sontag worried too, about the erotics and ethics of form, the aesthetics of clouds, the allure of liquid dynamics, the beguiling appeal of "pied beauty"—the chemistry of everything that is haptic, fractal, tactile, restless, and multihued.

The art theology of the 1980s, of course, held that abstraction, and abstract art particularly, was an elitist enterprise best avoided by progressive youth. A twenty-minute visit to the early 1970s would have proved just the reverse. At the Fillmore or in the *Inevitable*, at Paraphernalia (besieged by super-graphics) or listening to Lou Reed's *Metal Machine Music*, hanging with Billy Klüver at MIT or goofing in an acid lab, watching *Laugh-In* sound bites or *The Steve Allen Show* with fake Stella protractors in the background, it was clear enough, at this moment, that Gertrude Stein was right: that abstraction *is* the American vernacular and fully available to the so-called common man. Around this time, an artist friend of mine, Susan Teagarden, created a large suite of photographs called *Proof of Mondrian*. The photographs depicted Mondrian's graphic signature translated to adorn garbage trucks, dry-cleaning establishments, A-line dresses, basketball floors, and other objects of everyday production. She only stopped because she got tired, she said, adding that she could have easily created another large suite called *Proof of Jackson Pollock,* documenting the numerous instances of casually dripped kitchen enamel as an element of commercial design. My own favorite in this genre is on the front of the Pacific Shores Lounge in Ocean Beach, California.

As Philip Fisher points out in *Still the New World*, and Jennifer Steinkamp amply demonstrates, abstraction is the base language of democracy. From the Jeffersonian grid to the Nike swoosh, it engages us and unites us at a level of generalization that transcends our differences, and it

is this vernacular commonality, I would argue, and not abstraction's elitist provenance, that created the jihad against abstraction in the art world of the 1970s and 1980s. My position is that *pictures* divide us, that *representations* divide us, and for an art world desperately seeking European "distinction," the photograph proved a happy, frozen redoubt. If this were not the case, the broad positive response to Jennifer Steinkamp's refined technological inquiries into the "elitist" practice of abstraction and expanded cinema would be all but inexplicable.

In fact the generous response to Steinkamp's work, within and without the art world, is not inexplicable at all. For the length of her career, Steinkamp has moved along a road that began in the 1960s as an eight-lane freeway, shrunk to a bike path, and finally turns out to have been really going somewhere. Today, Steinkamp fashions the conditions for a very special brand of synoptic and synesthetic experience out of light and motion in real and virtual space; she creates externalized visual fields and weather systems in which one's consciousness may unself-consciously disport itself. Like the recent work of Frank Gehry, Richard Serra, and Bridget Riley, and the work of younger artists like Jim Isermann and Jorge Pardo, Steinkamp's work, once again, after a long hiatus, places the mind at work in the body—in a mode of high abstraction that is so totally in the service of the body that the Protestant distinction between them disappears. More to the point, she creates work that is so visually persuasive, so rhetorically acute, that we are happy to ignore the fact that its success proves a lot of us wrong about the primacy of representation.

One might argue, of course, that Steinkamp's recent forays into skeining flowers and twirling trees constitute a divagation from abstraction into this "discourse of representation," and these works do represent a divagation. They show us things we recognize and, as such, they may be taken as an inadvertent curtsy to prevailing taste on Steinkamp's part. The works, however, do not divagate into narrative, realism, or even surrealism. Their motion is still the motion of pattern and cycle. They do not propose a reality superseding the one in which we stand, or suggest any aspiration to verisimilar dominance. Their divagation is into an even more decorous idiom, into the language of the decorative arts, where Steinkamp's rooms of turbulent flowers and trees constitute a knowing, updated allusion to the tradition of designing interior space with natural iconography that dates

back to the high modernist glass fronts and from there back to the rococo. This allusion allows Steinkamp to exploit the high resolution of her evolving technology without breaking the bond of sympathy that her works establish with the beholder/participant.

This bond of sympathy, I would argue, is no small thing. It is very real and virtually ineffable. It derives from the residue of art that remains a *thing* in our world, the noise of music and the stuff of art, the aspect of a work that cannot be read and thus rendered absent or "other." This bond resides in those embodied and organized accouterments of art that, in their instantaneity, must invariably exceed our description of it. Gilles Deleuze calls this atmospheric effect "the logic of sense," the ghost of our patterned, precognitive, sensory perception. In Derrida's phrase, these effects "haunt" the world we know. By refusing to distance her work from us, Steinkamp relentlessly foregrounds a quick kinesthetic logic that is rarely mentioned these days. It is generally presumed not to exist, it would seem, because any engagement with the extant veil of sense smacks of connoisseurship, of the aesthetic as opposed to the anesthetic. Having said all of this, however, we are still unwilling to deny ourselves our pleasures. We will have our cake regardless of the subversive constituents of the recipe and take it as a special case.

Unfortunately, in our quest for pleasure, we have acknowledged so many special cases in recent years that our categories no longer describe anything, and categories should. Let us ask: Is Frank Gehry's Bilbao a modernist or a postmodernist structure? Is Richard Serra a minimalist or a materialist or a formalist? Does Jennifer Steinkamp make "video art" or "digital art" or "new media" or "new time-based digital video art" or what? The answer to all these questions, of course, is "Who cares? We like it." The categorical bond between Steinkamp, Gehry, Serra, Riley, and their younger comrades is nothing more than a presently unfashionable assumption about the "sisterhood of the arts," that unity of the physical arts, and the transposability of the senses they all exploit. All of these artists operate on the principle that painting, sculpture, music, dance, and architecture share a field of concerns that transcends genre—that they present a repertoire of analogous patterns, effects, and frequencies. Sadly, in a world where the visual arts are presumably bound most intimately to literature, philosophy, and sociology, where they are presumably concerned most urgently with

concept, narrative, and representation, this distinction is virtually inexpressible and, consequently, we are touched we know not how.

In order to talk about Jennifer Steinkamp's work, then, we need to question the extent to which bad language and slovenly categories have diminished our pleasure in good art and occluded the meaning of its success. Because even those who acknowledge the virtue of Steinkamp's work are hesitant to suggest what it *means* for art to be good in this particular way. So let us presume for a moment that we should categorize Steinkamp's project, as it often is categorized, as time-based digital art? How, then, do we distinguish Steinkamp's work from the work of slacker chicks in Williamsburg who "video" their bodies or from the work of techno-nerds in Nebraska who create "digital collages" that portray Hillary Clinton making love to the aliens from *Men in Black*? More critically, how do we characterize the time it takes to experience one of Steinkamp's works? Is that time analogous to the time it takes to walk around a Donald Judd or to the time it takes to watch Hillary Clinton making love to an alien? Obviously, I suspect the former, and suspect further that the motion in Steinkamp's work is more closely analogous to the shifting play of shadow and reflection we experience walking around a Judd than to the narrative calisthenics of motion pictures.

So a distinction needs to be drawn about kinds of time and motion. In his fine book, *The Sense of an Ending*, Frank Kermode defines the expectation of imminent closure (a "sense of an ending") as the primary attribute of literary time—the marker that distinguishes narrative and history from chronology and cumulative lived experience. On the one hand, Kermode locates *kairos* (time moving toward some conclusion); on the other, he posits *chronos* (time that simply moves, occasionally in rhythms and cycles, but never toward the determinate point of closure). This distinction, I would suggest, divides the field of "time-based art" succinctly between art grounded in memory, narrative, and representation (*kairos*) and art grounded in ongoing experience and living consciousness (*chronos*). The temporal world of Steinkamp's work, of course, is clearly more *chronos* than *kairos*, more closely akin to the peripatetic temporality occasioned by the work of Robert Irwin, Sol Lewitt, and Donald Judd than to narrative film or video. Like Irwin, Lewitt, and Judd, Steinkamp's work demands time, but it doesn't demand any strict portion of time, or any particular order of events, or any precedent memory. It is always happening. The moment we

arrive is the first moment. The moment we leave is the last moment; there is no beginning or ending.

The distinction between *kairos* and *chronos* in the realm of motion is kinesthetically observable. Narrative motion (*kairos*) moves and steals our mobility; it supplants our own activity with motion in the narrative space of the representation. Pure temporal motion, however, in its intimacy, moves and moves us with it. This has always been what Jennifer Steinkamp's work is designed to do, regardless of its technological medium. It moves us, quite literally. It demands motion from us in the way that all multidimensional art does, and through the medium of its own movement it exacerbates our sense of ourselves as physical beings in motion. It takes us nowhere, but it breathes in sympathy with us and embodies cycles of visual events that externalize and mimic our condition of being. (The verb "to be," it should be remembered, derives from the ancient Sanskrit and bears the meaning "to breathe.") The motion in Steinkamp's work, then, causes motion and maybe e-motion. Within the domain of her pieces, children go manic and scamper, adolescents vogue, and adults stroll casually around, generally unaware of the fact that they are being moved, that they are dancing with the art. They imbibe their dose of harmony and anxiety, never knowing whence it came.

The ability to move us, physically or emotionally, is an attribute of the best art, of course, but is not exclusive to it. Nor is the ability of representation to stop us dead. Once a week I lecture to a class of students at a university. I move as I lecture and the students move as well, with me or against me. They are never still unless they are asleep or playing a video game on their mobile phone. Occasionally, however, I bring a movie or a filmed interview into class and play it for them. The minute the image flashes on the screen, the class freezes. Henceforth, for the duration of the event, they only move to readjust their postures, because it's hard to sit frozen. As a group, though, whatever life they had when they were free, when we were just a bunch of bodies in a room, is stolen from them by the image, as it has been stolen from beholders of art for the past twenty years. Steinkamp's work is not only an antidote to this condition; it is a cure for this perpetual state of suspended animation we inhabit in the ubiquitous presence of images. If she has done nothing else (and she has, in fact, done a great deal more), Steinkamp has let us breathe again and feel the motion of things, and, in our own clumsy way, dance to the music of time.

Michelle Fierro

Beauty Marks

Michelle Fierro makes mandarin grunge—Zen gardens out of painting's refuse. Her plain rectangles of raw canvas present themselves to us as vacant lots populated with by-blows and leftovers of the painter's endeavor—communities of blob, smear, scrape, lump, stain, and blur. They all coexist in a condition of haunting equilibrium, rough, naked, and very brave—betting everything that they can make us dance. Because, when it all comes down, we either dance to them or we don't. Either these paintings are confirmed by our own physical sense of their dynamic equilibrium (in which case, everything about them is interesting), or they are not (in which case they are so much stuff).

They risk everything, in other words, on sheer eloquence. There are no fallback positions, no side effects that might redeem them in part: There are no displays of technical virtuosity, no seductive surface appeal, no virtuous political significations or expressive signifiers—nothing, in fact but the complex relationship of their rough parts and their relationship to us. In this sense, Fierro's paintings are set-piece demonstrations of Gerhard Richter's edict that abstract paintings are always and inevitably allegories of social relations—of the relationship of real bodies in the physical world, because the world exists in these paintings as ineluctable hardware—as a social reality to be dealt with in the moment.

So even though Fierro's paintings have their historical predecessors (in Cy Twombly's elegant graffiti and Joan Snyder's handsome catalogs of painterly marks), they mean what they mean right now—in the aftermath of two long decades of conceptual utopianism—at a moment in cultural history when the computer grids of social engineering and the random bounces of screen-saver entropy (toward which so much painting has

Michelle Fierro, *Impressionable Too*. Oil, acrylic, pencil, and paper on canvas, 1996, 30 + 36 in. Private collection. Courtesy of the artist.

aspired in this century) permeate the public domain. As a consequence, when you stand in a room full of these paintings, in the present, it's hard to deny the feeling that they are exactly right in their wrongness—that they come to us at a moment when their physical assertiveness and bravura pictorial strategies have become so ideologically unfashionable as to be useful and powerful again—for a new generation—in the service of a new sensibility that finds the physical world, in all its contingent materiality, to be a less abject and less pathetic place than it seemed a short decade ago.

It would seem, in fact, that for Fierro (and any number of her contemporaries), the gradual encroachment of cyberspace into the domain of our daily lives has served less to marginalize the practice of painting than to intensify its appeal—to foreground painting's stubborn resistance to linguistic protocols. Because, if they do nothing else, Michelle Fierro's paintings restore to us, in their asymmetrical intensity, exactly what technology steals from us in its logical extensions. "When you close your book and shut down the computer and turn the television off," they seem to say, "this is what you see. If you look, it is brand new."

All of which is simply to say that, when I first encountered Fierro's paintings, they seemed profoundly of the moment, and, perhaps as a consequence of this, the works they immediately called to mind were not other, older abstract paintings, but works by Fierro's near contemporaries, very different in kind. I found myself thinking about Elizabeth Berdann's exquisite trompe l'oeil portraits of little blemishes and Jeanne Dunning's latex replications of similar dermatological imperfections. It seemed to me, somehow, that the quotidian physical reality that Berdann's paintings celebrate in representation, that Dunning's sculptures so delicately replicate, could be found joyously embodied in the hard language of Fierro's paintings.

Each of these works, I felt, marked a path leading out of the valley of bodily abjection into the garden of the "redeemed blemish"—into a practice that first arose in the late sixteenth century, from the cooling ashes of Renaissance idealism and the plague: the "beauty mark." At this time, at the dawn of the baroque, artists began to abandon the utopian project of perfecting nature and set about the task of recasting its irregularities into a dynamic idiom of beautiful imperfections. The practice manifests itself first and most eloquently in Caravaggio's worldly angels and in the dark

love poems of Shakespeare and Donne. It manifests itself more modestly in the peculiar vogue of "beauty marks" or "patches"—to which, by some obtuse logic, Michelle Fierro's paintings seem to allude.

These "patches," of course, were small, black appliqués (bandages, really) cut into the shape of stars and tondos and crescents that fashionable ladies and gentlemen of the seventeenth century applied to their skin to mask smallpox scars and other misadventures. Their original function, however, was almost immediately subordinated to the ability of these "beauty marks" to particularize the wearer and accent his or her best features. As a consequence, the remission of smallpox among the cultured classes did nothing whatsoever to impede their use as cosmetic decorations. They continued to be worn well into the eighteenth century as cultural celebrations of beauty's physical idiosyncrasy—continued to be worn, in fact, until the very idea of beauty's eccentricity was itself obliterated by Rousseau's utopian ideology of perfect nature and unblemished virtue.

So it should come as no surprise, I suppose, that the beauty mark, the redeemed blemish, and the idea of beautiful dishabille should reassert themselves in this postutopian moment, in the age of tattoos, multiple earrings, and pierced navels. Clearly the vogue for such marks and for representations of such marks denotes a shift away from the idea that art perfects and obliterates nature's contingencies, toward an art that embraces them, that enhances and celebrates the rough complexities of quotidian nature in a cultural language of asymmetrical delicacy, and dynamic equipoise. Michelle Fierro's paintings provide us with instances of how this might be done because, finally, the intricacies of mandarin refinement only exist to redeem the grunge of the world. We have other, more brutal, means of disguising imperfections with surgery and with virtuous protocols that erode standards of the way things look. I am down with Michelle and the redeemed blemish.

MICHELLE FIERRO

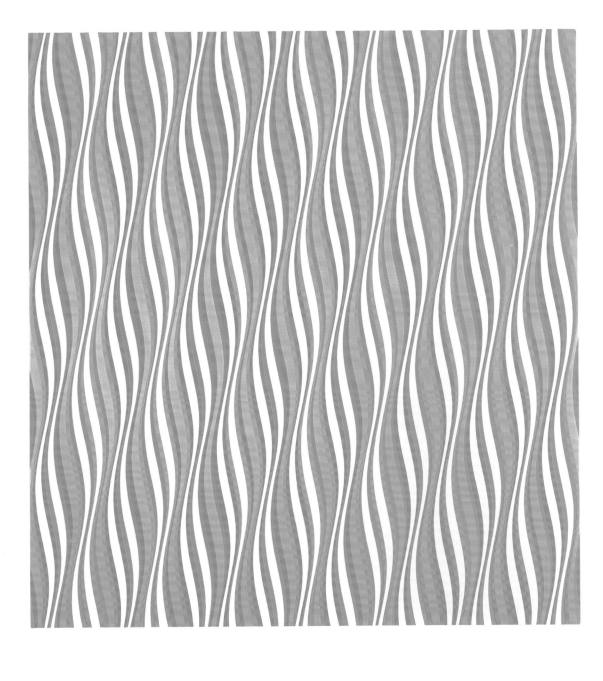

Bridget Riley

Not Knowing

Lately I've been peppering my essays with parables from my West Texas youth. I should stop, I guess, but they are the only parables I know, so this one is about the old horse wrangler and the novice cowboy. One bright Texas morning, it seems, not long after the young cowboy's arrival on the ranch, the old wrangler set out to initiate the youth into the mysteries of the horse. As they stroll across the pasture from the bunkhouse to the corral, the old wrangler drapes his arm across the young cowboy's shoulder and explains to him that a good working relationship between the human and the equine must be based on extreme physical sensitivity, on empathy, reciprocity, and love. One must sensitize oneself to differences between the two species, he says, and somehow bridge the distance between them, because if one could begin to feel some semblance of what the horse felt, the horse would reciprocate in kind.

At this point, the wrangler and the cowboy arrive at a corral. A proud young stallion is dancing around inside. The old wrangler studies the horse for a moment, then ducks between the rails of the fence and steps into the corral. The horse freezes and looks at the wrangler. The wrangler reaches down into the dust, picks up a long board, and, stepping forward, gives the horse a solid whack on the side of his head. The young cowboy is shocked and astonished, "Hey, what about sensitivity and love!" he shouts, "What about empathy and feeling!" The old wrangler looks calmly back over his shoulder and says, "Well, first, son, you have to get the creature's attention."

Back in West Texas, this parable is invariably offered as an antidote to those who would romanticize the cattle business and overestimate the intelligence of horses. In the present context, the old wrangler's agenda of a

smack in the head followed by a long, anxious romance seems an apt characterization of our sequential experience of Bridget Riley's paintings—from the aggressive smack of her first op paintings through the cool, tropical voluptuousness of her most recent works. The difference between horses and art lovers, unfortunately, is that horses remember. For a horse, that slap in the head remains a signifier of the genetic distance—of the primal otherness that informs the relationship between humans and horses. Human beings, on the other hand, almost immediately forget the lesson of such a slap. They suppress reminders of the void that separates them from the objects that surround them. They lose their sensitivity to the contingency of seeing and knowing and become inured or resistant to its pleasures.

As a consequence, the primary virtue of Bridget Riley's practice is all too often lost, simply because she doesn't relish the role of schoolmarm. She makes her point succinctly and irrevocably in her early paintings, as if to declare, "I'm only going to say this once," and then proceeds. Yet we seem to require a slap in the head every time, and, thus, Riley's willingness to move on from the didactic imperatives of her first paintings to a slower and more sensual exploitation of the conditions these first paintings demonstrate is regarded as some kind of falling away from that first "educational trompe l'oeil." The presumption would seem to be that art is supposed to teach us things and that we never learn, or that we never learn them well enough to experience the pleasurable benefits of our education. The simple explanation of our resistance to Riley's quick course in perception is that the lessons she teaches us are lessons that we do not *wish* to learn and, in fact, *refuse* to learn, because they compromise our current penchant for reading art rather than experiencing it.

The paradox that Riley theatricalizes in her early pictures is simply this: we look at these canvases and seem to *know* how they are configured, yet we cannot actually *see* that configuration unimpeded by disorienting visual noise. Thus, we are forced to recognize that our knowledge of the painting's configuration is a constructed generalization based on a statistical conflation of fugitive perceptions whose contingency is demonstrated by simply looking at the painting—and by our knowledge of how hard it is, just looking at a painting, exacerbated by our constructed idea of it. None of this is rocket science, of course, but it is important to note that the se-

rious pleasure we take in the contingency of seeing and knowing Bridget Riley's paintings is dependent upon our acceptance of these contingencies as general conditions of our relationship to the world, conditions that the artist teases into our conscious awareness.

If this reciprocal contingency of seeing and knowing is, in fact, a condition of all our perceptions (and it certainly is), then Riley's paintings transform the essential tragedy of our relationship to the world into a kind of vertiginous pleasure—into what Donald Barthelme called the pleasure of "not-knowing," which was for him the true occasion for all artistic practice. If, on the other hand, we chose to regard the didactic lessons of Riley's early paintings as parlor tricks, as fugitive effects local to their occasion, we may justifiably isolate them from the rest of our experience (including that of Riley's later paintings) and simply presume that, excepting these paintings and others like them, we know what we see and can therefore proceed to imbed these known objects into theoretical constellations of absent signification.

Our recent affection for art that incorporates ready-mades, found objects, appropriations, photographs, and other forms of representation privileges our penchant for reading, of course, by presenting us with objects and images which, since they are already known in memory, suppress the contingency of our knowing them in art. It is easy to presume that we know things that we already presume to know—and easier still to read the pattern of their arrangement as a cultural syntax alluding to some absent signified. The relationship between the shapes and patterns of art and the significations and syntax of linguistic utterance, however, is far from a necessary one. In the realm of the visible, the imposition of syntactical meaning on pattern and the attribution of linguistic reference to shapes is always more of a parlor trick than any effect Bridget Riley has ever achieved. The meanings we derive from such attributions are irrevocably local to their occasion or to the conventions of some local practice.

The desire to read visible images as we do bits of language, however, is undeniable, and it is exactly the urgency of this desire that Riley's paintings exploit even as they tantalizingly frustrate its object. By seducing and conflating the relationship between shape and pattern, Riley's paintings invariably compromise both the spatial arrangements that relate pattern

to syntax and the autonomous boundaries that relate shapes to external referents. This persistent, subversive instability is the single constant in Riley's practice—the attribute that keeps her paintings from devolving into dead formalism or dissolving into absent signification. Over the years, the effects of this instability have been calibrated with increasing subtlety and exquisitely slowed down, so that, today, we confront the fact of our not-knowing at a more intelligible pace and take away from her paintings not just the dazzling fact of our incomprehension, but the conscious experience of trying to make what we see comprehensible.

All of these effects, however, are premised on the urgency of our desire to make the world knowable, and it may well be that we have become so complacent in our easy reading of the world before our eyes and so certain of its meanings that the urgency of our desire to make sense of what we see has abated, and that, in the abatement of our urgent scrutiny, Riley's paintings have become less available to us. This is a defect of culture, however, and not a defect of art, since the world has become no less difficult to know, and no work of art can survive our casual inattention. The gradual abatement of our physical attention in the presence of art does, however, go a long way toward explaining the ambient assumption among many of my colleagues that Riley is an "eccentric" artist—that she is some kind of mandarin outsider, at once a relic and a radical—whose work presents us with a special case unrelated to the "broader discourse" of art in this moment.

It would be more accurate, I think, to say that Riley's putative "eccentricity" is a necessary construction, a compensatory fiction that allows us to continue talking about art as we presently wish to talk about it. Because, if the conditions that Riley's work imposes upon our perception and cognition of artworks have any general validity, a great deal of the art about which we talk is marginal at best, and the bulk of what we say about it is trivial, if not inconsequential. In this regard, one thinks of Walter Benjamin's response to Adorno's complaint that Benjamin's *Arcades Project* lacked a sound theoretical superstructure. Benjamin argued that the relationship between ideas and objects is comparable to the relationship we presume to exist between constellations and the luminous specks of the stars. Bridget Riley, by creating painted fields in which objects never achieve even the singularity of distant stars, which resist

even the fugitive syntax of constellations, makes us connoisseurs of the
never-ending, quotidian labor we perform as we negotiate between the
unknowable realm of stars and the un-seeable domain of what they seem
to represent. As Goethe would have it, Riley deploys the facts of our visual
experience in such a way that the facts become their own theory.

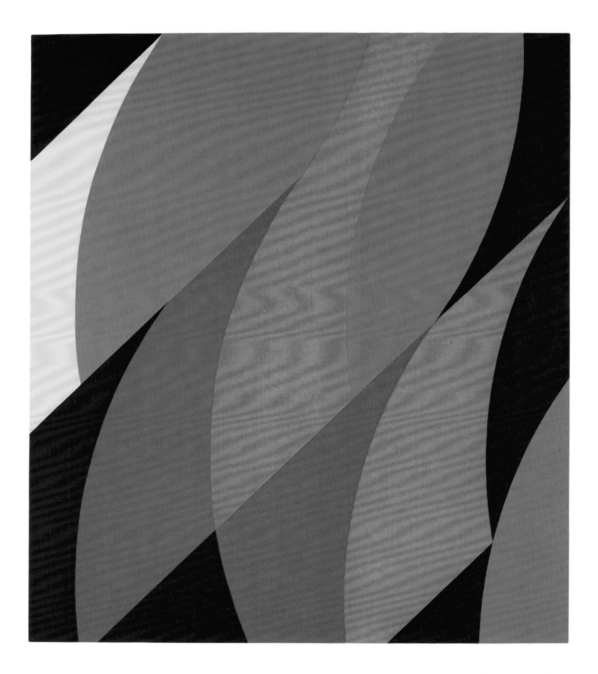

Bridget Riley

Bridget Riley II

For Americans

Pollock has always been a hero of mine. But if there's any similarity whatsoever, I have arrived at it by a very different route. The unexpected thing in his free structure is the immense control. The unexpected thing in my controlled structure is the free play of visual forces . . . I try to keep the constituents of any complexity simple.

—BRIDGET RILEY TO ROBERT KUDIELKA

My freedom consists in my moving about within the narrow frame that I have assigned myself for each one of my undertakings. I shall go even further: my freedom will be so much greater and more meaningful, the more narrowly I limit my field of action and the more I surround myself with obstacles. Whatever diminishes constraint diminishes strength. The more constraints one imposes, the more one frees oneself from the chains that shackle the spirit.

—IGOR STRAVINSKY, BOSTON, 1940, QUOTED BY BRIDGET RILEY

Fifty years ago last February, Bridget Riley arrived in New York for the opening of *The Responsive Eye* exhibition at the Museum of Modern Art. She immediately embarked on one of the swiftest, most vertiginous and peculiar trajectories of praise and blame in the history of Manhattan art celebrity. Riley's paintings in *The Responsive Eye* were instantaneously the talk of the town and were universally recognized as the dominant works in the exhibition. Her concurrent solo exhibition at the Richard Feigen gallery sold out before the show opened, and not long thereafter, Josef Albers publicly claimed her as his "daughter." New York's acknowledged master of rigorous abstraction, Ad Reinhardt, volunteered to squire her around town (to protect her from the "wolves"), and even Salvador Dalí, who could

smell buzz, sought Riley out and paid court to her, with his full retinue and live leopard in tow.

Then things got crazy. Her paintings were hardly on the walls at MoMA and Feigen before op-art imitations of her work began to appear on dresses and scarves in fashionable shop windows along Fifth Avenue and in boutiques in the East Fifties. Fashion spreads proliferated in popular magazines and daily newspapers. Head shops in the Village began offering straight knockoffs of her paintings as posters. These soon adorned the walls of crash pads all over lower Manhattan, providing visual accompaniment to the strains of Chocolate Watchband and Strawberry Alarm Clock. Shocked and astonished, Riley accepted the support of Barnett Newman and tried to take the predators to court, but the damage had been done. Local critics, unnerved by the enthusiastic popular appropriation of their newly discovered diva, were soon muttering. They began hedging their original enthusiasm with terms like "decorative," "psychedelic," and "purely retinal." Carnaby Street fashion was mentioned. The bane of Warholian celebrity was bemoaned, and the dread specter of the egregious Peter Max evoked.

For Bridget Riley, devotee of Veronese and Seurat, haunter of museums, and rigorously adept in the young tradition of abstract painting, this carnival of celebrity and merchandising must have been hell on earth, but, as a friend of mine remarked at the time, Riley, at least, got to go home—unlike poor Pollock who had to live in the mess celebrity had made of his life. So home she went, to London, in a state of stunned dismay, fully convinced that it would be twenty years before anyone would look at her paintings seriously again. This turned out not to be the case, but henceforth, Riley would pursue her career in the UK and on the Continent, always keeping New York at arm's length, as one would a foolish and fickle lover. Looking back at that moment now, with the length and richness of Riley's subsequent career in evidence, one thing becomes clear: the clamor over her work was certainly justified, and the work itself almost fatally misconstrued.

We always see what's new, of course, and recognize it as such, but we see it with old eyes—until the new work makes our eyes new again. It was Riley's fate in the sixties to make works of art that any eyes could see, to make work that happened at a moment when artists let things happen,

when works of art were things that things happened to. Such works existed to be discovered, praised, analyzed, selected, and historicized by the old eyes of a discriminating elite. In an environment like this, paintings like Riley's that aspired to the rhetorical efficacy of the sixteenth-century Venetians and nineteenth-century Parisians whom she revered—paintings that could not help but be looked at—were simply anathema. In a moment when the painter's innocence, purity, and impudence were presumably redeemed by the critic's sensitivity, knowledge, and rigor, Riley was clearly more knowledgeable, sensitive, rigorous, and radical than any of her critics. What's more, she presumed that it was the artist's responsibility to be so. How else could one make new things happen?

Consequently, when you look at the progress of Riley's subsequent career, you discover the history of an artist perpetually trying to exploit the resources of tradition to keep from repeating it. This untraditional traditionalism is grounded in Stravinsky's edict: "that which is without tradition is plagiarism," and informed by Riley's own understanding that tradition is not history. "There are good traditions and bad traditions," she remarks, and to distinguish one from the other Riley is always narrowing her focus, creating rigorous, formal parameters and physical limits within which she can exercise her improvisational empiricism. Accepting Goethe's edict that "nothing but the law can give us freedom," she seeks out those places where the law releases energy. "The perceptual medium is so strong," she says, "the elements that one is using—that all painters use—have the dynamics of natural forces. They have their own laws, not rules but laws, and woe betide you if you upset the boat."

Riley's practice, then, might be described as a sequence of controlled efforts to rock the boat without upsetting it. Her op paintings from the sixties, for instance, evolved from her desire to demonstrate that "there are some absolutes: Black is not white." Even so, something happens at the intersection of black and white. There is a zone of dynamic mystery there that is anything but absolute. So having observed that "Titian achieves his unity by building the painting according to those very factors which would seem most likely to tear it apart," Riley sets out to do the same and creates paintings that maintain their cognitive unity while remaining virtually imperceptible. In her subsequent work, Riley will gradually relax the

rigorous destabilizing controls on her paintings in order to achieve more controlled effects.

In the op paintings, Riley destabilizes the entire zone between the beholder and the work. In her next series, which I call her Flavin paintings (1967–1979), she focuses on the ambience of colored light created by extended edges of juxtaposed pictorial color. These paintings operate in a more restricted pictorial space than the op paintings but, like them, they still flicker and flash almost at random with the dynamics of our retinal accommodation to them, like thunderstorms seen from the air. In her next series of work, which I call her Stravinsky paintings (1979–1990), Riley seriously addresses the musical analogy that her paintings evoke as a matter of course. Throughout Riley's career, her studies for paintings have always functioned less as plans to be executed than as scores to be performed. In the Stravinsky paintings, Riley's performance aspires not just to activate space but also to shape it. By intuitively juxtaposing a restricted palette of vertical stripes in musical sequences, she creates a narrow zone of advance and recession within which the space-making dynamics of our perception make the surface roll like the soft Pacific off Newport Beach.

The space created by Riley's more recently completed series of paintings, which I call her Veronese paintings (1990–1997), is even narrower—a taut, vibrating veil stretched across the surface of a canvas divided into an irregular pattern of diagonal parallelograms. The high-contrast color palette of these paintings is dispersed in such a way as to create cross-tensions that counter the radical thrust of the diagonals, à la Veronese's *The Adoration of the Kings* (1573). These cross-tensions keep the paintings from "moving" as Riley's previous paintings have, but they clearly want to move, and we feel this tension in our visual accommodation to the field. Riley's more recent paintings open up this field into large areas of soft-toned, closely valued color enclosed by overlapping curves of similar speeds, Sumerian curves, they seem to me. In their faux-naïf clarity, these new paintings evoke Rousseau and Matisse. Speculation about what these new works are doing, however, must wait until Riley is done with them. Until then, we can comfort ourselves with Riley's reminder that, if Mondrian was the Giotto of abstract painting, the High Renaissance is yet to come, and presume that, in one way or another, she is reaching toward that.

Now Bridget Riley is back in New York—not a moment too soon and without excuses. Her work is still in progress. Her paintings still succeed, as they always have, in their cool brightness, as art of the highest order within its deepest tradition. Should they fail in this aspiration, there are no fallback positions. If you care about them, then, you must care about this kind of art and recognize the anxious dazzle of the experience. Beyond that, none of the fashionable excuses that justify art by identifying it with something other than what it is are applicable. You can't get a note from your teacher, your therapist, your clergyman, or your decorator excusing your frivolous enthusiasm. The best you can expect is a note from a critic who recommends prolonged mystery without explanation, wisdom without education—but mostly, always, pleasure—what Riley herself describes as stimulating, active pleasure, comparable to "running . . . early morning . . . cold water, fresh things, slightly astringent . . . certain acid sorts of smells . . . like wood being cut."

This is the experience Americans now have the opportunity of rediscovering, which, in fact, is an experience that young American artists have been rediscovering for the last fifteen years, coming up to me at odd moments with tattered copies of *The Responsive Eye* catalog in hand, pointing to a reproduction of Riley's work and demanding to know, "What's this? Why haven't I been told about this!" I never have an answer, but I am reassured that young artists are now finding in Riley's work what she found in Seurat, what, in her own recounting, Delacroix found in Rubens. In an essay called "Painting Now" (1996), Riley reminds us that Delacroix, "convinced that painting had gone astray and lost sight of its basic principles . . . went hunting in the Louvre—scrutinizing, analyzing and searching the paintings he found there. In Rubens and later in Veronese he found what he was looking for: clean, fresh color used for the building of a painting."

What young Americans are discovering in Riley's work, of course, is exactly what she brought to New York in 1965 and brings with her now in the year 2000—clean, fresh color, to be sure, but also the idea of a clean, fresh, virtually authorless modernism expressed in painting and dependent for its authority on nothing more than what happens when we look at the work. What interests these young artists about Riley's work, however,

is something more specific. For them, her work constitutes an articulate precursor to the rhetorical-empirical brand of "behaviorist modernism" practiced by Bruce Nauman and Richard Serra, for whom, as for Riley, the manipulation of material and formal means is directed toward the evocation of a local, cognitive-kinesthetic experience that is quite distinct from linguistic communication (which presumes that the work of art bears a message) and formal appreciation (which posits the work of art as a dead thing, artfully manipulated and sensitively perceived).

For this generation of artists, Riley's work constitutes the missing link between what they know and what they should know better. By connecting the concerns of Nauman and Serra with those of Seurat and, through Seurat, with a tradition of art making that leads back to the triumph of Venetian painting, Riley's work infers a direction and a vision that heals the schism created by our recent, obsessive preoccupation with the dead nominality of physical objects and the putative circularity of linguistic expression. Most critically, however, Riley's work liberates young artists from the tyranny of explanation, since the reinstatement of Riley's work has, demonstrably, taken place without it, and contrary to all received opinion. Because something happens when we look at Riley's paintings, and that "something" resides neither in our perception of their object-hood nor in our understanding of them as works of art, but in their "plasticity," a quality which, according to Riley, "hangs between the cognitive reading of an image and its perception."

In his famous study *Logique du sens* (1969), Gilles Deleuze calls the attribute of "plasticity" the "sense" of an object—an attribute that operates according to its own "logic" that operates along the border between the proposition and the thing, between de jure and de facto. Apropos of Bridget Riley's method of bounded experimentation, Deleuze remarks that "the logic of sense is inspired in its entirety by empiricism. Only empiricism knows how to transcend the experiential dimensions of the visible, without falling into Ideas, and how to track down, evoke and perhaps produce a phantom at the limit of a lengthened or unfolded experience."

It is likewise appropriate, then, that Riley would use Deleuze's term in likening the experience of Seurat's *La Grande Jatte* to confronting a phantom in which "the unfathomable appears in the guise of total

visibility." In all of her discussions of artists she loves, in fact, Riley focuses on the realm of "sense," insisting the art occurs when the way we see something and the way we know it impinge upon one another. She identifies "the vital tension between knowledge and sensation" as the wellspring of Seurat's vision; she quotes Cézanne's remark that color is "the place where our brain and the universe meet," and observes that "Veronese lays bare the web which hangs between perception and cognition more openly than Titian because he doesn't seem to be interested in expression."

She repudiates Clement Greenberg's materialist reduction of the painter's medium to mere stuff, arguing instead that the means of painting are turned into a "medium" only by the response of the artist who, through those means, is trying to make something happen in the realm of sense. It is exactly at this level of abstraction that Riley thinks and works, and only at this level of abstraction that a tradition stretching from Titian to Nauman (both of whom Riley greatly admires) can even begin to exist.

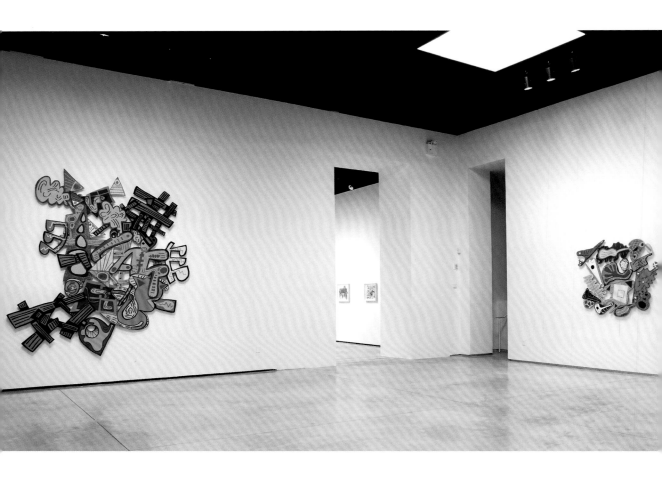

Elizabeth Murray

Dancing in the Dark

I am writing this essay while listening to John Coltrane and Miles Davis play "Billy Boy" set on repeat. Two years ago, I was lucky enough to see the Rolling Stones play a small room at the Hard Rock Hotel here in Las Vegas. The room was ultra-crowded, although it wouldn't have been nearly so crowded if the concertgoers, like the Stones themselves, were still trim. They weren't, of course. They had grown up and out, and they had come to have a good time forgetting it. Even so, everyone in the room, excepting perhaps Drew Barrymore and Cameron Diaz, looked a little bit awkward and out of place, myself included. Somewhere deep in my resentful heart, I think, I had come to scoff at old guys playing rock-and-roll, but the concert was, in fact, a dose of what you need, a woozy blend of cavalier insouciance and hardcore professionalism. The Stones, in other words, were dancing on the dark side of the mountain.

During the instrumental break in "It's Only Rock and Roll," Mick Jagger started bouncing around the stage, clapping his hands over his head, and I found myself cheering him on. How great, I thought, to be honing in on sixty years old still making your living by bouncing around in a T-shirt clapping your hands above your head. How prescient, I thought, to have devised for yourself as a youth, a practice with a built-in hedge against maturity and angst. Over the years, I have found myself cheering Elizabeth Murray's art in much the same way and for the same reasons, because early on Murray devised for herself a fountain of youth and good humor that has never run dry—that she has never *allowed* to run dry. So Murray's paintings may erupt and explode but they never flinch. They sustain their insouciance, dancing now on the dark side of the mountain—so persua-

sively that Murray's oeuvre is pretty much defined by this ebullient brand of courage. For her, if it's not too much, it's not enough; if it lacks high spirits, gestural eloquence, and blithe entropy, it's not Elizabeth Murray. If the art world ever giggles again, she will be acknowledged as the comic ingénue of her time.

As a consequence, in the gloomy pantheon of contemporary artists, Murray is the absolute mistress of high physical comedy, the hardworking party girl whose paintings with their slaphappy endings, artistic triumphs, and outright disasters take place while everything is happening at once. It often seems, in fact, as if Murray's design agenda involves throwing everything in the kitchen up in the air and trying to catch every thing before it all hits the ground. Some version of this strategy has always been Murray's *modus vivendi*. Over the years, in a Puritanical age of aesthetic divestiture, Murray has made a habit of acquisition and conglomeration. What was lost, she has found. What was neglected, she has attended to. What was dying, she has resuscitated. Of all the artists of her generation, who began their careers in the backwash of pop and minimalism, Murray alone found something to do with the pop sensibility that retains its spirit and ebullience, and since she has granted every painting its every whim, they seem calm and even relaxed in their chaos, like big old dogs dreaming by the fire.

Other artists under the influence of pop turned on its popular iconography in a new spirit of political critique. Others abandoned making things altogether and fashioned an "installation" aesthetic of manufactured found objects. For her part, Murray holds to Roy Lichtenstein's caveat that pop art is about art and not about pop. She holds to the American romance of small occasions that dates from Harnett and Peto—but with rather large caveats and special effects. First, she recoiled from the cool classicism of sixties pop painting. She dispensed with the refined grandeur of Lichtenstein's bourgeois interiors, the suburban intimacy of Wesselmann's eroticism, and the social panache of Warhol's chilly urbanity. In their place, Murray envisioned an unruly conjugal sublime, a language of chaos without terror, suffused with a destructive glee that always puts me in mind of the slow-motion exploding house at the end of Antonioni's *Zabriskie Point*—sexy without being sexual—sexy in the street sense of "Oh Boy!"

This new idiom, while still celebratory, aspires to embody the rough energy of a private tryst without pretending to control it. Like any number

of strong women artists—Joan Mitchell comes to mind—Murray seems dedicated to reminding the more ethereal habitués of high culture that we all have blood in our veins, and to this end, she has revivified the practice of gestural painting without trying to capture its spirit in anything so staid as the rectangle, without trying to flatten its expressiveness into anything so repressive as a picture plane, or to invest its speed and high spirits with any more anxious solemnity than a painted gesture can bear. So gestural painting is revivified and detoxified in a pictorial atmosphere that harks back to Miró and Picasso—their arrogant modesty and tongue-in-cheek surrealism. It is this debt to prewar art, I suspect, that provides Murray, almost alone among her peers, with the permission to evoke specific emotional atmospheres in her work.

Murray's paintings feel like something, like a genre or a species. The exploding images have their own specific energy and their ludic colors have their own music. These attributes combine with a graphic language that we almost understand and can nearly speak. We respond to Murray's paintings as we do to an opera in a language we don't quite understand. We attend the opera; we recognize the linguistic cognates and the voice of the music. We process the rhetoric of the singer's gestures and the iconography of the sets and costumes, and we do all of this so quickly that we almost forget that we don't know the language. Moreover, our not knowing the language may actually enhance the longevity of our interest, with our optimistic assumption that, eventually, we will. Or to put it another way, I have a sneaking suspicion that the crayon drawings an alien child might make and affix to the refrigerator door would look a lot like Elizabeth Murray's paintings, or they should.

Murray's idiomatic form of expression (which is, in fact, a new synthesis of older idioms) may be best described as still-life painting that is anything but still, that is more *vivant* than *nature morte*—a kind of "graphic cubism"—or "blobism," as a friend of mine calls it. Her debt to pop resides in the fact that Murray's paintings portray a relatively benign, although far from idyllic, image of bourgeois existence by deploying images-of-images in a manner that recalls the extravagant juxtapositions of Rosenquist and Rauschenberg, encoded and exploded. In the mechanics of this process, Murray overlays, abstracts, and encodes a private vocabulary of graphic images in a manner that is most reminiscent of Mayan glyphs. They con-

flate pictures, symbols, phonetic inflections, and syntactical markers into a unitary visual structure. The multiple, serial encodings of such glyphs (whether Mayan or Murray's) almost guarantee our ultimate failure to decipher and render them clear.

We look at Murray's paintings and we recognize the eggs, eyes, rooftops, rulers, furniture, fixtures, and baby snakes, but we are never sure whether these images signify objects or symbolize conditions. We accept the atmospherics of the blobs as pseudo-Oriental atmospherics. We read the talk balloons full of grids and squiggles as speech in another language, and interpret those little eighth-note triplets that appear in *Do the Dance* and *The Sun and the Moon* as musical accompaniment. Other recurring shapes, like the triangles, seem to function syntactically. In *The New World*, the triangle is at once a teepee and a frame for a landscape; in *Baby Snakes*, the triangle is either a corral for the baby snakes or their mommy's womb; in *The Sun and the Moon*, the triangle presents some kind of astrological vector—or maybe not. In any case, as a graphic linguist, Elizabeth Murray is sort of like Alfred Jensen with emotional reach and stories to tell—or someone like Keith Haring with a domestic life and a PhD.

The irony is that even though there is no modern painting with which Elizabeth Murray's painting doesn't have *something* to do, she is indebted to no one in her willingness to dispense with boundaries. The authoritarian pressure with which Miró and Picasso, Pollock and de Kooning force their painterly adventures into the rectangle or flatten them into a plane is graciously forgiven in Murray's work. The potential energy at the edge of the painting and on its surface of picture plane blows out, blossoming from the "picture plane," encroaching on the space around the edge and only stopping when it needs to. As a result, the crazy repose you feel in their presence. For all their zany energy, there is nothing neurotic about them. They are relaxed paintings because the artist has repressed no instinct or tendency. They are where they want to be as paintings, finished, successful, and in repose. They have grown into their full, extravagant, noisy eccentricity with the artist's ludic permission, and they have no plans to turn down the volume as the darkness gathers.

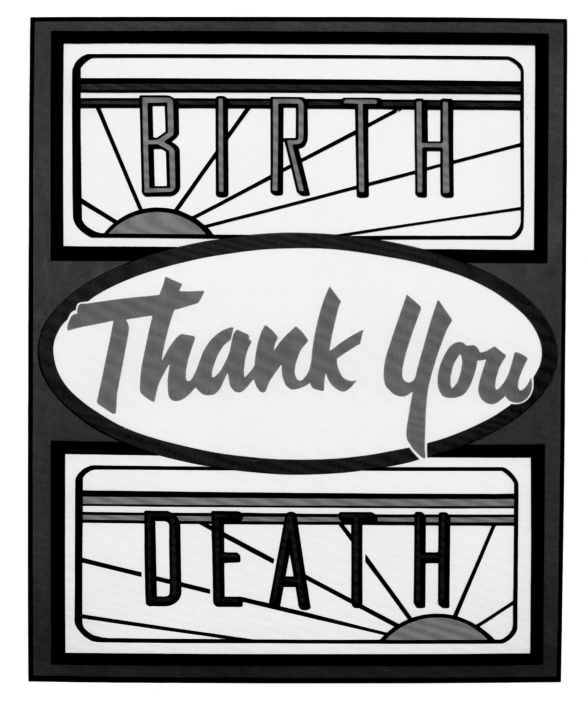

Karen Carson

Sophisticate

Then I pricked my finger on a thorn, or a thistle,
Put my finger in my mouth, and ran to my mother.
Now I lie here with my eyes on a pistol,
And there will be a morrow, and another, and another.
—DJUNA BARNES, *LULLABY*

About a decade ago, I momentarily lost my "pluck." I sat at my desk, moped and didn't write; and, sitting there one day, unable to write or read or even think properly, I began making this little sign out of a sheet of yellow note-paper. It said: "The Day We Die Is Just Another Day" in a Weiss Initials font. I embellished the words with leaves and flowers and put some smiley faces in the corners. I pushpinned the sign to the wall over my desk, and after that, every time I looked up at the sign, I laughed, because the day I made that sign was "just another day"—during which I obviously had enough free time to advertise my own angst. Over the next few weeks, that laughter transmuted itself into whatever passes for acceptance and fortitude among folks who are in no danger of violence, penury, or oblivion, so I just got over it.

Having done so, it occurred to me that had I made that image seriously in the first place, as an artist might, with the implicit intention of making it public, I should have encountered its delusional anomalies from jump street. This would have necessitated decisions about the ethics of presenting oneself in the world. I saw three options: First, I could have taken the "political option," applying my little slogan to the wall in Helvetica press-type and surrounding it with blurry, xeroxed photographs of the wretched of the earth, pretending to divert concern from myself toward the needs

Karen Carson, *Thank You*, 1994. Silkscreen on paper (edition of 15), 33 + 26 in. Courtesy of the artist.

of all mankind, while, in fact, clothing my self-regard in raiment of irreproachable virtue. This was too egregious even for me.

So I considered the "pathetic" option of simply pushpinning that yellow sheet to the gallery wall. This strategy, I had no doubt, would elicit tugs of protective, parental sympathy from a few of my potential beholders, but if I were going to do this, I could just as easily chain a puppy to the gallery floor, sign its butt, and attach an outrageous price. Finally, I was forced to consider the final option: I might, perhaps, behave like an adult in full possession of my powers and *crank it up*—affirm my own sentiment and redeem it with glamour and invention. "The Day We Die Is Just Another Day!" Ta-dah! That would work! I thought, and the beholder would be freed from acknowledging the artist as a repository of pseudo-self-effacing angst. And if the image had pluck, candor, and sophistication, it might own up to its maker's undeniable privilege and pleasure at being free enough and able enough to celebrate Neurosis in Excelsior.

To put it simply, if were I an artist in this situation, I would have made a "Karen Carson." I would have aspired to that passionate, cosmopolitan irony of which she is the living mistress because no one knows better than Karen that we all live Jane Austen lives with Dostoyevsky aspirations, and no one reminds us of this embarrassing fact with more forgiving acuity. So it is a pleasure to write about her art because you may not have seen it. She is a walking moral confrontation, damned with a level of knowingness, wit, and self-sufficiency that doesn't encourage "helpers," "mommies," or "impresarios." In this artistic era of sincerity and cynicism, she is probably the only person in the art world who could hold her own as a witty sophisticate at the Algonquin. (Her quick cartoons of Park Avenue dowagers parading down the sidewalk, leading dog-collared angels hovering above, would be perfect Algonquin fare.)

For nearly twenty-five years, Carson has been the queen of fashionista drama queens and the font of razor-sharp bon mots ("First sex, then gender. We're at war with these guys but we have fun fucking them.") Upon leaving Judy Chicago's feminist group, Carson announced that she was not bound by Judy's chains, and whatever chains Carson might be bound by, produce inexplicable, theatrical swoons and witty works of art. From the wry, striptease minimalism of her early zipper pieces, through the gaudy smoke and mirrors of her abstract "hot flashes" in the eighties, to the im-

pudent, in-your-face individualism of her more recent Vegas koans, Carson's work has consistently skewered everything I have come to despise about the public discourse of art in this nation. She is the mistress of a maneuver called the "jump-shift" by screenwriters, of moving quickly from here to there with no transition. *Recherché* metanarratives of style, politics, religion, and identity are simply *consumed* by Carson's acquisitive penchant and manifest themselves as a skeptical visual ethic—a habit of mind and heart.

Thus, at any point in Karen's career, the temper of the time, the state of the art, and the condition of her own sensibility resolve themselves in the physicality of the moment. Everything is always there: painting and drawing, image and object, narrative and arrangement, domesticity and formal grandeur, decoration and dishabille. The hard surface of local reality asserts itself—perpetually compromised by the irrevocable ability of the human mark to make space where none exists, transforming the time we spend looking at the art into a story of its own.

Even so, I have kept my pleasure to myself, a secret vice, like the barroom you drop by on the way home from church. I have always hesitated to write about it, lest I damn it with my praise, because, as comedians say in Las Vegas, Carson is "above your pay grade." How can one praise work for its wit and candor in a historical moment best characterized by earnestness, cynicism, and hypocrisy? So I have kept my counsel, cautioned by the knowledge that somehow, for some reason, the single most privileged, permissive, and secular subculture in the known world—that of the visual arts—has taken on the project of banishing any evidence of its privileged worldliness from the objects it purveys.

As a consequence, any piece of criticism that sets out to comment on Karen Carson's work must also defend the work's failure to disguise the fact that its maker is a woman of the world—a hardworking, passionate, secular female of considerable wit and erudition—and in failing to disguise who *she* is, Karen's work thoughtlessly fails to disguise who *we* are: closet lotus-eaters, nibbling behind our hands—civil servants, bureaucrats, tradesmen, and entrepreneurs who strive to think and feel and see with some intensity in relative safety and comfort, not in drawing rooms perhaps, but rarely in mean streets or on the moor.

Our feckless namesakes tread the stage in plays by Oscar Wilde and

Tom Stoppard. We suffer, but rarely, if ever, do we shoot one another, or beat one another senseless, or even detonate cubes of C-4 beneath the institutions that fund our lovely salads. Still we routinely pale at the prospect of an art that acknowledges our complicity in the silly-serious mode of bourgeois existence that we have invented for ourselves. As a consequence, at this moment, Karen Carson pretty much has the run of this tenebrous, comedic stage upon which Dorothy Parker must play Joan of Arc. She is a specialist in theatrical artifacts that refuse to transcend their domestic circumstances or make any special claim to righteousness.

Upon this stage, Karen is diva and maestro, her specialty is the extravagant *intime,* the operatic clock, "the tempest in the teacup"—the real tempest and the real teacup—the gorgeous tempest of raw sensibility—the delicate teacup of private life in a city with good weather. So her works protest and celebrate the privilege of doing so. And even when her heart is on her sleeve, she never fails to acknowledge that it is a very well tailored sleeve. Because, as she will tell you, it is precisely the aura of domestic comedy that privileges the sheer intensity of her work and defends it against the implication of striving to transcend this vale of tranquilizers and kale.

So Karen may show us Lincoln Boulevard in Venice, California, as a postcubist explosion of color, mirrors, hardware, and graffiti, but gritty, tacky Lincoln Boulevard is not occluded. Karen's image is made of the same urban stuff, and with the same offhand ebullience. That is the joke and the affirmation: it is everyday magic—so plangently everyday, in fact, that even her cartoon *angels* seem to dwell on Lincoln Boulevard, to wing their way through the smog in a miasma of erotic anxiety. Yet, somehow, we have difficulties with the idea that a practice this intense, so heavily invested with love and invention, should claim so little for itself in the area of universal profundity. We are so accustomed to grandiose content in domestic dishabille that we are disconcerted with Karen's inversion of this convention. It seems at once too theatrical to be so down-to-earth, but that's our girl. She moves with the times like a streetwise couturier. Every eighteen months or so, she is out with a new line of cosmopolitan schadenfreude.

Most dangerously for her career, I suspect, Karen's project is simply too fluid and too candid. It reminds us of our furtive, domestic pleasures:

We huddle at the cozy hearth and thrill ourselves with visions of the night; we lie down in mink-lined coffins to dream of dirty sex with local bikers; and Miss Carson, like the Lutheran libertine that she is, *condones* such tiny indiscretions as the stuff of life and forgives us (as she forgives herself). But she never lets us off the hook—never lets us stand before her work without confronting, at some level, the complexity and complicity of the artist's position in the late twentieth century—the scandal of pleasure that nestles at the heart of it.

So, today, a drawing by Karen Carson hangs above my desk. It is ominous, elegant, and confident in its privileged paranoia. It is less a drawing, actually, than a sinister object that contains a drawing inside it: a heavy, glossy, black, ornamental, beaux-arts frame enclosing a thick sheet of dark-green Plexiglas beneath which, when the light is right, an image flickers just on the verge of legibility. When we look closely, the image floats up out of the green mist like a memory of satanic abuse, revealing a battle (or the moment before a battle) in *The Great War of Iconography*—rendered as a mock-epic moment in some pop-culture *Rape of the Lock*.

This particular work is from a series that Karen calls her *Innocence* drawings. The content of these drawings is based on a narrative trope that we may best imagine in Disney animation: We are floating high in the air above the dirty, glowing grid of contemporary Los Angeles, then, losing altitude, we zoom across rooftops and along Venice Boulevard, execute a hard bank to the left and slip through the door of a tattoo parlor just as the owner is closing it behind him. Inside the darkened shop, the cartooned tattoo templates pinned to the wall begin to flutter, rattling the tissue upon which they are drawn, and then, one after another, the black images fly off the paper and swoop around the empty shop.

Some of them are bats, but there are eagles too, and dragons, knives, bombs, serpents, panthers, fighter planes, battleships, bloody hearts, and warrior maidens. Once airborne, this thick squadron of aggressive iconography curls downward and whooshes under the door into the adjoining storefront, a Hallmark card shop whose Arcadian population is, itself, just awakening into animation. Handsome shepherds and fetching milkmaids yawn and stretch. Cute puppies and cuddly lambs stagger about on sleepy legs; darling kids rub their eyes with tiny fists, arousing themselves from innocent repose.

In the drawing above my desk, a cute kid in a baseball uniform, with his cap on sideways and his bat raised in hitter's position occupies the center of the drawing. He peers earnestly out at us through the green twilight, awaiting the first pitch, oblivious to the cloud of demons swirling all around him, threatening to engulf him; and it's not hard to see how this image might have come into being as a defensive reflex against the never-ending image barrage of contemporary Los Angeles. Unlike my yellow drawing, however, Karen immediately carries her neurosis into the realm of redemption, demonstrating to us that however much we may decry the brutal sensory onslaught of urban life, the dangers we live with as contemporary Americans dwell largely in the realm of iconography, that it is less the wolf at our door than the image of the wolf that terrifies us—that, in fact, even the cute little kid with the baseball bat is a little bit creepy and must bear his own load of complicity in the image. In this way, Karen's drawing presents itself to me every morning as an exercise in the acquisition of ironic tolerance that more or less defines cosmopolitanism, which, in the United States, is the name we give to getting over our small-town utopian longings.

Herein, I would suggest, lies the abiding virtue of Karen Carson's shameless veracity. Empowered by it, or driven by it, Karen can reveal what half the artists in America are striving to conceal with their plangent altruism: that eternal, annoying American bleat of embattled innocence. Because she is honest, we can always hear it, squealing in the subcortex of Carson's endeavor, making itself heard amidst all the learned allusions, the knowing ironies, and the social graces. To silence it, for Karen, would constitute willful deceit. So as F. Scott Fitzgerald does with the character of Gatsby, Karen owns up to the primal whine. Then puts it in its place—inviting us to respond to that obscene little baseball player with an embarrassing tug of self-serving identification, even as we loathe ourselves for doing so.

Finally, it is Karen's great gift to keep that offended longing so clearly at the heart of things while transforming it so consistently into forgiving artifacts. In the process, she has evolved an artistic and intellectual position that is as remote from the small-town gee-whiz of her childhood as it is from the pat cynicism of the world she presently inhabits. You could describe her manner as another kind of innocence, I suppose, and it is sim-

ilar, in many of its aspects, to the accepting pop innocence of Warhol, but it is not quite that. Carson loves the daily, textured world too much and with too much enthusiasm. It is closer, I would suggest, to the benign worldliness of those children in Henry James, who also love the world without approving it, whose uninflected gaze, bereft of expectations, sees everything, knows everything, and owns up to everything without remorse. What Maisie knew, I suspect, Karen Carson knows as well.

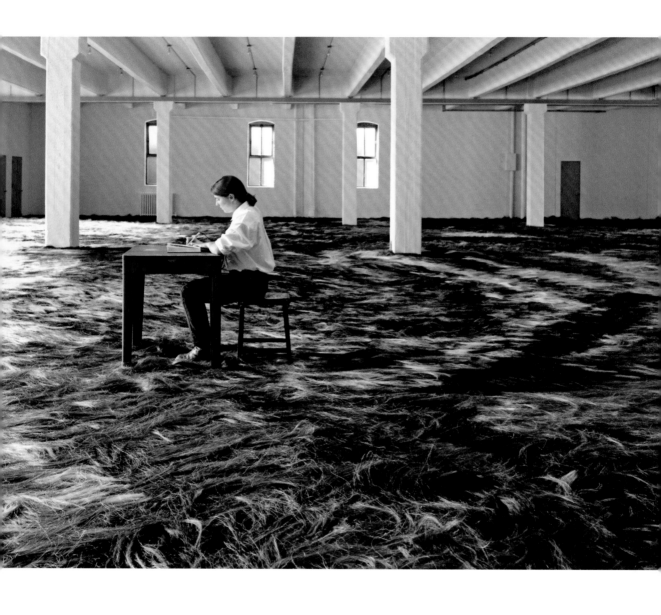

Ann Hamilton

Thinking Things Through

If I had a heroine when I was young, it was probably my grandmother, Lois. We used to read to each other. One of us would read while the other did some household chore. Mostly she would read, of course, so my memories of her all revolve around words. She would read to me, and I would immediately start daydreaming. So, if you ask me what she read, I can only give you hazy answers. What I remember most is her voice, the rhythm of her reading . . . I didn't care what she read once we left Winnie the Pooh, but I remember her voice.

—ANN HAMILTON, 1993

Ann Hamilton was born in Lima, Ohio, in 1956. She grew up in Columbus, Ohio, and until 1991 her career was pretty much boilerplate: a college in the Midwest, graduate school on the East Coast, job on the West Coast. She showed here and there, at this museum and that festival, won this prize and that award—etc. Then, in 1991, Ann Hamilton moved back to Columbus, Ohio. This was news. Artists do not move back home anymore, so I spent a few days in an overheated, patterned, flounced, and ruffled room on the second floor of a bed-and-breakfast in Columbus, Ohio, owned and operated by two of the heartiest Christians in Ohio.

The tiny window of my room overlooked a narrow, sycamore-shaded street. I immediately flung the window open. There was moonlight out there on the sycamore leaves, and a soft breeze shushing through them. I felt like Thomas Wolfe, "lost and by the wind grieved." I pulled my head back in. A framed rubbing from the tombstone of Samuel Clemens (1835–1910) interrupted the flowered wallpaper on the wall opposite my bed. I noticed similar rubbings throughout the house: Emily Dickinson (1830–1886) and Louisa May Alcott (1832–1888) in the upstairs hallway; in the downstairs parlor, I spotted evidence that both Ralph Waldo Emerson (1803–

Ann Hamilton, *tropos*, 1993-1994. Dia Center for the Arts, New York, NY. Photograph by Thibault Jeanson. Courtesy of Ann Hamilton Studio.

1882) and John Greenleaf Whittier (1807–1892) had lived, written, and died. I took these rubbings to be an earnest, if macabre, tribute to the flowering of nineteenth-century American letters, until I discovered that the reading matter at hand dealt almost exclusively with nature (gardening, local flora, matters equestrian), religion (Protestant), and local history (Ohio and the Ohio State Buckeyes).

I thought about this anomaly, and the "piping hot" food served from the cozy kitchen by the ebullient Christians, and the starched napkins and the crisp sunlight angling through the lace curtains and spilling in lacy patterns onto the rose-patterned carpet. I considered the total absence of neon, cocoa palms, and poker tables and I began to suspect that the gravestone rubbings were not there to celebrate the fact that Twain and Dickinson and Emerson had lived, but to remind me that they were dead and it served them right.

When Ann Hamilton picked me up the next morning, I favored her with my supposition. Hamilton allowed that my "rubbings" theory was probably a valid reading, and by way of redeeming Columbus in my eyes she took me on a tour of a used bookstores. On our way I pressed Hamilton a little about the "quilting bee" aspects of her work. She made a face and said that it was fun to work with other people, but the "quilting bee" aspect really didn't matter. "I'm interested in the accretion of small gestures, in the way we build the world with them. Immersing people in a communal bonding experience is actually counterproductive. I want people paying attention to how they take up space, to how they're doing something. Like the figure washing her hands in honey, I was really interested in how that exercise of privation and excess might be done—in the greed and denial of that gesture. Mythologizing domesticity only gets in the way. The group labor has more to do with the scale at which I imagine things. You can't be inside a painting and I want people to be absorbed into a physical kind of mass. I want to be absorbed—and I want it to be really beautiful and really present, you know. That takes a lot of work and sometimes a lot of people."

In the first bookstore, I was confident of discovering a well-thumbed copy of Whittier's *Snowbound* among the used books. I didn't find one, but I did find two Morse Peckham anthologies, an album of Julia Margaret Cameron photographs, and a copy of Julian Jaynes's *The Origins of Consciousness in the Breakdown of the Bicameral Mind*. I gave it to Ann Hamilton. She gave me a book by Walter Ong, and I couldn't help but be reminded of the

walls of books that Hamilton had installed in the gallery at MIT, nor could I avoid noticing the way Hamilton drifted down the aisles, calmly stopping here and there, then drifting on. It was the first time I had seen her demonstrate anything close to nonpurposive behavior, the first time I had seen her abandon her confident, no-nonsense stride and just mosey along.

It was interesting because, obviously, Ann Hamilton wasn't predatory about books, but she was clearly being fed by being among them. She floated, comfortable in the atmosphere of language; and I realized that, for me, language is nearly always sensual transportation, for Hamilton, it is a place. It is the physical presence of language that beguiles her, not the absence that it signifies or the transportation it provides. She loves the physical page, the book, the way it smells—the voice, its timbre, the atmosphere that it activates and fulfills. And this, I decided, was the community that entranced her, not the community of iterative labor, but the community of voices, like the atmosphere of culture that her grandmother's reading brought into being, the palpable, ephemeral opera of that ongoing, murmuring conversation. Here is John Shearman on that timorous relationship

> Raphael's portrait of Tommaso Inghirami introduces a paradox. Can it be right to interpret a spectator-subject relationship when the subject is explicitly described as unaware of anyone but himself? There are a number of very beautiful, very imaginative portraits . . . of the creatively distracted like Raphael's Inghirami or of the utterly absorbed reader . . . in Correggio's picture in Castello Sforzesco, or of the man lost to the world altogether, in a state of reverie, as in the extraordinary Moretto in London. In such portraits the reverie is descriptive not of a generalized state of mind, as it might still be in an idealized image, but in a space of a particularized character, because the context of the state of mind is emphatically particularized in . . . the lighting, texture, environment, and not least by a descriptive affinity with the spectator. But I find that in such cases, when the viewer is made to feel that, in a sense, he ought not to be present, he is all the more aware that he is, that his position and affinity are peculiarly privileged. Also, these portraits engage us all the more because they, preeminently, redefine the question. What is represented? What is supposed to be going on?

Standing within Ann Hamilton's *tropos* in a third-floor loft at the DIA Foundation in New York, "What's going on" is an urgent question. The room is approximately ninety-six feet wide by ninety-six feet long with a fifteen-foot ceiling. The rectangle of the room is notched by a large freight elevator centered on its long front wall, creating a U-shaped working space illuminated from three sides by large windows whose clear panes have been replaced by a marbled, translucent industrial glass reinforced by wire in diamond patterns. The brick walls are painted off-white, as are the ribbed concrete ceiling and the square concrete pillars that support the ceiling. The entire concrete floor of the room has been repoured into an irregular prairie of slow dips, swells, and berms. Its entire rolling surface is carpeted with a swirling layer of horsehair whose color shifts in mottled gradations from black to sorrel to blonde like a pied pony. The piece is entitled *tropos,* which alludes to the troposphere, the lowest level of the earth's atmosphere and to those phenomena that cling closest to the earth.

Entering the space through a door situated at the upper-left-hand corner of the "U," your gaze is drawn diagonally across the room through a haze of smoke and silvery light toward a young woman who sits facing away from us reading a book at a small table that is incongruously perched on a gentle rise of surging horsehair. As you shuffle into the young woman's territory, you discover that the acrid smoke blurring the atmosphere rises in a thin stream from the page of a book whose lines, as the young lady reads them, are studiously burned away, phrase by phrase, with a homemade electric instrument that fills the air with a palpable aura of disappearing language. The language smoke is reinforced by a disembodied floating male voice enunciating unintelligible phrases with actual words that are being read by a vocally impaired stroke victim whose reading and speaking skills have been biologically rewired. The lines he reads, however, fall in stately, homiletic periods while remaining totally indecipherable. In the lines, we discern the vocabulary and the diction of modern American poetry, of T. S. Eliot's *Burnt Norton* probably, or Ezra Pound perhaps.

The effect of the deracinated poetry is disconcerting, but once we perceive the disembodied rolling voice and the swirling, worded smoke as coextensive and analogous to the swirling horsehair, the quotidian sublinguistic context of Hamilton's tableau becomes more available to us.

Its synesthetic haze of incinerated ink, paper, and garbled vocalizations is rather straightforwardly presented to us as the sensory effluvia of the young woman's reading as that activity might insinuate itself into a prelinguistic consciousness—as it might be overheard, perhaps, in the basement of the subcortex. In any case, we stand slightly off the vertical, ankle deep in a fractal slurry of hair, swaddled in smoke and vocalization, all but adrift in a fluid, decontextualized territory that quite rigorously means nothing and hides nothing—but which, when inflected by the slightest outside stimuli or colored by the merest whim of reverie, seems capable of meaning almost anything.

During my first few minutes in the space, I noticed the embodied musculature of the Gothic line—a rolling section of prairie steppe, much miniaturized—like the mountains of Michoacán from twenty thousand feet, or a languorous Caribbean swell, frozen in its flux, or the flank of my beagle, Ralph, much magnified. I listened to the liturgical cadences of the drifting voice and heard T. S. Eliot scrambled but still in cadence and saw a Wasteland swathed in smoke. And thanks to the millions of paintings that live inside my eye, I looked down and found myself walking on a Titian, striding across its surface, keeping pace with the swift, sure scumble of the master's horsehair brush; and having seen the giant Titian beneath my feet, I lifted my eyes and found the haze of Leonardo's trademark sfumato, and I could have continued. Had I stayed, I could have woven a filigree of allegory to rival the Alhambra while knowing that I hadn't added a thing to it, that I had discovered nothing but my own associative proclivities on that cognitive vacant lot, which was not even mine to interpret, which belonged to its guardian, to the absorbed young woman seated at the table, reading and burning language.

We are placed inside a situation that we must remain outside of—since the atmosphere we inhabit is clearly an externalization of the consciousness presiding over it. If, like Alice, we could step through the frame into Raphael's portrait of Cardinal Inghirami—if we could stand beside the cardinal's desk as he reads—our situation would be much the same and equally proto-mythic. We would have full benefit of the atmosphere that Raphael creates for his friend and of whatever knowledge its ambience might convey, but the full, active content of the work would still seem occluded and remote, although, as trespassers in Inghirami's space,

we would be preternaturally sensitive to the nuances of that atmosphere. (I always imagine the Cardinal refusing to just *sit there* for a portrait and Raphael proposing that he read as a compromise.) In any case, as we occupy an analogous position in *tropos*, it is easy to understand why Hamilton refers to the figures that inhabit nearly all of her work as "guardians," because they do, in fact, guard her works. They override the values of the institutions that enclose them and attenuate the proprietary gaze of the beholders who visit them.

⌐

After breakfast that Christmas morning, James Elliot Taylor and I emerged from the warm kitchen bundled in coats, hats, scarves, and gloves. We loaded the sacks of feed into the bed of the pickup as quickly as we could on account of the cold. Then we clambered into the cab and headed out through the bright, deserted streets of residential Lubbock. The curbs were lined with American cars parked in front of ranch-style homes that were set well back from the street, centered in plots of yellow grass, each trimmed with evergreen and adorned with red ribbons. Over the clatter of the truck's heater, we could hear bells bonging out Christmas carols—"Joy to the World" and "Good King Wenceslaus"—but, otherwise, everything was cold and still. The cab of the pickup smelled of dry cow dung, cold grease, and James Elliot's Red Man snuff.

Eventually, the houses fell away and the flat horizon began to assert itself. James Elliot pointed up the road. "There 'tis," he said, indicating a low cluster of tidy silver cattle pens constructed of welded pipe. The pens were set about fifty feet off the road and surrounded by raw dirt cotton fields. As we pulled off the blacktop onto the gravel, we could see the dark cattle in the pens bestir themselves. They began to drift toward the troughs.

"Amazing," I said.

"Huh," James Elliot said.

By the time we pulled to a stop beside the pens, the animals had arranged themselves in two rows according to some bovine nudging order, one row just in front of the troughs and a second row, tucked between them, about half a cow back.

"What are they thinking?" I asked.

"They're thinking they're gonna get fed," James Elliot said.

"No, I mean, do you think they really think?"

James Elliot pulled his hat down over his eyes and gave this some thought as he climbed down out of the truck. Walking up to the pens, he offered his conclusions:

"Well," he said, "whenever the truck hits the gravel, the animals head for the troughs. So I guess you could say they think a little. But, then again, they're obviously not worried about *why* I'm feeding 'em. So you could also say that even if they do think . . . *they don't think things through!*"

While we were loading the troughs, James Elliot went on to explain that being in the livestock business undercut one's confidence in the Scripture. "If you raise animals for slaughter," he said, flopping the open mouth of a grain sack over the edge of the trough, "the Twenty-third Psalm is not all that reassuring. 'The Lord is my shepherd' is fine unless you know that shepherds raise animals for slaughter. This is just shepherding," he said, indicating the feedlot with his chin, "but with better equipment."

⌣

This Arcadian memory, bright and intact, rose into my consciousness on a cool November evening, careening uptown in a Manhattan taxicab, I was happy for it. Earlier that day we had walked through Ann Hamilton's *tropos*, and in the interim, I had been talking with the artist about that mysterious endeavor—so this unbidden recollection amounted to the first intellectual fruit of those encounters. The horsehide. The cowhide. That smell. When I was younger, I would have dismissed it as neural static, but I have learned to trust those random bits of image and anecdote that the brain tosses up in the face of difficult art. More often than not, these fragments define a territory of confluence between one's own sensibility and that of the work.

In this case, my preconscious had managed to come up with a point of intersection—one of the few—between Hamilton and myself. As banal as it seemed, it led me to suppose that somewhere in Hamilton's background there must have been some experiential analogy to James Elliot's subversive insight into the darker aspects of shepherding—for, if Hamilton's work did nothing else, it fretted away relentlessly at the duplicitous relationship between humans and the living world in those communities where nature and culture overlap, where natural economies and abstract

economies rub one another raw. So I found myself thinking about the sheep—the ones that Hamilton had penned up in San Francisco in the anteroom adjacent to a meadow of pennies and honey. Blood into money and sweets, would be my reading. Almost certainly, I thought, these captive creatures and that field of sweet currency were Hamilton's clear-eyed way of insisting that the penned sheep were doubtless thinking: "The Lord is my shepherd, indeed!"

Criticism tends to work like this for me. It arises, when it does, out of the cacophony of such tangential similitudes and differences—and the more I thought about Hamilton's work, the more theatrical our own differences seemed to be. The clearer it became that, while I might be far from the ideal beholder for Hamilton's work, I was very nearly the ideal student for the visceral lessons it had to teach about the language and the blood—living, as I do, so happily, such a long way from the farm. Occasionally, at the Las Vegas airport, I will spot the white lobster plane from Seattle as it taxis over to the freight depot, but this is as close as I come, these days, to the livestock business. Otherwise, I live in a fissure of twentieth-century civilization wedged between the Metropolis and the Wilderness—between the pure neon of Las Vegas and the pure desolation of the Mojave that surrounds it. A few feet and a million years divide them.

Ann Hamilton is and always has been a creature of the Town and the Country, of the village and the farm—the daughter of a world in which nature and culture have so completely bled into one another that they are indistinguishable—where such nature as survives has been domesticated into "agriculture"—where such culture as exists has been subsumed beneath the rhetoric of "human nature." Further, she has rigorously delimited the physical language of her art to the province of this nature/culture overlay, eliminating the exclusively "cultural" idiom of the Metropolis and the exclusively "natural" idiom of the Wilderness. This has contributed heavily to the exotic appeal of Hamilton's work and to its casual misapprehension.

We are so used to the urban language of "art in the age of mechanical reproduction," and to the wilderness language of "unspoiled grandeur" that we sometimes forget that Baudelaire did not invent urban culture nor Frederic Church wild nature—that both of these iconographies are the products of displacement. They are idealized antinomies from the wishful

dreams of human inhabitants of pastoral cultures positioned at the cruel interface of domesticated nature and naturalized culture. We forget that we live in the utopian dreams of Protestant country people who tilled the earth, fed their livestock, slaughtered them and ate them, and dreamed of a peaceable kingdom without harvest or slaughter, who lived out their lives within the gestalt of large families, in full view of family and neighbors, and dreamed of a larger and more private world of the city where one might be free of that suffocating, tribal intimacy and the hard predation of human survival.

Considering our forgetfulness, it is at once cautionary and refreshing to confront an art like Hamilton's that preempts both the rhetoric of mechanical reproduction and the liturgy of Arcadian nature and delves into these indeterminate, fractal mysteries. In this sense, we should regard Hamilton's endeavor as an extension of the disheveled agendas that were introduced into American art in the late sixties by Eva Hesse, Robert Smithson, Richard Serra, and Bruce Nauman. These artists insisted upon art's status as labor made manifest. Their endeavors made cruel fun of the object's pretense to autonomy and cast an equally acerbic glance at the institution's ambition to possess such objectified human struggle. Hamilton might be said to have executed a genetic shift. Where Hesse, Smithson, Serra, and Nauman concerned themselves with the calamitous intersection of human industry and inanimate nature, Hamilton concerns herself with the high-viscosity tussle of working humans and living nature, with the preindustrial economies of grazing and agriculture that feed industrial economy.

One problem arises. These preindustrial economies are so heavily invested with cultural nostalgia that Hamilton can inadvertently evoke it for stubborn utopians unwilling to dispense with its glow. It becomes vulnerable to nineteenth-century habits of nomenclature that denote the Metropolis and the Wilderness as "masculine" venues while designating the Town and Country as "feminine" enclaves. Thus, Hamilton's work is routinely ghettoized as "woman's work"—most often by women who should know better—and gathered into that branch of art making that revels in the mysticism of iterative practice and the communal romance of "materials." This is an understandable defensive reaction, I suppose, considering the ruthlessness with which Hamilton's practice lays bare the masochistic

justifications that human culture has conjured up to redeem such mindless "woman's work" and to valorize all the dehumanizing labor required to translate nature's cataclysmic processes into a rational, usable form. Even so, as Hamilton herself puts it: she is nobody's "material girl"—and, as anyone who has talked to her will testify, she tends to regard the willful labor required to make her art with wry anxiety, as if the proclivity to do that work were a kind of hereditary Puritan disease for which the art is but a momentary palliative.

Still, even though romantic "materiality" and the cult of "caring woman's work" are light-years from the heart of Hamilton's endeavor, it is instructive to note just how profoundly the iconographies of the Metropolis and the Wilderness have been purged from her idiom. Finally, there is nothing wild nor anything cosmopolitan in Hamilton's language. The animals and the animal products that Hamilton integrates into her work are exclusively domestic commodities, organisms co-opted by culture. She employs producers and performers (sheep, canaries, silkworms, bees), their products and byproducts (honey, turkey flesh, horsehair, pigskin, tallow, and inarticulate song). Even meat-eating Dermestid beetles are recruited to devour turkey carcasses. Their breeders usually sell these insects to museums to devour the flesh of animals without damaging the bones. The Kiowa would look askance at this Enlightenment brutality. The plant life Hamilton uses is likewise domesticated: functional greenery like eucalyptus, cash crops and products like flax, lettuce, flowers, indigo, and grain.

Beyond these animal and vegetable products, there is very little manufactured in Hamilton's work, just the occasional domestic artifact: a sink, a table, a chair, a cabinet, a shirt, a bag, a loaf of bread. For these objects to exist, the Industrial Revolution need never have transpired—the fixed firmament of replicated urban artifacts need never have come into being; and as if to emphasize this point, the preexisting architectural enclosures within which Hamilton's works are routinely, and even aggressively, defaced and made mutable. The layers of candle soot and grime that contemporary restorers have been meticulously removing from the Sistine Chapel are meticulously reapplied by Hamilton and her assistants to the walls and ceilings of the Henry Gallery in Seattle—and such songs as fill this secular church are provided by hothouse canaries, flown in from Belgium to sing until they die—as die they must—and as we must die as well.

The historical genre of Hamilton's artistic endeavor, then, is certainly that of the vanitas and very cold indeed—a genre invented to tell the mutable tragedy of material culture—the story of lost song, disappearing language, and dissolving smoke. As told by Hamilton, these stories tell themselves in colossal, not-so-still-lives that do not survive, as a painting might, but exist as momentary, material occasions to meditate upon the vanity and complexity of human wishes. They suggest a glimmer of redemption and then dissolve into the larger economy of things. This rhetoric of perpetual struggle and dissolution recalls John Calvin, sleeping in his coffin, and even if one doesn't go that far, it is hard to avoid the inference of a refined, Puritan sensibility at work in Hamilton's art. It is, however, a heretical Puritan sensibility, beyond the church—a Puritanism as distrustful of the Word as it is despairing of the Body, and full of longing for both.

Hamilton is the wordless poet of a world that defies abstraction—a world of abattoirs and plain churches—a world whose economies produce the food we eat, the shelter we seek, and the clothes we wear—whose values are ruthlessly focused on the disciplines of that production—on the "real economies" of en-cultured nature—to use the artist's phrase. The whole construction of denatured "permanent" urban civilization feeds itself upon the plunder and production of the Town and the Country. Ann Hamilton's bodily knowledge of this plunder and production might be taken as her gift to us; and her project as an artist, in its broadest terms, might be construed as an absorptive and nondiscursive effort at "thinking the culture through"—as an attempt to feel her own way down through the infinitely complex systems of the urban world (in which she works) to the equally complex systems of the town and country world in which she lives. The deeper message of her labor, I suspect, has less to do with making us "sensitive" to the "nature" of that world than it does with reawakening us to our complicity in its predatory predisposition—in its awesome capacity for abstraction, destruction, and denial.

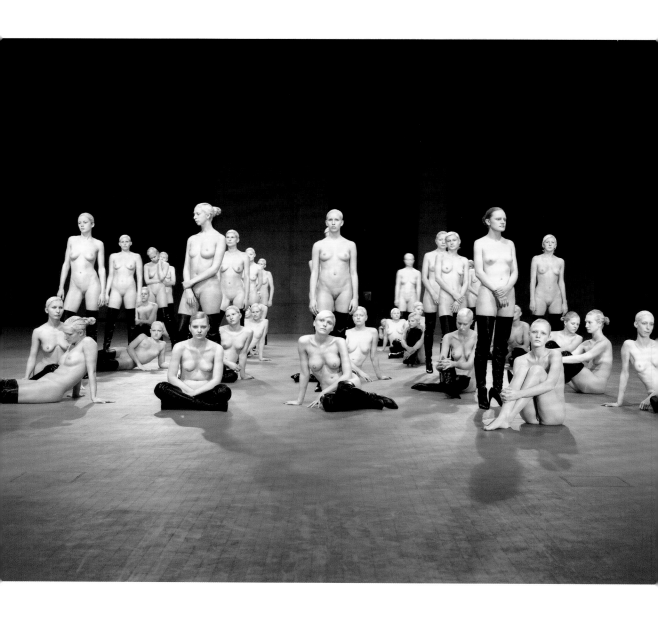

Vanessa Beecroft

Painted Ladies

The first thing you learn in conversation with Vanessa Beecroft (the thing that most readily confirms and complicates what you have seen) is that the work begins in Italy, where Western art began in the mystery of corporeality—that it begins, specifically, in a scene that has been enacted and reenacted there for more than five hundred years. The artist as a young woman sits on a stool in a large modern room, pencil in hand, sketchbook on her knee. She and her fellow students are deployed like satellites around a model, and the young artist is supposed to be drawing. Occasionally she does, but for the most part she just sits there looking, beguiled by the draftsman's gaze and wondering what is "wrong" with her. The marks she makes on the paper seem redundant and extraneous, so remote and conceptually removed from the rapture of that gaze as to constitute its opposite. Also, she is not particularly interested in marks. To see what they portray, we must somehow *read* them out of our knowledge, out of expectation and desire. She would like to create something richer and more opaque than that, some equivalent of the model's physical immediacy, her psychological unavailability, her erotic obbligato, and some simulacrum of the draftsman's gaze.

In John Ruskin's speculations on drawing, he calls that draftsman's gaze "innocent," and, in a sense, it is Edenic, aspiring as it does to see the world in all its nakedness—to see what is *there,* as opposed to what we know is there, what we expect to be there, and what we want the things we see to be. Having characterized the draftsman's gaze as "innocent," however, Ruskin hastens to argue that this gaze is the farthest thing from primitive or primordial. It does not aspire to see what *was* there once or to see

in some older way, but to see what is there now. Such an "innocent eye," he suggests, can only arise from the profoundest sort of sophistication, from the most delicate extrication of physical forms from their putative, cultural content. Thus, the sophisticated innocence of the draftsman's gaze is irrevocably local and ephemeral. The products of that gaze, assimilated into culture, do not survive in their innocence. In the moment of their making, however, works of art informed by the "innocent eye" can wash the slate of their accumulated designations, They can show us the world new, purged of fashion and desire, alive in its perpetual, incarnate opacity.

Not surprisingly, the traditional locus of the innocent gaze in Western art has always been those subjects most deeply imbued with the iconography of fashion and desire. In its mindful mindlessness and sophisticated innocence, the draftsman's gaze strives to bring these icons closer, to override their status as representations by the immediacy of their presentation. For Ruskin, oil painting stood as the classic vehicle for this incarnate assault on reading. The passionless glamour of Guido Reni—the "divine Guido," as Ruskin called him—stood as his classic exemplar of its power. For Vanessa Beecroft, who deploys constellations of women in fashionable dishabille within the cool temples of high modernist culture, oil painting has lost that innocence—and that sophistication. Painting remains the touchstone of Beecroft's work, however, and one may usefully regard her ephemeral tableaux vivants as standing in the same relationship to painting that painting does to drawing. She does not want you to see what she sees. She wants you to feel the way she feels sitting there looking.

Thus, in their relationship to us, as we gambol in the naked spaces of Bauhaus modernity, Beecroft's women in tableau are more present than Guido Reni's Magadalenes and Madonnas, but not so present as other creatures in the space. They are not paintings of women, in other words, but they *are* painted women. Deployed in the ever-narrowing space of simulation, they are imbued with more vitality and volition than Reni's models, but, like those women, they too are governed by rules of deportment and composition that don't apply to us. They occupy the same territory that we do, but not the same space. They act in their own space and do not interact with ours. "They are carefully made-up," the artist explains, "painted with body make-up, to alleviate the embarrassment of nakedness, and their behavior is governed by rules of loose movement," but these rules apply

to the piece—to the work of art—as they do in Jennifer Steinkamp's spectacles. They don't really apply to the women personally because we don't know who they are. That is a part of what interests me: the mystery and opacity of women. With men, I don't think it would work, not in this format. Men are too transparent and abstract, as Beecroft demonstrates with her uniformed sailors.

So if there is an argument in these works (and there may not be), it might be construed as demonstrating the subversive consequence of confronting as presentation that which we are accustomed to confronting as representation. Beecroft's tableaux, as described and as documented, seem undeniable products of the photographic imagination, confections whipped up out of the iconography of fashion and desire. In person and in situ, however, they are changed utterly. They are at once less erotic and more flagrant, more corporeal in the manner of Italian painting. Rather than teasing us with fantasies of the flesh, they tease our shame about the fact that we all have bodies. In the presence of these tableaux, we are denied both the privacy of contemplating a representation and the intimacy of participating in a real encounter. As a consequence, we find Beecroft's women at once more present to us and less accessible than we would wish—as unavailable to our understanding as they are available to our gaze.

Our anxiety, then, does not arise from the fact that naked women are near to us, but from the unbridgeable, yet ill-defined distance between them and ourselves. It is not the anxiety of desire, but the anxiety of displacement. The odd frisson of confronting something like casual, domestic nakedness in a public space is combined with the unnerving frisson of confronting the constituents of a flagrant showgirl revue in a naked modern space, robbed of its theatrical accouterments, its framing proscenium. In the mirror image of an anxiety dream, we find ourselves unkempt and slovenly in our clothing. Confronted with the cool authority of art's nakedness, we have no role to play, and we miss the privileged role we are used to playing as beholders. We are neither worldly enough to stare—to reimpose the distanced logic of the gaze—nor innocent enough to accept the world in its nakedness and opacity. We drift and loiter. In short, the tableaux *move* us.

Finally, however, the anxious displacement and exacerbated imme-

diacy we experience in the presence of Beecroft's tableaux derives most powerfully from the classic, innovative maneuver of Renaissance art— deploying the rhetoric of one genre in the space of another, so what we feel is not so much the jolt of innovation but the jolt of confounded conventions. Michelangelo deployed the rhetoric of sculpture in the space of painting. Bernini deployed the rhetoric of painting in the space of sculpture. Beecroft's tableaux deploy the rhetoric of painting in the space of live performance. We discover more than we consciously know about the virtues and limitations of these genres. The escalation of presence we feel between the drawing and the painting, we feel between the imagined painting and these subsequent tableaux. At the same time, the performative ephemerality of each event acknowledges Ruskin's insight into the fleeting, almost instantaneous, nature of the innocent artistic encounter. These things have happened, now they are gone, and may only be inferred at this late date from the flat fugitive memory of photographs. These live, not-quite-performed performances float out there in sensuous memory as Beecroft's tremulous live album.

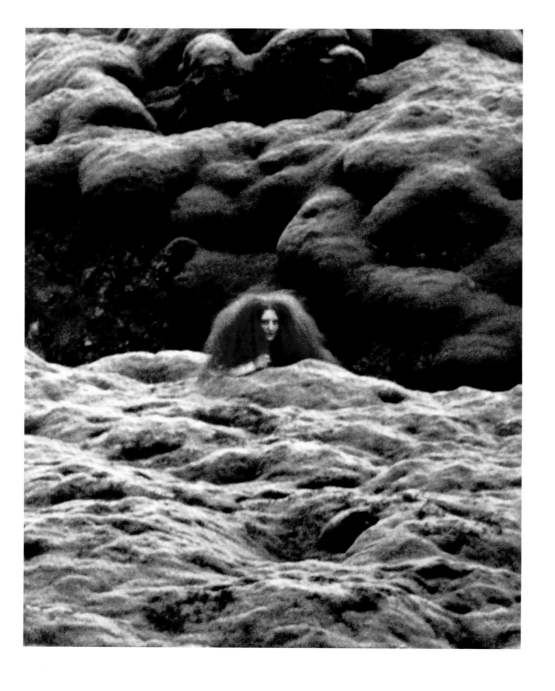

Roni Horn

She Resembles Herself

I should begin by admitting that I like Roni Horn as a person, because one should admit this sort of thing, and because it has nothing to do with my writing this essay. Over the years, there are three artists about whom I have written because their vernacular interpretations seem inadequate: James Lee Byars, Ed Ruscha, and Roni Horn. I would have been happy enough enjoying their work in silence as long as I felt that *someone* had taken a serious shot at divination, but they haven't yet. So, in my own aesthetic universe, Byars, Ruscha, and Horn are like red giants, floating free in space, inexplicable but undeniable, with no planetary systems of thoughtful text around them—and these artists are far from obscure practitioners. When I set out to write about them, they all had well-recognized names, good sales, and thousands of works whose owners and keepers, like myself, were satisfied to appreciate them in silence.

In the late seventies, when I started writing the catalog for Edward Ruscha's first retrospective, I had known Ruscha and owned his work for twenty years. Even so, I had only *eight* pieces of criticism and journalism to guide me (counting one of my own that Phil Leider had rejected for *Artforum*). This is not what you would call a rich bibliography, but it is proof of how little art needs words. Today, however, I think of Horn, Byars, and Ruscha as a constellation unto themselves—a triangle of "soft stars" with fading edges and rhyming attributes. The external and interior atmospheres of their work remain coextensive; their métier is neither descriptive nor expressive nor material, but something more effulgent and evanescent. There is no linear, formal, or material progression from work to work. Their works speak an incarnate language of icon and ornament whose full meaning is less incomplete than uncompleted, since the fantasy of closure

Roni Horn, from *Roni Horn aka Roni Horn*, 2008. Courtesy of Hauser & Wirth, London.

and autonomy, properly speaking, only applies to the oeuvres of dead artists or bundlers. Because nothing is done until it's done.

And there is a lot to be done, especially with Horn, Byars, and Ruscha, given their soft interaction with the world. They each have talismanic atmospheres that are intertwined with their lives and our imagination of them in a cultural context. Between Los Angeles and Edward Ruscha, between Japan and Jimmy Byars, between Iceland and Roni Horn there is a peculiarly American bond that dates back to the birth of American modernism, to Charles Burchfield's pagan romance with Ohio that we are only now beginning to understand. So today, it's reasonable to presume that when Horn and Byars and Ruscha are gone, when Iceland, Japan, and Los Angeles have changed utterly, we will have something like history. Until that time, the best we can write is intellectual speculation.

This, for me, is the attraction of Roni Horn's *AKA*, a slim volume of nonchronological photographs of the artist from infancy to adulthood, an exercise in Foucault's lost art of resemblance and its gradual dissolution. In *AKA*, Horn manipulates "portraits of the artist" seen in rigorously cropped glimpses through the medium of time, as if through water, breathing herself in and out as we do oxygen. The book's ur-mystery, of course, derives from the problematic of portraits themselves. They always purport to provide evidence of their subjects' importance, inner selves, social statuses, and territorial domains for those who wish to find it.

The randomizing algorithm of Horn's title, the shorthand acronym AKA, is that anything "also known as" is really some unnamed something else that is not really knowable in any proper sense from the AKA. The idiomatic AKA suggests imposture. It implies an ongoing deviation from a lost, forgotten, promised, or disguised original, so the knowledge that we acquire by comparing photographs of these aliases creates an infinite regress of sequences, priorities, and problematic relationships. In Timothy Wilson's book *Strangers to Ourselves*, he argues that the interior self that we imagine knows nothing of the exterior self our friends and colleagues perceive, because the mechanics of knowing ourselves and being known by others are so radically disjunct. Our interior selves are rationalized and unified. They explain everything to our satisfaction. Our exterior selves are random, precognitive, invisible to us, so we are never the person we imagine ourselves to be. A collection of outside images of the artist arranged by

her inside self should show us her interior view of herself in the moment of their juxtaposition, but it doesn't. People change, and each pair of face-images tells a story, but all the stories are different.

In *AKA*, Horn's inner self is gone in the instant of completion. The photographs move back and forth in time; our interpretations move forward, like a mystery novel. The subject is always new. The photographs are always old, and they always demonstrate past interactions between the artist's inner and outer selves. So the viewer is asked to infer a real "Roni Horn" from twenty-four images of real pictures, of "real Roni Horns," that tell twelve stories. This is not doable, and, if it were, its consequence would be closer to faux-psychology then art. When the Inside-Roni-Horn curates images of the Outside-Roni-Horn, "honesty" is virtually unimaginable, although Horn seems to be playing her own game pretty straight.

The "Roni Horns" in all of Horn's images do resemble one another. Horn's chin is a pretty steady landmark. The smile departs at about age nine. As a girl, Horn favors my late friend Marcia Tucker. A great many of these photographs resemble portraits by Dante Gabriel Rossetti, and, at some point, in the twilight of hippiedom, they were doubtless intended to. These echoes supply a topography of culture and resemblance. In two photos, Horn looks like a lesbian. In one, she looks like a man. Like gels on spotlights, these images contribute their own tonality. What's missing is the ground zero of Horn's narcissism, unless one counts my favorite image: Horn as wild-haired, witch-oracle lurking amidst frothy Icelandic lava. In any case, by resisting "pretty pictures," we presume some authorial intentionality when Horn's images begin to resist resemblance. We presume that this resistance reflects some biographical threshold or new dimension of Horn's internal narrative expressed here by her external change.

The ontology of the portrait itself as a genre plays a large part in this project, and most contemporary readings of the genre derive from the Catholic Church's shrewd accommodation of the second commandment to the proliferating, realistic images of Christ that were painted in the late sixteenth century. According to the church, such likenesses were deemed acceptable because Christ, at that moment, was only temporarily out of this world for a snack in the spiritual realm. He had lived in the historical world and would live in the historical world again. So a verisimilar image

of Christ is not an unconstitutional graven image, but a portrayal of the "once and future" Christ (and the check's in the mail).

This tricky conflation of image and icon never restored the future Christ to us, but it did fuel the history of art without degrading its magical accouterments. An "icon" proclaims the presence of its subject. An "image" proclaims the absence of its subject but also the powerful residue of its presence. Thus Renaissance gentlemen guarded their homes in their absence with portraits by Titian. Civil servants keep a picture of the president on the wall of their office. No great mystery, but consider the problematic of impressionism: Is it the paint on the picture, the picture of the desired real estate, or the actual suburban real estate itself that we desire? This dilemma was exacerbated by the era of the snapshot that stole portraits from their sitters. As a result, not many of us today keep our own portraits around the house unless Robert Mapplethorpe took them or we are hugging a president.

Portraits now belong to the cameraman, the media, and the public. Since this is a democracy, our icons are elected, but thanks to the second commandment and Walt Disney's Wagnerian imagination, some magic still accrues. Even though our icons are "elected," portraits are still part magic and part mimesis. They still stand in for our power in our absence, whether we wish them to or not. One's photo on the cover of a magazine invests the sitter with anonymous grandeur. One's portrait on the "contributor's page" invests one's writing with more iconic authority than those auteurs who are unportrayed—this, I suppose, is because photographs unlike text occupy measurable territory.

So consider the deeper sources of Horn's portraiture: the rows of statuary portraits in the Roman Forum, on the buildings of Vitruvius and Palladio, at Versailles and Disneyland. These are the forebearers of Roni Horn's rows of portraits, clowns, and birds. Consider the grids of iconic saints that have divided the altar from the nave in Byzantine Christian churches since the age of Justinian I, then revived by Warhol as new gods and goddesses, identical and eternal—revived again by Roni Horn as grids of varied and historical portraits in *This is me, This is you*, in which the documentary and narrative function of the photographs is virtually obliterated by the liturgical heritage of arranged portraits.

Another parallel analogy with Horn's *AKA* and her book *Bird* may be

found in Edward Ruscha's book: *Twenty Six Gasoline Stations*. These are more mysteriously encoded than Palladio's Graces. Ruscha's book contains photographs of twenty-six gasoline stations visited on a drive from California to Oklahoma City and back to California; to a good Catholic, the twenty-six stations should be the twenty-eight—the Stations of the Cross times two, less two. As a visual parable, the artist approaches the cross (Oklahoma City) then returns to Eden (California) and refuses crucifixion at either end. This encoding, however, is *not there to be decoded*. It is not an in-joke. It is part of Ruscha's typology that decodes itself with increasing familiarity. It requires Ruscha's portraits of *Norms Restaurant* and *Standard Stations* and other oddments from his oeuvre to sense completion.

The availability of Horn's "AKA" as an ornamental icon is similarly opaque; it derives from her variegated shifting portraits of the Thames, from her portrait grids, and Horn's rough, luminous cast glass sculptures that flicker toward representation. None of these images can be anything more than ornamental parts of a developing whole, just rest stops on the path, and certainly nothing so diminished or diminishing as minimalism. They are closer to James Lee Byars's ornamental glass sculptures that can be read as nothing other than ornaments that embody some ambient virtue. In the early twentieth century, all of these works would be considered vignettes of philosophical architecture, as each Picasso or de Kooning infers a larger structure in progress. The early twentieth century was right in this. We look at works, love them, or buy them in the hope that the oeuvre in progress will ultimately confirm our judgment.

Art like Horn's, and Ruscha's, and Byars's (and Nauman's, and Gober's too), reveals itself as an archipelago on its way to becoming a continent. Typological atolls and islands appear in chains and clusters and infer a world unabridged—beginning with number one, then, perhaps, jumping to number fifty then back to number twelve. It also jumps from glass, to stone, to photographs, to found objects, films, tools, paintings, and drawings without a blink since all this work lives in a larger universe where pleasure derives from our feeling that a continent is taking shape before our eyes. (When I tried this metaphor out on Rauschenberg, he asked if I meant that he was, at present, incontinent. Well, that was Bob.) When work number one hundred and fifty suddenly connects work number ninety to work number three, this intensifies our sense of organic solidity.

My point here (and the point of all too many essays I write) is that the current language of art criticism sputters along using the language of "zeitgeist" that disguises itself as the language of history. It creates fields of criticism not unlike streams of bubbles and foam. Since we don't know the end of the story, when we write about contemporary art, we tend to locate the beginning of our story anywhere we please, so none of our teleologies make sense and all of our logical precedents are bogus. They are fiction. Works like Roni Horn's *AKA* require as much time past as they require, yet, somehow, we never make it back to the Roman Forum.

When we think about James Lee Byars's glass works, we may get back to Venice but never as far as Japan or Persia. Pondering Ed Ruscha's Standard stations, we never make it back to the Crusade narratives from whence the Stations of the Cross arise. These endpoints are implied, but still we long for closure and lack the patience to live without it. We must know that if our eyes tell us one thing and our tongue says another, that our language is defective, that what was once a vocabulary of precedence is now a dictionary. So if all our theories about Roni Horn's *AKA* disappear like a pile of betting slips set to the match, they may have been designed to do just that: a lot of art is designed to go up in a puff of smoke and remain where it is, ready for another shot.

None of this, however, is serious. It's intellectual play. So I thought about preparing a book like *AKA* from pictures of myself and wondered what it would reveal. To a neutral stranger, the difference between the portraits of Roni and the portraits of Dave would define the differences between us. One glance would tell you that Roni is an artist and Dave is not—that Roni is as solid as cast glass and Dave is a disco-mirror-ball with a long history of bad fashion decisions and bad hair days. By reading the mise-en-scène and my own body language, I could discern who the photographers were: after a certain point, they would be anonymous magazine photographers. Arranged in chronological order, then, the images would become increasingly impersonal and unfamiliar, so I would probably make the same decision Horn did and mix the chronologies.

Some of the photographs in my book would call up memories for me and no one else. I remember Dennis Hopper taking my picture in an alley in Taos, this because I could tell that Dennis was trying to photograph what was there, and not just what looked good. I remember Bill Wittliff

taking a pinhole picture of me that came out very fuzzy and romantic. I look like a legendary football coach. My friend Jeff Burton, the fashionista shutterbug, took my picture in a room at the Standard on Sunset Strip. I am holding a towel in my hands so I look like an elderly chicken hawk who has just dismissed a young visitor. I remember Andy Warhol snapping a Polaroid of me at the St. Regis, and me trading that image to Norman Fisher for cocaine without giving it half a glance. There is a picture of my first wife and me in boots and Stetsons, just back from a ride in New Mexico. I remember this because I was also thinking about D. H. Lawrence's *Women in Love*. None of these photographs would tell me or you anything about me, probably, because I am too busy for inner life, but it would tell me that Roni Horn imagines herself as a part of the physical world and that I am only a visitor. This would be terribly embarrassing, but it would be a fitting testament to Roni Horn's seriousness as an artist, nevertheless. She is irrevocably there—a fragile system unto itself.

Fiona Rae

Good after the Good Is Gone

It's always sexier when someone who is predisposed to hold on tight lets go and sweeter when the maiden plays the tramp. It would be sweeter still if the maiden had a choice, if there were some real option between purity and promiscuity, between exclusion and inclusion. But we can't have everything, and, as a consequence, Fiona Rae's new paintings, for all their impudence, seem founded on a dark necessity, and they are no less beguiling or fun for being fun as a last resort. This has always been Rae's predisposition, and it is her earlier abstractions that now seem repressed. Their present frivolity bears with it an underpinning of willful resolve, of nuns dancing in the atrium. My first impression: these are the kind of paintings you make when you're on your own, when you can't depend on anyone for anything, when you can't improvise or update anyone, or harmonize with anyone—as Rosenquist might be said to harmonize with Wesselmann—as Lewitt might be said to harmonize with Judd—when you can't presume that there is anyone "in the know." In this respect, Rae's new paintings propose a solid answer to a question that everyone has been asking for the last two decades: what will "good" art look like when the idea of "good art" finally disappears, when diversity reaches the threshold of entropy, when all the tribes of modernism are, once and forever, shattered, intermingled, and dispersed, and the covert bond of "knowing" between artists, dealers, critics, and collectors has evanesced into the air?

What happens first, of course, when "good" disappears, is that one hundred and fifty years of "insider art," that speaks the language of tribes and coteries, disappears. With no "good" art, there is no "bad"; Bernini, Michelangelo, Picasso, and all art that is not perfectly redundant becomes

Fiona Rae, *My Favorite Puppy's Life*. Oil and acrylic on canvas, 2004, 60 + 50 in. (152.4 + 127 cm). © Fiona Rae, courtesy of Timothy Taylor Gallery, London.

"outsider art" output—in Peter Schjeldahl's phrase—the product of a "culture of one." The first public consequence of placing every artist in his or her own atomistic niche is that the primary signifier of human languages, "the power of the negative," disappears from the visual language of *beaux-arts* practice. The "negative" option of doing something by *not* doing something (which lies at the heart of modernist practice) disappears. There is no tribal imperative that one "should" be doing something that one would rather not, thus no frisson of impudence. What one is not doing doesn't register without some expectation of what one should. So what one is doing becomes *all* that one is doing. In this way, the energy associated with breaking rules is dissipated; the sense of community that is asserted by obeying then breaking the rules dissolves, and art becomes more wholly visible, more democratic, more inclusive, and more self-evident and ephemeral for being on its own.

Fiona Rae's new paintings have become all of this and more. They take pastiche to the level of benign hysteria. The spill, the pour, the gestural swath and the painterly drawing, the depictions of natural life and mythological animals, the appliqué and silhouette, the high, the low, the oriental, the Victorian and the late medieval all coexist in a dreamlike, pre-Enlightenment pictorial atmosphere that is less concerned with differences than with similarities, less concerned with the hierarchal relations than with the lack thereof. At the end of three hundred years of distinction and difference, we arrive once more in the realm of proliferating likeness, in the neo-psychedelic realm of "everything is everything." For Rae, the age of decoration is over and the age of ornament has begun. The refinement of the decorative choice is replaced with a bouillabaisse of decorative iconography, none better or worse than the next.

In the progress of Fiona Rae's art over the past fifteen years, one can trace the dissolving consensus about what should and should not be done by the gradual replacement of the decorative with the ornamental. Ornament, according to the great decorator Adolf Loos, is crime. According to John Ruskin, it is love, so we might settle on the idea of contemporary ornament as free love, as opposed to decoration, which is a form of decorum, a chaste canon of appropriate behavior. By the rules of decorum, of course, an impressionist painting behaves as an impressionist painting should; a cubist painting behaves as a cubist painting should, and Rae's early paint-

ings behaved as paintings in the tradition of "synthetic abstraction" should behave. They assert their individuality within a coterie of paintings that includes work by Gerhard Richter, David Reed, Jonathan Lasker, Lydia Dona, and others. Within this coterie, Rae's early paintings can be read for what they do and do not do. They are decorative paintings insofar as they refuse behaviors that might be considered inappropriate while remaining visually aggressive and non-ingratiating.

Rae's new paintings refuse very little, and looking back along the line of her production, we can see her pushing out the decorative by pushing through it into the inclusive domain of decorative iconography. The idea of the decorative dies quickly when the power of art to exclude it is pre-empted, and the tendency of artists to align themselves with larger aesthetic agendas is repressed. Today, the assumption that generations of artists might have consonant aesthetic aspirations has been supplanted, even though we still talk of generational affinities. Today, the power of exclusion in the realm of modern art has been repealed. The presumption of "difficulty," with which the power of exclusion has always been associated, remains faintly in place, however. "Difficult" art continues to be made. The expectation that a member of the art world should make an effort to come to terms with this difficulty has, however, been waived.

As a consequence, the art world at this moment is brimming with difficult art that no one has made the slightest effort to comprehend. Difficulty itself has become a signifier of eccentricity. Each work may be regarded as a positive field of idiosyncratic iconography that aspires to include everything and everyone. This brand of agape has supplanted the critical imperative that once informed modern art and its reception—and that once constituted its claim to distinction. One of the unintended consequences of this neo-positivism is that, since the once-safe presumption of subliminal consensus can no longer be made, artists may no longer depend on the broader field of practice to confirm their own, as Warhol once depended on Lichtenstein.

Contemporary artists set out alone and on their own. Without a cultural or aesthetic platform from which to launch one's work impersonally, without an audience whose rising expectations are vaguely congruent, contemporary artists must, almost of necessity, "brand" their work with full disclosure. Since global systems first unite, then divide, then

subdivide, and subdivide again, artists are ultimately thrown back on the eccentricity of their own cultural personas, on their regional identities, their politics and taste. As a consequence, they are more or less obligated to show us works of art that are more representative of the "whole artist" than they are of the "best artist" they might be. Out of this necessity, then, Fiona Rae's new paintings function as palimpsests of her whole persona. The Hong Kong girlhood is there, the childish enthusiasms, the taste for Bosch and Dürer, the New York School aspirations, the adolescent penchant for pop decoration, swimming dreams of the schoolgirl on acid.

Since there is no coherent discourse that her paintings might contradict or fly in the face of, all these attributes need to be present as a simple matter of shape and definition. With no visual context against which they might resonate, the paintings must contain and embody their own resonant contradictions, which Rae's inclusive paintings do to good purpose. In most of her paintings, constellations of flora and tiny cartoon animals define an eccentric atmosphere of Victorian spatiality, à la Richard Dadd, that tugs relentlessly at the modern flatness of the gestural brushwork. For Rae, this is more than a formalist device. As she remarks in our correspondence, "the cartoon characters function like indestructible superheroes. They're quite personal and have something to do with finding a way to live with authority. They puncture the authority of the gestural brushmarks and the grand tradition of modernist painting, which is still there, of course. So the paintings are defiant but at the same time, they're still going to church."

Perhaps so, but they are going to a new church, with no "Thou Shalt Nots" in evidence. In terms of the moment, then, Fiona Rae makes paintings that are full of heart and life. They speak their own language and bespeak their own provenance. They are, in fact, paintings in the tradition of Western modernism made plangently available and radically personal without necessarily being personally "expressive." Their fullness, eloquence, and generosity seem a happy recipe for a "new good" that might serve now that the "old good" is dead. Their very currency and inclusiveness, however, dates my own practice of writing about paintings, but there is not much pain in that. Over the years, one becomes so habituated to art that brings with it a flurry of Thou Shalt Nots (Thou Shalt Not write about this art this way, or that way, or any of those other ways) that a little healthy

promiscuity can prove disturbing. I find myself a little unnerved in the presence of paintings that I wish to write about—that may, just as easily, be written about in all the ways I hate for people to write. This, however, is the new world beyond negation and exclusion. Neither Fiona Rae nor myself have much choice but to live in it, and Ms. Rae is doing a much better job of it than me.

THE COLLECTIONS OF BARBARA BLOOM

same

envy

Ringo

19th C.

Richter

Miranda Rights

as if

Sobriquet

Dear Diary,

Monopoly

Betrayal

blush

Nov. 2, 1997, 2:15 pm
elevator: 10013

Lolita

Cayman Isl.

Enzyme

Orange

Nietzsche

G Minor

anon

Barbara Bloom

Barbara Blooms

The idea of mounting a retrospective of Barbara Bloom's work seemed reprehensible from the outset, especially to Barbara Bloom. She found all retrospective exhibitions to be events of dubious provenance and doubtful consequence. For Barbara Bloom, who had devoted her artistic life to the creation of site-specific, time-specific moments, it seemed an offense of some kind. More to the point, the project of mounting a retrospective exhibition of her work presented a number of unattractive eventualities. At best, it might create a fog of aromas and perfumes, like the ladies room at a senior prom. At worst it could turn out to be a dry, archaeological reconstruction of her career drained of the tremulous moment and the pleasures attendant upon it. This reconstruction might then be transmogrified into a theme park for "issues in conceptual art," and nothing could have been further from the drifting fragrance Bloom aspires to, so she declined such opportunities until she came upon the auction catalog for the estate of Jacqueline Kennedy Onassis.

Here, she thought, was an occasion with provenance and consequence—as old as history itself—an occasion on the ridge-line between celebration and dissolution, glory and oblivion. The specificity and limitations of the catalog were, if anything, more beguiling than its trenchancy. The auction catalog did not aspire to the "whole Jackie," or even the "true Jackie"; it proclaimed to be the "residue of Jackie," a resonant idea with a provenance. Jackie's collection, as it was offered at auction, fulfilled David Hume's definition of "culture" as that which survives its creator and patron. The auction itself evoked the moment that W. H. Auden delineates in his poem on the death of Yeats—the moment of dispersal when Yeats,

Barbara Bloom, *Color Chart*, 2007. Digital print. Cover illustration of the book *The Collections of Barbara Bloom*, with essays by Dave Hickey and Susan Tallman, 2008. Courtesy of the artist.

in the act of dying, "became his admirers." The posthumous aura was also appealing in its succinctness and its gravitation around a fatal moment the artist herself had only just avoided.

As an homage to their absent subject, the objects and the photographs in the Jackie auction catalog bore something of Jacqueline Kennedy's aura with them in the elegance and solemnity of their presentation—enough, at least, to make them a "set." The visible contiguity of treatment and design created a cloud of fugitive reference among a variety of disparate frills, French furniture, minor impressionists, and fugitive memorabilia. These proclaimed Jacqueline Kennedy's *absence*, along with the inference of "Jackie" that held the objects together and set them free, like the slaves of a dead master. Selected by the same sensibility and photographed for the same solemn, commercial act of scattering the ashes, the objects were each invested with an aura of perceived nobility that evoked Jacqueline Kennedy, but only vaguely as a skein of rapidly fading, wellborn, feminine ectoplasm.

For Barbara Bloom, this was something more like it, something with a filigree. It was better than planning one's own funeral. For an artist devoted to the light touch and the blush of the moment, it was a challenge she had no other choice but to accept. The idea of resurrecting the past was obscene. The idea of gathering the residue and reassembling what survived in memory (where art must survive) was radiantly attractive. It required no muddling in the purgatory of lost time, no contemplation of sepia-tone kisses, no fearful reassessments of missed exits or frantic efforts at resuscitation.

This funerary document would mark a new California day, and, like any true Californian, Bloom would pick through the rubble of the quake and save what she recognized. She would reassemble the residue, so it might once again be burned, drowned, broken, or blown away. That, in a personal and practical sense, would be the work of Barbara Bloom; its subjects would be her subject. For the critic addressing these occasions, then, there is a tacit prohibition of analysis, lest it kill what it touches. So in the dance of similitudes, the task of inferring just what the experience of Barbara Bloom's art might be like resides in our ability to tease out similitudes from other sources—about its resonance with other acts than hers.

⌐

In his travel book *Etruscan Places*, D. H. Lawrence speculates on the practice of divination that was native to Etruscan culture and later adopted by the Romans. The prophetic practice required an adept to attend very carefully to the entrails of a goat, to the flight of birds, to the weather, or to any number of physical phenomena. The idea was to focus with intensity up to and beyond the point of hallucination and vision in search of insight. As such, divination differs from sorcery. Sorcery creates something, and divination discovers what is covertly there. Through the diviner's act of concentration the truth or the future or that which is hidden is revealed. As a mode of prophecy, divination derives from the antique assumption that the world presents us with a tapestry of resonant rhymes and similitudes, each pregnant with harmonic deviations and absences, so that any one thing, carefully attended, might reveal everything. In his defense of this practice, Lawrence argues that the *object* of attention matters little in the search for wisdom; the guts of a duck, the flight of an eagle, or a summer storm—one will serve as well as the other. Wisdom's font, according to Lawrence, resides in the "quality of the attention" we pay to the world. This payment is our tithe.

This "quality of attention," when it is made visible, presents itself as a frisson of indeterminate origin, an atmosphere of *brio*, panache, or solemnity that attaches itself to the act of seeing or knowing. It is variously attributed to the object's power, to its subject's charisma, to its creator's sensibility or its beholder's sensitivity. Andy Warhol, the sorcerer, conjured his own specific "quality of attention." He painted gestures and silkscreened fields of color over stock photographs of Marilyn Monroe to make her charisma manifest in the room where the painting hangs. Barbara Bloom, the diviner, is more interested in locating this fugitive ambience than in creating it. She teases specific and often unnamable "qualities of attention" into visibility out of tiny eccentricities and rhymes in found photographs and texts.

As a result, Lawrence's emphasis on the "quality of attention" always springs to mind when I am tussling playfully with Barbara Bloom's art—and one must tussle playfully with it (as wary children might tussle in Emily Dickinson's sitting room) lest one break a plate and shatter

the atmosphere. Brute force and hard analysis are blunt instruments in this regime, so, in the presence of Bloom's work, one's sensibility must gradually recalibrate, as a diviner's must, to identify evanescent qualities that manifest themselves like fugitive colors at the intersection of devotion and adoration, of humility and desire, of loathing and admiration, recognition and romance. This elaborate dance of seeing, picturing, imagining, and comparing evokes a condition of reverie that conjures up, quicker than thought, nothing more substantial than some specific "quality" of the atmosphere it creates. In this sense, Bloom's art is a pure high modern art; it requires an engaged beholder who is something more than a sightseer. Bloom's work resists being experienced as Bridget Riley's paintings resist being seen. Even so, they both require a certain level of attention and inquiry for their resistance to become manifest, for the game to begin.

In the realm of modern art, this "resistance" was once presumed to be an indispensable attribute, a signifier of the work's difficulty. In a blatant and baroque moment like the present, any assumption of the beholder's curiosity seems quaint, but, when exercised, such curiosity has its benefits, because, at the end of the game, the power of Bloom's art is best measured by the extent to which our experience of its difficulty pays off in the world beyond her art. Having looked at Barbara Bloom's work, one is invited to look through it at the world beyond, to recapture in reverie one's own "Barbara-Bloom-Moments" in the world—as anyone who loves the art of Ed Ruscha must find their own *Ruscha trouvé* in the world beyond his work. (My own favorite is a sign beside a church near the Las Vegas Strip that reads "Cathedral Parking in Rear," with its naughty inference.)

Moreover, citing evidence of Bloom's work from beyond the realm of Bloom's work seems more in line with her sensibility and more demonstrative of the work's efficacy. Finally, it smacks less of "analysis," so here goes: A few weeks ago, in the *New York Times*, David Brooks's column cited a perfect "Bloom-Moment." Professor Brett Pelham of SUNY, it seems, has, by some statistical sleight of hand, ascertained that "people named Dennis and Denise are disproportionately likely to become dentists. People named Lawrence and Laurie are disproportionately likely to become lawyers. People named Louis are disproportionately likely to live in Saint Louis and people named Georgia are disproportionately likely to reside in the "Peach

State." This haunted batch of statistics, at least to me, seems designed to evoke and appeal to a sensibility like Bloom's—a woman who never signs her name "Barbara Bloom" without smelling the flowers and thinking of Molly in Joyce's *Ulysses*.

On the subject of blooming flowers, I have my own Barbara-Bloom-Moment, from my youth, because my grandmother owned a flower shop in south Fort Worth where my mother routinely parked my brother and sister and me while she ran her errands. There's not much for kids to do in the scuffle of a chaotic small business, so we would go into the large refrigerator, stand amidst the chilly gladiolas, irises, chrysanthemums, carnations, and roses, and play the "flower game." We would close our eyes and say the word "flower" about fifty times until the sound lost all its meanings and connections. We moved from "flower" to "flow-er," to "flaow were," etc. Then we would open our eyes and let the category of "flower" reconstruct itself before our eyes in fits and starts.

I have always regarded the "flower game" as a kind of preadolescent acid trip and it is important to me. It also evokes Bloom's obsession with the fluidity and slipperiness of the relationship between names and the things they represent, between mediums and messages, between the body and the mind, and the world at large. So what do we make of a color named Richter? Why do we blush at the thought of that? Why do we smile at Bloom's idea of the Bible in shorthand or *Playboy* in braille? How do we detect the presence of what's implied? How do we distinguish the picture from the frame? How do we parse the endless vocabulary of similitude: the proliferation of twins, pairs, doubles, rhymes, harmonies, symmetries, inversions, substitutions, and palindromes? In other words, how do we think and feel about the apparatus of our seeing, thinking, feeling, and knowing? Most critically, wherein does the pleasure and beauty of our seeing and knowing reside?

Bloom plays in this special territory, even though not many artists may be said to play and even fewer play amidst the recognitions that precede cognition, Bloom does. Like a child running through a hedge maze, she flits through the spaces that divide the five roses in Gertrude Stein's famous lyric "*A rose is a rose is a rose is a rose. / Civilization is a rose.*" Bloom tweaks the soft boundaries between the sensibility that notices the rose, the cognitive act that recognizes it, the word that stands in for it, and the

empty phonemes, "eh roze," that we attach to the word and ultimately to the blossom. The fifth rose is a rose whose subject is "civilization." The abstraction of this subject reinvests the empty phonemes "eh roze" with a new word of comparable generalization: "eros." This, in turn, activates to the fog of Western metaphors connecting roses with sex and romance. This, ultimately, defines the act of looking at a rose.

This is the territory in which Barbara blooms and the critical inference we may draw from her work is that, if there is pleasure there, if this territory actually exists, then Michel Foucault is right. Levi Strauss is right. "harmony is all." Our engagement with the dense tapestry of superficial resemblance that unfolds before our eyes each day—our happy embrace of moments when we find ourselves "rhyming" with the world, and things "rhyming" with one another—still drive the deep tides of our personal existences in special harmonies. We have inherited these proclivities (abjured by advanced thinkers) from the premodern world, and, since the primary task of high modernist art has always been to restore to us those aspects of living that modern science and technology have suppressed, the high modernity of Bloom's work (and of Stein's, Joyce's, Nabokov's, and Eliot's as well) is defined by its ability to self-consciously rediscover and reinvent the tapestry of experience bereft of absence, to ignite the murmur of fugitive harmonies amidst the residue of knowledge.

More specifically, without this murmur, one could not "marry the glove." The link between names and their consequences would remain opaque. The predisposition of Dennis to become a dentist, of Laurie to become a lawyer, of Georgian parents to name their daughter Georgia, would not haunt us with enjoyment as it does. The entire beaux-arts appetite for pleasant surprises, patterns, recognitions, and moments of self-recognition can be dismissed as delusional. Bloom's task has always been to make this murmur audible and visible to us in its intricacy, so let me conclude with the author Colin Thubron's Bloom-Moment. In his book *Shadow of the Silk Road*, Thubron recounts his visit to the end of the Great Wall of China outside the city of Yongchang. There, he discovers what he felt sure was there, a scattering of tall, redheaded Roman-Chinamen right where history left them, poised between glory and oblivion. In the late days of the Roman Republic, their ancestors were captured after the defeat of Crassus's army and Crassus's death. These Roman invaders were,

appropriately enough, assigned to work on the Great Wall designed to keep invaders out, and there they remain, half a world from Italy and their German homelands, like a distant genetic echo, visible evidence of the way things blur, and flow and swarm. They blossom forth in reverie to amaze our imaginations in the manner of Barbara Bloom. That's what it's like.

Sharon Ellis

Modest Ecstasy

She says, "But in contentment I still feel
The need of some imperishable bliss."
Death is the mother of beauty; hence from her,
Alone, shall come fulfillment to our dreams
And our desires.
—FROM *SUNDAY MORNING* BY WALLACE STEVENS

Throughout the history of art making in the Western world, there has always been a war. It is not a *real* war, of course, in which people are slain, but it is more than a quarrel and definitely a conflict between the raggedy world and the orderly battalions of eternity, solemnity, and utopia. These latter are artists who use form to envision the world made smooth. Then, there are the ragtag legions of death and beauty that elaborate upon the world as it exists—who would ornament that same world in order to arrest and intensify its actual fleeting benisons.

The imaginative battalions of eternity and solemnity believe in heaven. They don't call it that these days, but they invariably evoke a "world elsewhere" populated and administered by an "elect." (Thus their solemnity in the face of their election.) They disagree about the nature and constituency of this world elsewhere and about the mechanics of its becoming, but they all agree that it *is* coming, that it *will be* elsewhere, and that it will divide and refine the world in which we live. At some revolutionary moment, they believe, the future will be divided from the past; the selected self will be divided from the unselected other. Other distinctions are presumed to prefigure this ultimate division: the body divided from the mind, the senses from the soul, the realm of wild nature from the domain of human culture.

Sharon Ellis, *Lunarium*, 1996. Alkyd on canvas, 26 + 22 in. Photo: Scott Lindgren. Courtesy of the artist.

In Sharon Ellis's paintings, these indivisible attributes are all enhanced by art, meticulously intensified and rendered ornamental. The aspirants of Heaven oppose artists like Sharon Ellis who are aspirants of Eden. The inference of this elaboration is what we see in her paintings, is what we might see in the world if we were not time's prisoners, hurtling toward our fate, thus the meticulous pace of their creation. The paintings imagine all the magic we are missing in the fleeting magic that we do experience. Thus, the quick-frozen symmetries of Ellis's paintings imply no eternal balance, but rather the rare, musical cadence of nature and culture—the instantaneous harmonic symmetry toward which nature aspires and by which culture is defined. By granting nature's aspiration to symmetry and fulfilling the cultural expectation of symmetry that informs our perception of its lack, Ellis creates images from which negation, defect, disjunction, and default have been so exquisitely purged that the putative line between nature and culture, body and mind, self and other is invariably blurred.

In a very real sense, there is no nature in these paintings, nor any culture—no self, nor any other—no mind, nor any body, only the handsomely wrought instant of their authoritative confluence. Like her singular California predecessor Vija Celmins, Ellis presents us with landscape images in which the fractal universe we see—and the abstract language of our seeing—and the procedural methodologies through which we portray what we see—are so totally compromised as to be indistinguishable from one another. In the work of both artists, the pictorial is always on its way to abstraction; abstraction is always striving toward a condition of pictoriality; the artist's hand is disappearing as the artist's presence is subliminally suffusing itself through the atmosphere of the image—as our own restless, de-centered perception of the image is suffused as well.

Amidst this meticulous suffusion, Ellis's paintings are never lost to us, but they are not easily found, because—to put it simply—their appeal is not *personal*. The paintings address us as human creatures, as citizens of our own distinct moment, but not as individuals, so even though we are *there* in the paintings, as is the artist, we are not ourselves. We sense, in the work's exotic glamour, an ominous familiarity, like the sound of one's own voice vaguely perceived amid the harmonies of a symphonic chorale, and we recognize that, for all their oddity, there is something profoundly *right* about the paintings, in their time and in their own place. They arrive in the present

without peers but with a host of improbable ancestors in the realm of painting, at the culmination of their own history—one in which the extravagant intricacies of Jackson Pollock are traced back to the floral accouterments of Caravaggio, aligned in genealogy with the hallucinatory specificity of Caspar David Friedrich, Martin Johnson Heade, and Philipp Otto Runge, with the articulate complexities of Bridget Riley, with the stillness of Seurat.

Even granting the singularity of this family tree, however, it is easy enough to argue that the singularity of Ellis's paintings in this seemingly past-less moment derives less from the eccentricity of their genealogy than from the fact that they have any genealogy at all. This, however, is not quite the case. The distinction is really in the genealogy itself and in the permissions it grants. The bulk of contemporary art *does* declare its own tradition—a tradition of modernist reduction, Freudian abjection, and Protestant renunciation. We read its virtues and its historical precedents in the language of what the work lacks and what it chooses not to do. As a consequence, the sheer appropriateness of Ellis's paintings in Southern California at the dawn of the twenty-first century speaks directly to the problematic of Protestant postmodernism in temperate latitudes and cosmopolitan cultures where neither industrial modernism, Freudian psychology, nor Puritan rigor have ever expressed themselves with much cultural resonance.

Works in a post-something idiom speak with no apparent echo while Ellis's paintings, for all their apparent eccentricity, resonate in a most unnerving way, simply because they express, in a positive, accumulative vernacular, a cultural inheritance that persists and continues to be shared by fellow inhabitants of the culture in which she practices. In fact, if one tries to imagine the kind of art that might have been produced in Southern California without the imported overlay of industrial modernism and Protestant rectitude—the kind of art that might have flourished had California's own, odd comingling of Mediterranean generosity and Victorian romanticism been allowed to flourish unimpeded, that art would look a lot like the work of Sharon Ellis. In a world to which nature has been imported along with culture, in which the mind needn't labor to keep the body alive, and the self resides comfortably in the temperate atmosphere that surrounds it.

In this climate and culture, Sharon Ellis's paintings seem not just appropriate but virtually inevitable, and the artist's serene confidence in this inevitability, I think, is best expressed in the cool modesty of the actual ob-

jects. This modesty is occluded in reproduction, of course, where the grandeur of Ellis's subject matter subliminally enlarges our imagination of the paintings' actual sizes, but when we are present with the actual, physical work, the effect is distinctly different. The paintings, as objects, are neither grand nor sublime. Somehow, their modest scale gentrifies the grandeur of their subject matter. We imagine Jane Austen passionately imagining the universe, and we are forced to acknowledge that, at this moment, Sharon Ellis may be making the most positive, least needy paintings in the world.

They give everything and ask for nothing. Their scale betrays no demand for an August setting, no aspiration to public oratory or civic circumstance, no inference of the artist's heroic persona, or any urgent necessity to persuade. The paintings are clearly made, like the best jazz, for people who love and understand them, and, like the best jazz, they are redolent with the joy of fugitive occasions and secret enthusiasms. Thus, for all the time and skill with which they are invested, Ellis's remain, happily, housebound paintings—as intimate as they are impersonal—as irrevocably secular as they are elusively tribal in their appeal. Like the landscape paintings of Fairfield Porter or Alex Katz, they assume a level of knowledgeability and refinement to which the public will never aspire, nor ever think to. Yet, like the paintings of Porter and Katz, they remain available to us, simply because they reject nothing. By embracing abstraction and representation, composition and pattern, temporality and narrative, death and beauty, Ellis's paintings hold out the possibility of being recognized as objects that exceed our grasp without demeaning our longing—objects toward which our understanding might aspire, that we may love and respect even as we await the good, solemn, eternal reasons for doing so.

Hung Liu

The Polity of Immigrants

It used to be that styles and objects traveled, while artists stayed at home; or if they traveled, they soon came home again, bringing exotic manners with them to dazzle the locals. These artists, having traveled and returned, were still assumed to be creatures of the *volk* or of the finer classes, bound by the conduct and conventions of their own cultural location and social station. Thus, even though they might import, appropriate, and employ the manners and materials of other cultures (the way sorority girls trade party clothes), it was presumed that they could only adapt these alien modalities to the habitus of their "home" culture, as Picasso supposedly adapted the manner of West African sculpture to the conventions of modernist Europe. In this way, the presumed stability of the artist, within his or her culture, was used to validate the power and validity of "culture" itself as an informing concept.

The moment artists begin traveling and not coming home, however—the moment they begin moving from "culture" to "culture," as Hung Liu and many of her contemporaries have done, the classical idea of "culture," as proposed in nineteenth-century Germany, begins to dissolve, since, in all of its visible attributes, artists *make* culture, while culture may no longer be said to make artists. Thus, to anyone who looks, it should be obvious that Hung Liu (an American artist of Chinese descent—who makes "Western" paintings of "Chinese" photographs—who was educated in China in a European tradition—who has struggled to reacquire her Chinese cultural inheritance while living and working in the western United States) may indeed be engaged in "cultural production," but the works she makes are *not* "the products of a culture." They are the products of Hung Liu, and only available to us because the methods, manners, and materials that art-

Hung Liu, *Resident Alien*, 1988. Courtesy of the artist and Nancy Hoffman Gallery, New York.

ists have passed from culture to culture for hundreds of generations have achieved enough transcultural transparency to validate her local resolutions of their multivalent possibilities.

I would argue, then, that Hung Liu's paintings do not derive their authority from "culture," but from the transcultural appeal of *paintings* and the manners of painting she employs. The interest and attraction of Hung Liu's paintings and the pleasure that we take in them today—in the wrecking yard of history and on the precipice of the millennium—discredits one of the most pervasive fantasies in late twentieth-century art: that "painting is dead." The truth would seem to be that painting is not "dead" simply because *paintings* indubitably are (dead, that is)—because paintings are inanimate, inarticulate, portable *things* of considerable longevity, whose semiotics are invariably iconic and bound by their context. So, even though we can and do "read" paintings, we read them rather as we do the weather and rarely read them in the same way for very long. This is to say that paintings are utterances, like birdsong, but they are not language, and they are not *texts*, since the defining characteristic of linguistic texts is that, even though their *meanings* may change depending on their context, the *way* we read them, does not.

In a text, we can easily distinguish "noise" from "information." In a painting, one day's "noise" is the next day's "information." The "signifying attribute" is never stable, so the first question with a painting is never what it means, but which of its attributes are meaningful, how they become meaningful, and in what order. In a painting, the brushstroke may function as the primary signifier for one set of beholders, the image might serve this purpose for the next, the scale for the next, the color for the next. This is, and always has been, a matter of local fashion, and, as a consequence, paintings are physically incapable of retaining the emotional, ethical, and institutional meanings that we attribute to them. Such meanings may be assigned to paintings, and we may find them there from time to time, but they do not *inhere* in them.

Thomas Crow may remark that painting in New York, in the 1980s, was "a shorthand code for an entire edifice of institutional domination exerted through the collectors' marketplace and the modern museum," and he may be right (although I do not think he is). This, however, does not mean that Crow's "shorthand code" will still be intelligible in the 1990s, during

which period the same painting may just as easily come to function as a "shorthand code" for the haptic, tactile, fractal modes of information that have become endangered attributes in the digitization of postindustrial culture. Because, in paintings, as opposed to texts, the signifier is not absent. It is a matter of choice and deliberation; it is contingent and protean.

The attraction of painting as a practice, then, has never been its precision of expression, but the fact that it has meant so much for so long, in so many ways and so many places. As Chuck Close puts it, "You tie some animal hairs to a stick, dip it in colored mud and rub that mud on a surface." Human beings around the world have been doing this for a very long time, and there is every reason for them to keep doing it, simply because the act of painting, due to its ubiquity, calls up a *world* of meaning out of which one can carve one's own—in which the beholder may find their own, as well. So it well may be that painting, far from being dead, is only now coming into its own as a vehicle of idiosyncratic expression in the practice of artists like Hung Liu.

Consider it this way: For thousands of years, in Western and Eastern cultures, painting was practiced within the domain of the church, the state, and the academy and subject to their authority. For the last hundred and fifty years in the West, paintings made outside these institutions have concerned themselves with the mechanics of practice and the logic of their history. Since painting today is no longer so concerned or so regulated, it may well be that we are only now beginning to see the practice employed to achieve local solutions that may be said to have cosmopolitan consequences because we are no longer parsing the cultural norms purportedly embodied in artists' practices. We are, however, appreciating the ways in which various artists exploit the transcultural norms of various practices to their own ends.

Now consider how Hung Liu's situation as an artist exemplifies this change: She is an American artist of Chinese descent who was educated in China in a European tradition, that of mid-twentieth-century "socialist realism"—a style of heroic painting practiced in China and the Soviet Union and grounded in French academic practice from Poussin to David—with Chinese socialist realism tending more toward the "classical" Poussiniste manner and Russian socialist realism tending toward the gaudy heroism of David's late "Napoleonic" style. To further complicate this situation, both

socialist realism and French academic painting have traditionally opposed themselves in different ways to "mandarin" painterly styles that have both Eastern and Western manifestations.

As a consequence, Hung Liu's efforts in the United States to familiarize herself with her own Chinese cultural heritage—with the history of Chinese painting and the manner of improvisational, painterly masters like Wang P'o-mo—simultaneously introduced her to the painterly tradition in Western culture that stretches from Titian to de Kooning with its own shifting atmospheres of signification. Not surprisingly, this introduction to Western painterly practice would prove as valuable to Hung Liu's cultural reorientation as her rediscovery of Chinese gestural painting, since it not only provided a cultural bridge, it provided her with a counterweight to the first artistic academy she would confront in the United States—another Poussiniste establishment at the University of California, San Diego. This American "postminimalist" academy, whose provenance flows from Poussin through David, Puvis de Chavannes, Cézanne, and Duchamp, privileged "conceptual" art rather than the "ideological" art espoused by the Russian and Chinese academies. Over the years, however, this distinction would become as faint as it actually is.

In fact, in the 1970s, the paintings made by the "photo-realist" wing of this academy differed only in minor details and purported intention from the socialist realism in which Hung Liu was trained. Upon arriving in this country, she would exploit the similarity of these painting styles to theatricalize her own peculiar vantage point. To do so, she would exploit the differing status of photographic subject matter in China and the United States. The peculiar power of photo-realism in the United States, of course, was grounded in the fact that photographs are both indigenous and ubiquitous in America. Thus, photo-realist painters sought to redeem this quotidian banality by translating photos into art. Hung Liu's photo-socialist-realism, however, was informed by the fact that photographs in China were both rare and exotic, yet provided her only visual access to her homeland.

Responding to these local realities, Hung Liu adapted the formalizing strategies of American photo-realism to the more urgent task of humanizing the formality of the Chinese photographs, opening a door to her own past and culture. Thus, in her first body of American work, Hung Liu

paints photographs of contemporary China and *uses* the photograph to distance her manner from the Marxist ideology that informed it in China. At the same time, she works to "open up" the sealed surface of the photograph that in the twentieth century has transformed our historical memory into a strobed sequence of stop-action "moments." She tries to reestablish that "middle distance" in which the domain of the image and the domain of the artist/beholder intersect—to reestablish that connection and replace the remote instantaneity of photography with the loose, interactive temporality of the "studio time" whose memory is embodied in the finished painting.

In Hung Liu's paintings, then, the issue is less about making than matching, of establishing some local intersection, some sympathetic resonance between the actions of the artist, the manner of the painting, and the nature of the subject matter. Thus, her paintings of Chinese imperial life are rendered in a Western "mandarin" style of drips and painterly gestures, establishing that bond, and allowing the rhetoric of mourning and mutability that are associated with those "Western drips" to speak of the lost reality of the imperial court. Likewise, when Hung Liu deals with the quotidian subject matter of snapshots, her work segues into a more demotic painterly style that, for Western beholders, evokes both the nineteenth-century "ink wash" and the antiheroic mode of "painterly pop" in the American 1950s—most closely associated with the work of Larry Rivers, early Warhol, Rosenquist, and Wesselmann.

Hung Liu finds what fits, in other words, and this procedure of finding what fits, of achieving local accommodations within the global array of artistic practices, emphasizes an aspect of representation that is rigorously suppressed as long as we regard the artist as coextensive with the culture within which he or she supposedly operates. The fact is that representation is *always* multivalent: it represents both the objects portrayed and the artist who brings the work into being. Subsequent to that, the work represents the beholders who choose to invest it with public value. If, after a suitable period of time, a representation can be said to represent a substantial segment of those who behold it, it may perhaps be said to represent "the culture," as Vermeer and Rembrandt are said to represent theirs.

This, however, presumes that the idea of "culture" will remain a viable one in the fluid global tumult that human beings have created for them-

selves in this century, and the idea of "culture" may not survive. It may be that Hung Liu's transcultural, local solutions, to her particular desires in her particular social and geographical situation, constitute a new artistic model which is, in fact, as old as America's transcultural polity of immigrants. This is a model of artistic practice in which works of art represent that which they portray and beyond that represent not the culture but the loose, diverse society of individuals who hold these works in esteem and invest them with social value. In Hung Liu's case, I count myself a member of this cosmopolitan society.

Teresita Fernández

Tropical Scholarship

We assume that the art created in a particular cultural moment is an expression of that particular moment. This is never the case. Art is a bet on the future. Michael Baxandall identifies the "period eye" that pertains to the temporal construction of vision of the populace in a particular time, but the "period eye" is the opposite of "period made manifest" that does not exist. The new art of a particular time and place is more likely to be an effort to *replace* the "period eye" and restore those erasures and comforts that present circumstance and technology are winnowing away. As a result, it is more rewarding to think of persuasive new artworks as wild cards from nowhere that help us complete the hand that culture is dealing us unawares. Think of abstract expressionism as compensating for the post-traumatic blandness of postwar America. Think of pop and minimalist art as compensation for the elitist Marxist and Freudian critical culture that grew up around abstract expressionism. Think of postminimalism and conceptual art as compensating for the spectacular mindlessness of pop and minimalism in their plastic decadence.

From this perspective, new art may be said to have fulfilled its particular social function in the moment that it *becomes* culture. At this point, it enters the realm of academic typing, history, and sociology. At this point, art becomes less interesting to those of us who prefer art that retires the past for a moment until it becomes the past and a ghost of Christmas Yet to Come. New art is that wild card. It mitigates some presently invisible cultural deficit. This is why, even though I would never refer to a cosmopolitan artist like Teresita Fernández as a "Miami-based artist" or a even a "Cuban-American artist," I do think of her as a "tropical artist" who deals

Teresita Fernández, *Untitled*, 2012. Polycarbonate tubing, 96 ✛ 542 ✛ 264 in. (243.8 ✛ 1376.7 ✛ 670.6 cm). Installation view, Lehmann Maupin Gallery, New York, 2012. Courtesy of the artist and Lehmann Maupin, New York and Hong Kong. Photo by Christopher Burke Studios.

with issues that, in my own critical vocabulary, are peculiar to "Tropical America"—a cultural configuration that is only now gaining and expressing a new and accumulating relevance asserted by artists like Cy Twombly, Nancy Rubins, Lynda Benglis, and Robert Rauschenberg. So the best I can do is provide a cultural validation of Fernández, to provide a cultural armature for its apparent eccentricity.

Fernández's art deploys architectural fields of stones and glass in rectangles and explodes them into biomorphic shapes without destroying the inference of their original shape so the exploding stones seem to tug back toward that configuration. She exploits the elevation map (with its stacked plates of variable configurations) as the classic signification of fractal nature's intersection with cultural geometry. Fernández translates the landscape and flora of the tropics into cultural objects by translating them into horizontal and vertical plates that trace out the irregular planes and swoops of their configurations in fractal detail. Thus, in Fernández's language *Precipice* becomes a crooked mesa of gray stairs; *The Dune* is a shaved, dazzled stack of concave planes—like a choir riser for tiny people. Her *Waterfall* is a slow free-floating curve of luminous blues that flows down from the wall to the floor, marked with horizontal lines that locate the planes of the space through which the object curves. Instances of willow, wisteria, acacia, falling water, and tidal residue present themselves in relief, in reflective precision—as intricately cut stacks of stainless steel planes through which the light falls and from which it reflects.

None of this has anything to do with northern Europe or New York. Fernández has inherited a Latin American history of art that is distinguished by its direct traverse from the baroque to the romantic to the modern untouched by the rationalist enlightenment. Her narrative jumps from the baroque to the surreal to the abstract, and it is less radical than it might seem, since any narrative bloodline works as well as any other in a democracy. Over the years, this elided history has created a modernist idiom of Latinized color and geometry that northern critics (when they refer to it at all) call "sexy modernism"—a modernism that does not come freeze-dried by enlightenment rage. These critics, of course, have not yet decided if "sexy modernism" is a good thing or a bad one, but I vote for good, mostly because it provides a persuasive alternate story for Ameri-

can paintings coming of age after World War II; it suggests a history that moves differently than we presume. Fernández suggests an art practice that moves directly from the Mediterranean baroque, through the actual and indigenous folk-baroque of Latin culture, through the revolutionary politics of Latin American modernism, to the Mexican *muralistes*, to the triumph of New York School painting. From Titian to Miró, to Siqueiros, to Pollock, to the new world of postwar art, in other words.

This is worth mentioning here because Teresita Fernández's work feels comfortable in this flow, as does the work of other Tropical Americans like Jorge Pardo, Jim Isermann, and Ken Price. All these artists engage in an odd romance between chaos and design. They opt for an impersonal rejection of romanic auteurism. The work of these artists is interesting as art, but it is also interesting as a cultural proposition that seems to be on the winning side. The behaviors, phenomena, and objects that, in the North, seem to invite or demand deconstruction, are already in the process of deconstructing themselves in the tangles and mutable swamps and wetlands of the South.

In my view, the world that Teresita Fernández evokes matters more every day because Fernández's affection for tropical culture softens the hard distinctions that pass as hard currency in the intellectual casinos of the North. In the tropics, the distinction between one thing and another, between one place and another and one identity and another, is all flux—dirt turns to water, water turns to air, and air back to water and dirt. In this world, culture is nothing more than the grid and the plane. All the rest is fluid nature. Since most of it has been imported, it qualifies as culture too, or the fantasy of it. The visual irony of Fernández's *Ink Mirror* (landscape) is that both the vertical, black, rectangular slab and the dune of white sand from which it arises are as natural as they are cultural—and something beyond that, since they evoke an imported, imaginary landscape that humans have built, in which real humans dwell.

Living in this world, in the fantastic temperate cocoon of Tropical America, means that one's mind is not fully occupied with keeping one's body alive, so the mind and the body blur at the edges, and since your body is at home in the air around it, the self and the other blur at the edges too. The "class-language" of clothing is suppressed, as is clothing itself on numerous occasions. The echoes of one's self move outward in arcs of physi-

cal resonance. As do the physical attributes of one's world. The bougainvillea in your yard are yours first, an extension of your body's centrality. They are only secondarily God's nature. One lives in a full world in which one is occasionally punished but never inconvenienced by the climate—a society in which fine distinctions are hard to come by.

So Fernández works at the edge of entropy but never beyond it. Her works exist in the domains of the translucent, the reflective, the blur, and the slide; she embraces the scatter, the splatter, the explosion, and the splash, and only as much physical matter as it takes to achieve the curve and reveal lineaments of culture. Her objects occupy the realm of surfaces but not the realm of objects, because the easy northern distinctions between space and volume, between one's interiority and one's exteriority at the false threshold between appearance and reality, dissolve in the Okefenokee. Manners and morals become indistinct. The idea of "identity" has no practical meaning. The qualifying virtues of artistic chaos and abjectitude, which feel so necessary in the overorganized North, approximate the conditions of tropical life so closely as to become trivial.

So this is my question. What is the wild card in the hand that Teresita Fernández deals us? What do the tropics need from an artist? Or, what does an artist in this environment see that needs to be done? My suggestion is that the tropics are always in need of a good redesign, and are receptive to them, not a northern redesign that extends the bland encroachment of repressive geometry and not a Disneyworld reproduction that only reminds us of the unauthentic absence of thorns and insects but a tropical redesign that speaks its own language, that provides a stable armature at the intersection of nature and culture for its mutable profligacy. Morris Lapidus identified this intersection as the curve, the shape that nature and culture share, where mathematics, calculus, and physics meet the harbor, the bay, the wave, the dune, and the bend of the river— the universal algorithm.

Lapidus began his Fontainebleau Hotel on Collins Avenue in Miami Beach with the curve, because, as he told me once in an interview, curves signify leisure, because a curve is the longest, most beautiful distance between two points and we are tropical human beings who are not in a hurry. We are always shopping for views, or news, or toothpaste, like Romans in the curve of Trajan's market. Also, curves are sexy because hu-

man beings are curved and the curvier the sexier. Curves also stand for change because curves are how we measure change and express it in the calculus. Curves signify flexibility and adaptability to nature, because nature is not rectangular. Curves also stand for self-sufficiency and independence, because, as Richard Serra so aptly demonstrates, curved walls can stand free and straight walls cannot. "A lot of good things about a curve," Lapidus said, "and about ovals and circles and biomorphic shapes because they have no normative 'size' relative to any enclosure they might adorn."

For these and other reasons, Teresita Fernández organizes her work around the curve. She balances her work on its precipitous fulcrum. The formal function of Fernández's planar objects, it should be noted, reverses the function of this practice in architecture. In architecture, the stacked irregular planes of the articulated elevation maps are intended to extend the contour of the landscape. In Fernández's sculpture, the vertical and horizontal plates accommodate her fractal objects with the rectangular enclosures in which they are exhibited—a minimalist device in baroque circumstances. All of these works may be taken as confirmations of Bernini's contention that there is nothing so ephemeral or protean that a master sculptor cannot freeze it forever. Fernández's translucent yarn cubes, her pillars of fire and atmosphere, also speak to this aspiration and suggest a group show of works that share this ephemeral aspiration by Peter Alexander, Robert Irwin, and Jesús Rafael Soto.

The interesting point for me is that Teresita Fernández and her all colleagues in this delicate endeavor (Pardo, Isermann, Alexander, Price, Irwin, Nancy Rubins, etc.) are children of Tropical America. They have a touchstone in those southern corners of the continent that are not properly America at all, but are not properly anywhere else. In the years of their innocence these corners of the continent were literally nothing. They were nowhere at all—just big sky, big clouds, saltwater, sand, dirt, and that full, luminous haze, the green lightning bouncing off the water that makes the atmosphere a palpable realm of blur and dazzle. Nothing is quite itself. The sky, the sea, and the landscape blur together at their intersections. There were also weeds, brush, palms, marshes, deserts, serpents, rodents, and a scattering of scantily clad human beings. Nothing too organized, and, even today, in its penultimate cultural maturity, after

human beings have added plants, streets, flowers, and architecture, Tropical America has not changed that much: Los Angeles, Miami, New Orleans, and Houston are still less proper American cities than swathes of equatorial wasteland divided into tribal neighborhoods.

In the years of its social flowering, theorists referred to the realms of Tropical America as Hyper-places, or Surrealities. Today they just shrug and say so what. They acknowledge that these places may not constitute nature or culture by American standards but they are no less real and the tropics are winning. People admit that our comfort with the putative inauthenticity of tropical, cosmopolitan America speaks to the death of Culture as weathered clapboard in Connecticut. For myself, I consider the waning of romantic Nature as an energizing concept for the tropics and not a signifier of its decadence—especially when one considers the fact that, when approached from the south, from Latin America or the Caribbean, Tropical America seems to be a perfectly ordinary and comfortable place in its rapacious fecundity. What has changed is that Tropical America, once regarded as a final refuge from Protestant America, has finally become a real place, the last refuge from entropic Latin America and Puritan America as well. It has become a place from which one might seek succor, more and more a viable alternative to the dominant culture.

One principle supports this option. The joys of Tropical America with all faults can be made more livable with less effort than the conformity of Middle America can be made more joyful. Any urban designer will tell you that the messy, chaotic infestation of human beings in the tropics may be tidied up more easily than the rigid culture of the heartland may be relaxed into a more global generosity. This assumption lies at the heart of Eames, Shindler, Neutra, Lapidus, Gehry, and many others; it informs the architecture of California modern and Miami deco. Artists like Fernández, Pardo, Price, Irwin, and Isermann speak volumes.

They create handless and virtually impersonal objects that are routinely overwhelmed by the ego and theater of their designing and architecting colleagues. This because these artists, so often degraded by their association with design, do, in fact, transcend design more profoundly than those who visibly reject it, because these artists are designing functions to some philosophical purpose. They are creating for the first time some occidental approximation of scholar's rocks, Zen gardens, quiet

sites, and objects of contemplation, molding them into a collectively
imagined society. Each is a parable of a sort, so if the work of Teresita
Fernández seems too quiet for you, shut up and listen. She is whispering
the future. I always think of a meticulous nineteenth-century painting of
a hummingbird by Martin Johnson Heade as marking its beginning.

Nancy Rubins

The Rapture and the Tsunami

I had never noticed the angular, meticulous shadow thrown by a half-open barn door until I saw the paintings of Ellsworth Kelly. I had never really thought about the oozy sand in the tidal pools at Malibu beach until my friend and fellow surfer Kenneth Price made that goo a gift to me in art. Now, thanks to Kenny, I can feel it sliding through my fingers. Today, finally, I can luxuriate once again in the clean, fluid, highway reverie implanted in my lizard brain by a million miles of American highways, scrawled there by my dad's big-band tours, by my own beatnik adventures, and endless, bloody, promiscuous, rock-and-roll crusades. For decades this serenity was lost to me, burned away by the ferocity of whatever mission I was on. Now the smooth whoosh is back, mine again thanks to Edward Ruscha—happily restored by the haunting, floating language, the hazy atmospheres, and razor sharp horizons of his paintings.

Had Michael Heizer not dug his *Double Negative* in the desert outside Las Vegas, I should have forgotten the lesson Larry McMurtry taught me in his novel *Horseman, Pass By*. When told by the parson that his father had "gone to a better place," McMurtry's hero snaps, "Yeah, if dirt's better than air." Without Heizer's fiat, I might have forgotten the primacy of air, the priority of surface over volume. I might have forgotten that negative space is positive space for human beings, that gravity is death and the hard earth is our only destination, pressed down as we are by a power for which art is the only redemption.

My oft-told story about Nancy Rubins concerns my brother and sister and me. When we were youngsters, my grandmother had a large walk-in refrigerator in her flower shop that was devoted to exotic flowers—a refuge

Nancy Rubins, *Big Edge*, 2009. CityCenter, Las Vegas. Aluminum boats, stainless steel, stainless steel wire cable, 51 ✛ 75 ✛ 57 ft. Collection of MGM Resorts International, Las Vegas. Photograph by Erich Koyama. © Nancy Rubins. Courtesy of the artist.

for multicolored orchids, for flaming heliconias surging upward like fire-works, for ginger, yellow fern, birds of paradise, Madagascar honeycomb, *anthurium andraeanum* and other varieties of the "flamingo flower." Compared to dingy brown Texas surrounding us, my grandmother's icebox was heaven, so we played a game inside it. We would shut ourselves in, close our eyes, and chant "flower, flower, flower, flower, flower, flower" until (like Gertrude Stein's "rose") the sound "flower" was just noise, washed of meaning and reference.

Then we would open our eyes and just for a moment, before the mechanisms of cognition kicked in, the flowers weren't flowers. They were sheer amazement—a chilly multicolored dream. The clouds of blooms and fragrance seemed to bear us up with rapturous lightness. At the same time, the curve of the stalks bending over our heads evoked the surfer's nightmare of coming up into the leading edge of a thirty-foot wave. I should never have remembered this anecdote, however, if the catastrophic glamour of Nancy Rubins's sculptures had not produced in me the same brew of sensory memory. Thus the title of this essay: the rapture and the tsunami—which is a good title, although I have discovered that most of my friends tend to favor one over the other. Lotus-eaters love the glamour. My anarchist friends embrace the apocalypse. As an adept of creative destruction, I quiver at the dread of the wave coming down and also imagine myself rising like a dolphin within the clear blue wall of wave.

Rubins's work, in fact, could easily have been Wallace Stevens's subject when he wrote, "Death is the mother of beauty," since, parochial aesthetics aside, neither death nor beauty is ever absent (or *could* be absent) from Rubins's graceful, brutal sculpture. Her giant, ragged straggle of airplane parts crashing from the downtown Museum of Contemporary Art San Diego (adjacent, of course, to the airport) evokes some aviational catastrophe. The clumps and folds of airplane parts that adorn the tree up in Topanga echo the wreckage of every misguided smuggler's plane that ever plunged into the cypress swamps of Louisiana. The pyramid of trailers piled helter-skelter in a field outside Pittsburgh speaks all too clearly of the aftermath of a tornado in Oklahoma. The salad of house trailers and hot water heaters Rubins constructed for the *Helter Skelter* exhibition at MOCA rather ominously recalls one of Fernand Léger's bad dreams.

The sculpture that Rubins has snuggled into the alcove of a museum

in Graz, like a giant robot's knuckle or a titanium canapé, is located next door to what was once the home of the Archduke Franz Ferdinand, whose assassination in Serbia set off World War I. Today, it could easily be construed as a war memorial, or, at least, at worst, as testament to malignant industrialism, but it's not and has never been. Rubins's graceful sixty-five-foot flower in Las Vegas blossoms among the faux-modernist sleekness of CityCenter like a *fleur du mal,* a repudiation of everything around it, and everyone still loves it. The bouquet of canoes shooting off the roof of the Museum of Contemporary Art San Diego in La Jolla (adjacent, of course, to the ocean) imagines the tsunami in the moment of its sucking roll.

Rubins herself has her own view. She is sort of indomitable. "I am an optimist," she says. "You mentioned Wallace Stevens. Well, for me, junk is the mother of beauty. We live like squealing babies between nature and disaster. We have parks to remind of us of ideal nature. We have my works to remind us of the catastrophe, to bracket our comfortable lives with something scary and beautiful." Thus, Nancy Rubins's sculpture has joined what for me is an elite category of art that I find to be self-evident in the Jeffersonian sense—art that exists without precedent, excuse, cultural confirmation, decorum, science, psychology, or theory, just hard-core physical staying power—intellectual art in the sense that it makes ideas visible, but never conceptual. Conceptual art, in Rubins's view, is the job of beholders and dependent on their own reading list.

Because of their categorical cleanliness and freedom from denominational off-ramps, these works, for me at least, move with alacrity, without the slightest hesitation, into the scrambled wires of my perceptual mission control. They light up an assortment of talismanic moments from my youth or adolescence, and, at first, when I was learning about art, I thought these unbidden recollections were causes of my art preferences (I grew up in West Texas, therefore I liked Ellsworth Kelly), but that was a tyro's delusion. Today I consider these self-evident objects as sensual cues, random gifts of feeling that generate forays into the opaque nebulae of the cortex. The art itself, of course, is *always* the cause and never the effect of something past. It restores fugitive moments hitherto lost, blurred, or buried. This is one of the many things that art does, and one of my favorites.

The difficulty of nailing down the long, unspooling procession of these artists' works, and other artists of their clan (Pollock and Chamberlain

come to mind), is that these artists are *practitioners*. Like doctors, lawyers, and architects on the site and in the weather, they have a contemporary task to perform in a particular place and a cluttered warehouse of ahistorical precedents from which to take what they need. They can take anything from anywhere because they are not developers. They are not concerned that this year's model is at once similar to and different from last year's model. Like Pollock and Chamberlain particularly, Rubins practices incremental improvisation. Pollock's method was to paint one good painting and cover it with another good painting, and another good painting. No fixing up or "do-overs" allowed, except for the occasional splash of zinc white. Chamberlain started with a good group of objects picked up off the studio floor, like words from a book, and proceeded from there, elaborating his object with steel paragraphs of wreckage that proceeded with increasing delicacy until the whole chorus sang.

Rubins proceeds like this. Her recent pieces start with a provisional maquette that is subject to intervention. On site she mounts a canoe on a steel armature in what she considers to be a cool position and secures it with cables. Then she decides where the next canoe should go and what color it should be and secures that canoe with cables. Then she decides about the next canoe and the next canoe and the next, etc., securing each canoe with cables. Needless to say, Rubins's sculptures are enormous and daunting industrial projects, but there is the trick. At first, when you look at her work, those of us who have been indoctrinated by sleek software and ingenious engineering solutions (and that's all of us) presume that there is a rationally designed system of enclosing cables. There is not. The canoes are attached incrementally, decided upon one at a time. The more cables the better, in Rubins's view, so what at first appears to be an incredibly complex engineering solution turns out to be a poetic, material ballet, hard as hell to reimagine but easy as pie to improvise if you have a gift for it as Rubins does. One good canoe is wired up; another good canoe makes it better and so on and so on. The challenge of this practice is the increasingly outrageous improvisations and adaptations, lifts, inversions, and cantilevers, which are demanded at every level, so each work may contain ten new options, ten versions of the future, one laid upon the other.

Think of Art Pepper playing "So Nice to Come Home To" with Miles Davis's rhythm section, always outdoing himself—each solo surpassing the

previous one in its daring and effortless invention; then imagine the chromatic complexity of laying all these solos over one other. This would comprise the whole heart of the endeavor, and it's hard to write about art that arises out of such complex physical poetry because Rubins's performances are so daunting, humongous, intricate, and original that they raise the primary question about all great performers: How does one sustain a belief in one's gift that is profound enough even to *embark* on such a mission? Most of us believe in our skills, our intelligence, our moves and experience, but these won't set us asail. When Nancy Rubins begins a project, or Mick Jagger steps onto stage, or Kobe Bryant steps on the basketball court, they believe in their gift. All other circumstances aside, they believe they possess the moral resources that will bring their endeavor to its fruition—that will make it happen. And where does this faith come from? Jackson Pollock, the most gifted artist of the late twentieth century died of not believing in his gift, died listening to people and trusting people, unable to find in himself the insouciance and carelessness that Joe Namath bore with him onto the Super Bowl field.

In search of an answer to the mystery of great performance, I thought for a moment that I would describe one of Rubins's sculptures in process, observe her performance step-by-step, with canoes sailing by, rising up, cable-by-cable, part-by-part, impromptu decision followed by impromptu decision. But prose could never do this. Words are things, to be sure, but, they are not heavy enough things to do the job, and that would be the point. I have written this kind of story before about Lou Reed and the New York Dolls—tour stories—and I would probably come out with nothing more now than I did then. There would be chatter, numbers, hard labor, tears, panic, desperate decisions, and finally: *Boom*, the work would be there and nothing that came before would matter. The process would evanesce like dry ice but the work would not disappear as music does; it would not yellow like the pages upon which I wrote about it. It would stand there viewable in a thousand dimensions, painted with a thousand shadows, not quite writing, not quite music, not quite painting, and not quite sculpture, really—just a gift—a visible concert that goes on forever.

The consequence of this protean, mercurial process is that Rubins's work, while shining in the light of the moment, casts a light into the past. Her work confirms a tradition that began with David Smith's antigravi-

tational urge to draw in space in three dimensions. She also exploits the glistening surfaces of Smith's sculptures, and the invention that Tony Caro made in America of slicing the air rather than the medium, of substituting surface for volume. According to Caro, this idea almost had to be imagined in America, since the UK, with no sky and too many trees, provides such an ideal environment for solid blocks of steel. (In America, a solid block of anything situated anywhere just doesn't light your candle.) My best explanation for Caro's insight is that America is beautiful for its spacious skies, compared to which the amber waves of grain and purple mountain majesties are nearly negligible attributes.

This war between earth and sky, surface and volume, has intrigued American sculptors since Smith's shining cubes, especially on the West Coast where, thanks to plastic, the paints, and the surfaces got stronger and sleeker quicker. As a result, when I asked John McCracken about Clement Greenberg posthumously sanding the color off Smith's sculpture, he just shrugged. Some ideas precede the technology available to execute them, he noted, so the scrape and repaint would have been inevitable because Smith used bad paint. The redo would have to have been done for the same reason the Guggenheim conservators transferred Jasper John's two white flags (*White Flag,* 1955), chip-by-chip from the bed sheet upon which it was painted to an archival canvas.

Rubins's greatest fiat, however, was to explode the geometry of Smith's arboreal, floral *Cubi* into tropical profusion, and there is surely a local explanation for this. Like many of my artist friends who have lived and worked in the American South—like Bob Rauschenberg, John Chamberlain, Lynda Benglis, Jim Rosenquist, Bill Eggleston, and Teresita Fernández—Rubins is profoundly beguiled by the South's semitropical jungle landscape, its horizon-less, tawdry, proliferating tangle, its opaque profusion—and its trailer parks, of course. In this sense, Rubins's plane parts crashing into a tree is analogous to Lynda Benglis's early pour pieces, which arise from Benglis's familiarity with the oil slicks on the bayou. Rubins also shares an interest in "agriculture" with Ann Hamilton, although Rubins's "agriculture" is much less bookish. They both love the soft point at which nature and culture interpenetrate.

Many of Rubins's sculptures are given titles that infer the possibility of growth arising out of destruction, and this organic leitmotif is all

the more explicable when you imagine Rubins growing up and attending public school in Tullahoma, Tennessee, where (as a genetic enemy of overorganization) she flunked synchronized swimming. From Tennessee, the temporal sequence of her work is less a story than a picaresque travel narrative, bouncing around America and Europe with evolutionary stops along the way. The long narrative of her work in material terms, begins with mortar (clay). She adds bricks (found appliances), then demotes the mortar, then upgrades the bricks to ungrounded objects in part or intact—boats, airplanes, surfboards, trailers, jet skis, hot water heaters, canoes, and mattresses—anything you can pick up and take with you, anything streamlined with airfoil lift or buoyancy. Then she eliminates the ground altogether. She floats objects, like the clouds of German mattresses, Belgian mattresses, and Danish hot water heaters—all of which she created in Europe. She creates enormous metal juggernauts that disguise their footing in a steel armature. Then there are those sculptures that present themselves to us like wounded warriors with space-age prosthetics. These grow out of live bases, like one of Ovid's *arborescere* reversed. Rather than Daphne's metamorphosis into a laurel tree, we get a tree transforming itself into a glistening industrial instrument.

At school in Maryland, she began with clay, fashioning teacups with bananas tilted in them, thus establishing the single consistent visual leitmotif in her art: the phallic banana-canoe, an icon in which she takes some ironic delight. In New York in 1980 at OK Harris and Battery Park, Rubins substituted concrete for clay and added found appliances to create standing objects best characterized as deep mosaic or macho terrazzo. In 1982, in Washington, D.C., the concrete goes clandestine within an enormous bulb of clustered appliances, like a bulging, penultimate flower bud. Before this, she wasted a few years in San Francisco, a city whose artistic toxicity is best characterized by local artists' tendency to hang together and support one another's work—San Francisco being so "special" and so genteel that nobody has the guts to tell you it's shit. Then she moved to Los Angeles, where everyone hates everyone and everything. At this point, things really took off. It was as if the blade that "Nice Nancy" had been hiding all these years suddenly slipped from its sheath.

People started hating Rubins's work right away and that was better than hugs since nobody questioned her high-handed authority or the

work's absolute self-evidence. They just hated it, and this meant people were afraid. It meant that they didn't understand what they knew was irrevocably happening. Taking Caro's example and following Chamberlain, Rubins bypassed the paint problem by using prefabricated, industrially painted and finished material to create certified, volume-less, 360-degree sculptures. She happily exploited broken, crushed, and bent industrial accouterments to insist upon the emptiness of their prefabricated, conceptual curves, to acknowledge the fractal universe and the primacy of surface. Then, finally, there is Rubins's virtual, inexplicable, and always welcome predisposition to make her sculptures fly—to make a place for themselves above the tree line—and this, too, may be the residue of claustrophobic Tennessee.

In any case, in every possible sense, in every possible maneuver, Rubins strives to free her sculpture from the hegemony of gravity—to invest it with the blessed weightlessness of painting (without which we would have no angels), and having seduced gravity, her work carries the historical prolixity of visual imagination back into the heart of the baroque and the rococo, to the ceilings of Carracci, Tiepolo, and Boucher. In these maneuvers, Rubins does for lightness what Richard Serra does for visible weight when he re-evokes the palpable avoirdupois of Mantegna's dead Christ. Rubins, for her part, slips the surly bonds of earth while eluding the conceptual protocols of modernist abstraction. The objects she sends aloft all reference human scale, so they are very nearly creatures, floating in the atmosphere, contiguous but unattached like the gods and icons that float on Tiepolo's ceiling in Würzburg. And why? When I asked Bob Grosvenor this question about his radically cantilevered sculpture, he shrugged and said, "Because I hate things that make sense." As do I, except when they make the sensual logic that Nancy Rubins has mastered.

Elizabeth Peyton

At the Prince's Chateau

Elizabeth was looking out of the window of the first-class carriage at the passing countryside. "The city makes all this possible," she said.

"Actually," David said, adjusting his glasses, "*Death* makes all this possible. But the city is a part of it. The city makes human things seem permanent and that makes death seem unnatural and that makes everything natural seem amazing."

"Maybe you're right, " Elizabeth said, leaning back into the tapestry of the cushion and exhaling. "In any case, it's all a bit too much."

They were alone in the carriage, smoking Turkish cigarettes whose papers had been dyed to match the smoke they produced. The smoke also matched the smoke of the city, so they watched it curl around the interior of the carriage and talked about pop bands in the city while blue-green meadows, bejeweled by the dew, glided by outside the window. The meadows were populated by white sheep and gleaming horses. Patches of ghostly fog floated here and there like delicate erasures. It was a lovely vista, but Elizabeth, at that moment, could not appreciate its subtlety because she was very confused and worried about her schedule. David was confused as well, but, being older and hugely successful, he was more accustomed to being confused and less worried about his schedule.

In the small hours of the previous morning, they had been sitting in darkness, in the crowded basement of a huge, Victorian building. They had been drinking Irish coffee and listening to a band that played lively songs with exquisite harmonies about dead fashion models. Now the two of them were sitting in this sunlit carriage, clicking along silver rails. At some point in the journey, David knew, there would be a dogcart. They

would ride in this dogcart beneath a cathedral vault of ash trees, and there would be a prince. Elizabeth knew this, too, but she hadn't mentioned it to David, and, since neither of them acted confused, neither thought the other was confused at all. As a consequence, ever since their abrupt and inexplicable departure from the great glass station, David and Elizabeth had been riding along as if nothing were amiss, talking about the city. Now the city seemed very far away, indeed. By the time the train began to slow, as if cushioned into pillows of its own steam, the two travelers had fallen into pensive silence. They gazed out the window. The yellow-brick station glided slowly into the foreground and stopped. The dogcart, they presumed, was just out of view, on the other side of the station, on a dusty path beneath the ash trees.

⌐

Prince Harry spent this beautiful morning tending the three volcanoes that graced the great lawn of his chateau. Only two of them were active, but Prince Harry tended all three of them, because you never can tell, and also because tending the volcanoes was his favorite chore when he was up-country. It seemed a very princely thing to do, to tend volcanoes, and it gave his two beagle puppies, Ti and Do, an opportunity to scamper around under his feet, barking, until he accidentally bonked one or both of them. Then they could tumble around joyfully on the grass and bark some more. The prince was particularly happy this morning, because late the previous evening, just before retiring, while he was drinking his beaker of warm milk, he had thought of summoning David and Elizabeth from the city to amuse his friend Oscar, about whom he was mildly concerned. Now, he was mildly concerned about Elizabeth's schedule, but he knew that he could work that out, because that was what princes did. They could wish things so, or, failing that, they could say, "Get me Zurich on the phone!" and, having gotten Zurich, they could work things out— even when they couldn't cheer up their friends. Now David and Elizabeth were coming, clicking along silver rails. They would cheer Oscar up by giving him someone with whom he could discuss Prince Harry, and Prince Harry would work out Elizabeth's schedule, and David, of course, had people to work out his schedule for him. So it would be a fine adventure for everyone.

Every summer, when he came up-country, Prince Harry brought Oscar along with him, because he loved Oscar's company. He also loved it that Oscar loved him in a very different way than he was loved by most of his subjects. Oscar, he had discovered, had *sympathy* for him, and claimed to understand the limitations of princely existence. Harry, of course, had no idea of what these limitations might be. He had, after all, but to wish and it was so, but he liked being cared for in this way. He also understood that the sympathy Oscar felt for him made Oscar feel better, too. Once, during the previous summer, over a leisurely lunch, Prince Harry had asked Oscar about his sympathy, and Oscar had said, "The problem is, Harry, you have no wound or blemish. Your wound is not having a wound. You're beautiful, and, sad to say, the beautiful know nothing of beauty—and they *should not*, since this knowledge only breaks their hearts and leaves their loveliness intact."

"Did Falstaff say that?" Prince Harry inquired. "People are always quoting Falstaff to me."

"No. Oscar said that," Oscar said, dropping the subject and picking up his utensils. A little later, but still during lunch, Prince Harry had asked Oscar to expound upon all the specific people that he, Oscar, had ever loved, because one of the *few* problems of princely existence, he explained, was that, in the process of loving everyone, a prince's affections rarely took on much texture or specificity. Prince Harry knew that Oscar would love this question, and, indeed, he rose to it like a carp through emerald water. Clearing his throat, Oscar began somewhat formally by enumerating the helpful virtues of a governess named Leticia. By the time their lunch was over, Oscar had described in loving detail his parents, a gamekeeper, a neighbor girl, a tutor named Eugene, and a stable boy named Ned. As Prince Harry had wished, Oscar's spirits were much improved by this enumeration. That, however, had been last summer.

This summer, not to put too fine a point on it, Oscar had been a big mope. He reclined on the wrought-iron chaise at the edge of the verandah overlooking the great lawn, his paisley-bound notebook closed upon his lap. He stared at Prince Harry's single, inactive volcano—stared at it critically, as if its dormant status constituted some kind of a flaw or a challenge. Seeing this, Prince Harry was afraid that Oscar had come down with a case of connoisseurship. This happened occasionally to commoners who

came to the chateau, who were so unused to any degree of elegance that when confronted with a lot of it, they immediately set about labeling some of it less elegant than it might be, instituting hierarchies of elegance— comparing the camellia in the bowl this morning to yesterday's camellia. So the prince (who had only as much tact as one can have without guile) just said it. "Do you find my little volcano inadequate, Oscar?"

"I find it quite adequate," Oscar had snapped. "I find *three* volcanoes, two of which are active and one of which is inactive, *quite* inadequate. I am not made of stone. I have *some* need for closure, but I am trying to be patient."

"No need for patience at the prince's chateau," Harry said, laughing. "Just look behind you, my friend." And Oscar did, at the chateau itself. "Observe the roof line, Oscar. There you will find three weathercocks, two spinning and one frozen in place. A subtle but rich, harmonious relationship: two active volcanoes and two spinning weathercocks, one inactive volcano and one frozen weathercock. My Chamberlain of Incarnate Protocols, Mister Devereaux, assures me that this configuration constitutes closure of a very high and abstract order."

Oscar scanned the roofline, and seeing that what the prince had said was so, sighed a contented sigh and let a beautiful smile spread across his face. The prince smiled too, but Oscar's good humor did not last the morning. It was not long, in fact, before Prince Harry caught Oscar glaring balefully at the frozen weathercock on the roof of the chateau. He decided that Oscar's problem was "personal," whatever that meant. He thought that perhaps Oscar was having trouble writing whatever he was writing in the paisley-bound notebook that lay closed on his lap—that, somehow, the inactive volcano and the frozen weathercock seemed a rebuke to him. So the prince (who, you will remember, had only as much tact as one can have without guile) just asked him. "What are you writing, Oscar? Read me the beginning of it."

Oscar looked up and smiled. He slipped the bonbon he had been about to pop into his mouth back into the pocket of his frock coat and cleared his throat.

"Very well," he said, opening his notebook. "*The Happy Prince*," he announced and began to read; "*High above the city, on a tall column, stood the statue of the Happy Prince. He was gilded all over with thin leaves of fine*

gold, for eyes he had two bright sapphires, and a large red ruby glowed on his sword hilt.

"He was very much admired indeed. 'He is as beautiful as a weathercock,' remarked one of the Town Councillors, who wished to gain a reputation for having artistic tastes; 'only not quite so useful,' he added, fearing lest people should think him unpractical, which he really was not.

"'Why can't you be like the Happy Prince?' asked a sensible mother of her little boy who was crying for the moon. 'The Happy Prince never dreams of crying for anything.'

"'I am glad there is someone in the world who is quite happy,' muttered a disappointed man as he gazed at the wonderful statue.

"'He looks just like an angel,' said the Charity Children as they came out of the cathedral in their bright scarlet cloaks and their clean white pinafores.

"'How do you know?' said the Mathematical Master, 'You have never seen one.'

"'Ah! But we have in our dreams,' answered the children; and the Mathematical Master frowned and looked very severe, for he did not approve of children dreaming."

When Oscar finished reading, Prince Harry said that it was a wonderful beginning, but he was not quite sure about this. Since he was the only prince in the vicinity, Prince Harry assumed the story was, at least in part, about him, and he wasn't particularly fond of stories about himself or statues either. He thought of *himself* as a statue of himself, living his own prince-story. Also, he was not sure he liked where Oscar's story was going. The Happy Prince, being described so beautifully and in such happy circumstances, was almost certainly being set up for some kind of fall. Prince Harry, however, kept his reservations to himself. It was sufficient unto him to know that his friend Oscar was not suffering from writer's block and that he had not been tamed into connoisseurship. So he suppressed his curiosity, made a little "ta-ta" gesture and wandered out across the lawn with Ti and Do gamboling around his feet. A secret smile played about Oscar's lips as he watched the prince depart. Even princes, he thought, liked to know what happened next. *Especially* princes, he thought, correcting himself.

At this very moment (as Prince Harry very well knew and Oscar didn't), David and Elizabeth stood in the shade on the dusty path contemplating the dogcart. Two large brown dogs hitched to the cart slept on their paws,

their breath blowing up little plumes of dust in front of their noses. Occasionally, one of them would emit a snoozy, doggy sneeze.

"Well, what do we do now!" Elizabeth demanded querulously, her hands on her hips. She did not *like* not knowing what to do, and this was all getting to be too much.

"We get in and go, I suppose," said David, who, after many years of smiling at people who presumed he spoke their language, was perfectly at ease not knowing what to do.

"Where?" Elizabeth demanded, "Where do we go?"

"We go where the dogs take us," David said.

"Great," Elizabeth said, with a sniff.

They climbed into the cart, and sat there for a moment.

"You drive," David said. He was polishing his glasses with the end of his scarf. When Elizabeth glared at him, he said, "Pick up the reins, jiggle them, and say some doggy equivalent of 'giddyap.' I'll watch out for elephants."

"*Elephants!*" Elizabeth said, "Are there *elephants* around here?"

"I don't *know* if there are elephants around here, " David said patiently, "That's why I am going to look out for them. One always should, because elephants can be very cruel."

"Elephants are not cruel," Elizabeth muttered, "They never forget."

"Is that not the very *essence* of cruelty?" David asked.

"Jeez," Elizabeth said and jiggled the dog reins. The two dogs rose slowly to their feet, one paw at a time. They stretched languidly, glanced amicably at one another, each to see if the other was ready, and set off down the path under the cathedral arch of ash trees in the direction of the chateau.

After about a mile, the path came out from beneath the ash trees at a large wrought-iron gate. The gate swung silently open as they approached, and they embarked upon a smooth gravel path that wound away before them into the grounds of the chateau. The dogs never broke their trot as they passed through the gate. Then, after they had been padding along the path for nearly a mile, the two animals calmly came to a halt at the foot of a perfect, green lawn that rose from the edge of the curving path, past a small, active volcano, toward the deep-blue sky. And right there, on the crest of lawn, silhouetted against the sky, stretched out on a wrought-

iron chaise, wearing fawn trousers, a gray frock coat, a yellow vest, and a loose, mauve tie, holding a paisley-bound notebook in one hand while popping a bonbon into his mouth with the other, was *Oscar*! This was *really* a surprise, and a very pleasant one, too, because even though we are all, always, looking for our prince and hoping to find him, coming upon dear friends in unfamiliar circumstances is easily as wonderful. So David and Elizabeth literally leapt from the cart—calling, *"Yo! Oscaro! Oscarino! The old Oscarmeister!"*—scampering up the ridge like Ti and Do, past the active volcano that decided, at that very moment, to blow rings of white, sympathetic smoke into the bright air.

Oscar did not move, or, rather, he did not move that much. He saw his friends, heard their cries, and, letting his head fall back and closing his eyes, exuded a profound sigh of relief. All morning he had been sitting there, sipping weak tea and worrying about his weight. Every ten minutes or so, he would stop worrying about his weight, slip his hand into his pocket, withdraw a bonbon and pop it into his mouth. The pleasure of the bonbon would make him worry about his weight again, so he would sip tea for another ten minutes. This cycle had been in place since soon after breakfast, but now his friends were here! They came rushing up to him saying, "Oscar? Oscar? Are you all right?"

"Sublimely so, now," he said, opening his eyes and honoring them with his most wonderful smile. "But how came you?" he asked eagerly.

David and Elizabeth looked at one another and shrugged. "We don't know," they said in unison, "There was supposed to be . . . uh . . . a prince."

"Of course!" Oscar said, "There is indeed a prince, and your presence here proves that he is, indeed, well, a prince! He summoned you, don't you see?"

"I suspected something like that," David said, "It could have been a whim of my own, I suppose, but I'm not much of a daytrip person."

Elizabeth couldn't say anything. She couldn't believe it. She had been summoned by a *prince*! She was looking around for the prince when Oscar launched into a diatribe on the utter *uselessness* of an artist like himself in a contemporary chateau environment. "I fix things," Oscar said, "but everything here is fixed! I thought I had located a volcano in need of my generosity, but *no*! Its abjection was designed and counterpoised with this frozen weathercock. It's so frustrating," he said, shaking his head. "I adorn

the world, but everything here is authentic beyond adornment. I comfort the unlovely, but the prince is all too lovely and very comfortable as well. He has no wound or blemish!"

"But he has been wounded," David reminded him. "His mother's tragedy, you know."

"That was not a tragedy, " said Oscar, in his most tony inflection. "It was only *called* a tragedy because Harry is a prince, and, as a committed socialist, I must insist that, if it's not a tragedy when *my* mother dies, it's not a tragedy when Harry's mother dies. It was sad, that's all. It happened to a boy who turned into a prince, but not to the prince. The prince, unfortunately, happened to me. Here, listen to this:"

At this point Oscar opened the paisley-bound notebook and read them the same passage of *The Happy Prince* that he had read to Prince Harry.

When he had finished, Elizabeth said, "What happens next?"

"The prince was too polite to ask," Oscar said, "but since you ask, you shall know. The Happy Prince gradually becomes aware of the sadness and deprivation that surrounds him in the city, so he recruits this little swallow, who, for reasons of his own, has refrained from migrating south for the winter. Using the swallow, the Happy Prince disperses his gaudy accouterments to the needy citizens of his city—his ruby hilt, his sapphire eyes, his golden skin. Then the little swallow dies in the cold, and since the prince's statue is now ugly, the townspeople tear it down and put it in the scrap heap with the body of the swallow. Then God rescues the dead swallow and the Happy Prince from the dump. God gives them both a special place in Paradise."

There was a long silence when Oscar stopped speaking, and finally David said, "Oscar, that is a very dumb story."

"My point exactly! It raises the question of which is better, beauty intact or beauty broken down for parts." Oscar said.

"And what about the Charity Children who just want to look at the Happy Prince?" Elizabeth said, "Also, precious materials are exhaustible, art is not. It keeps on giving."

"Riches are monogamous," David said, "Art is promiscuous."

"My point again," Oscar said, "This, I fear, is the sort of drivel that artists create when they are stranded in Paradise—or hope to get there."

"You couldn't have written that story in the city," Elizabeth said.

"Oh. I *could* have," Oscar said, "I am highly skilled. But I never *would* have. In the city, I would have understood the necessity of the Happy Prince, his statue."

"You need to get out of here," David said, "It's blunting your edge, and there isn't even a pool."

"I need to get out of here, " Oscar said, "But I do keep things on an even keel. If I left, Prince Harry might inadvertently become aware of his own loveliness. He might understand the extent of its earthly power over and beyond his princely mandate. Then he would just be another rock star."

"Would that be so bad?" Elizabeth said.

"It might not be bad, but it would be sad, because then he would not be Prince Harry, he would be Princess Di."

"Ah," David said, who didn't want to admit that he rather liked Princess Di.

"The better ending for your story would be for the Prince to blind himself and stay beautiful up there on his pedestal for people to see," Elizabeth said.

"You are one cold lady," Oscar said, "Would you blind *that*!" He made a gesture and they both turned to see Prince Harry, accompanied by Ti and Do, ambling up the lawn toward them. Seeing them looking in his direction, the young prince made an awkward little wave and grinned sheepishly.

"Oh Jesus," Elizabeth said.

"Ditto," said David.

"He doesn't talk, does he?" Elizabeth said, "Tell me that he doesn't talk."

"Oh, he talks," Oscar said, "But not so you notice."

"Great," Elizabeth said.

"Who needs a pool," said David.